Dames

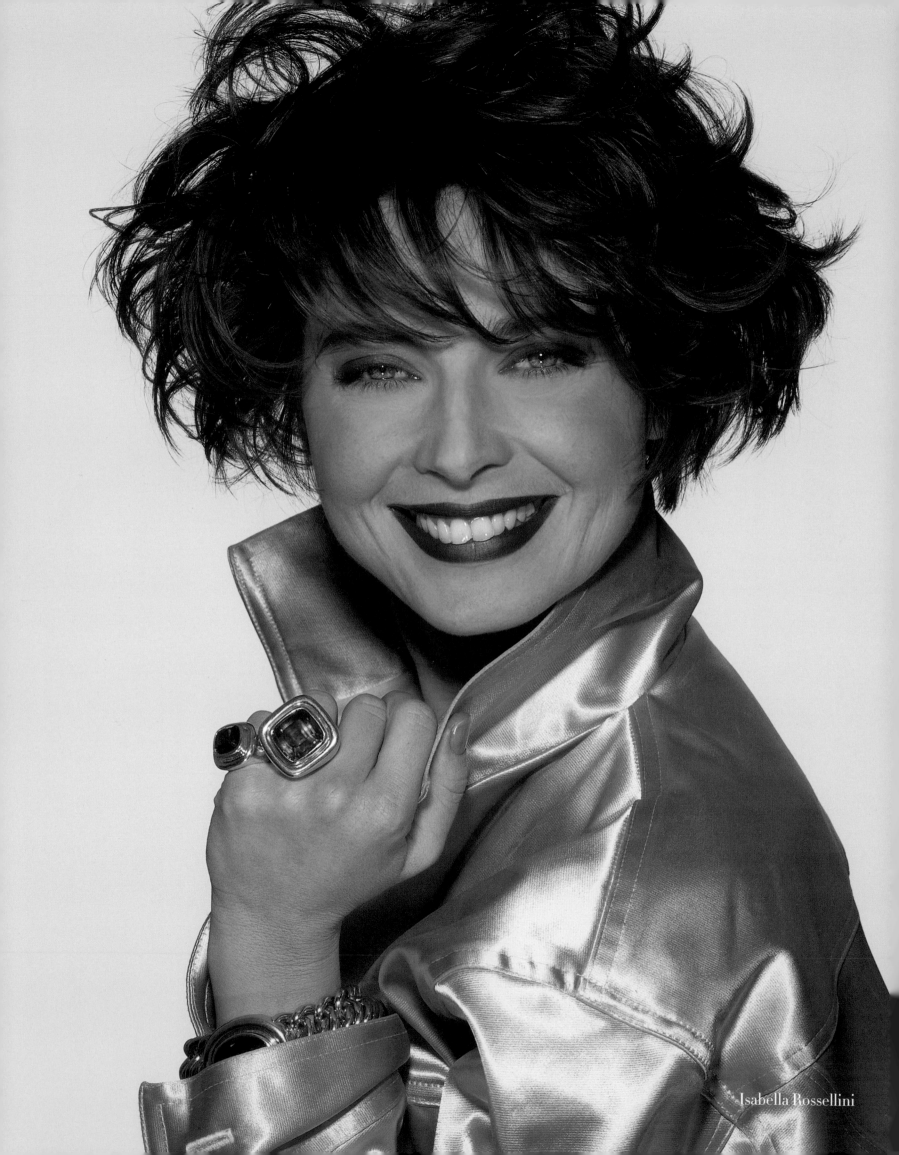

Isabella Rossellini

Eric Boman's Dames

Introduction by **Bob Colacello**

The Vendome Press

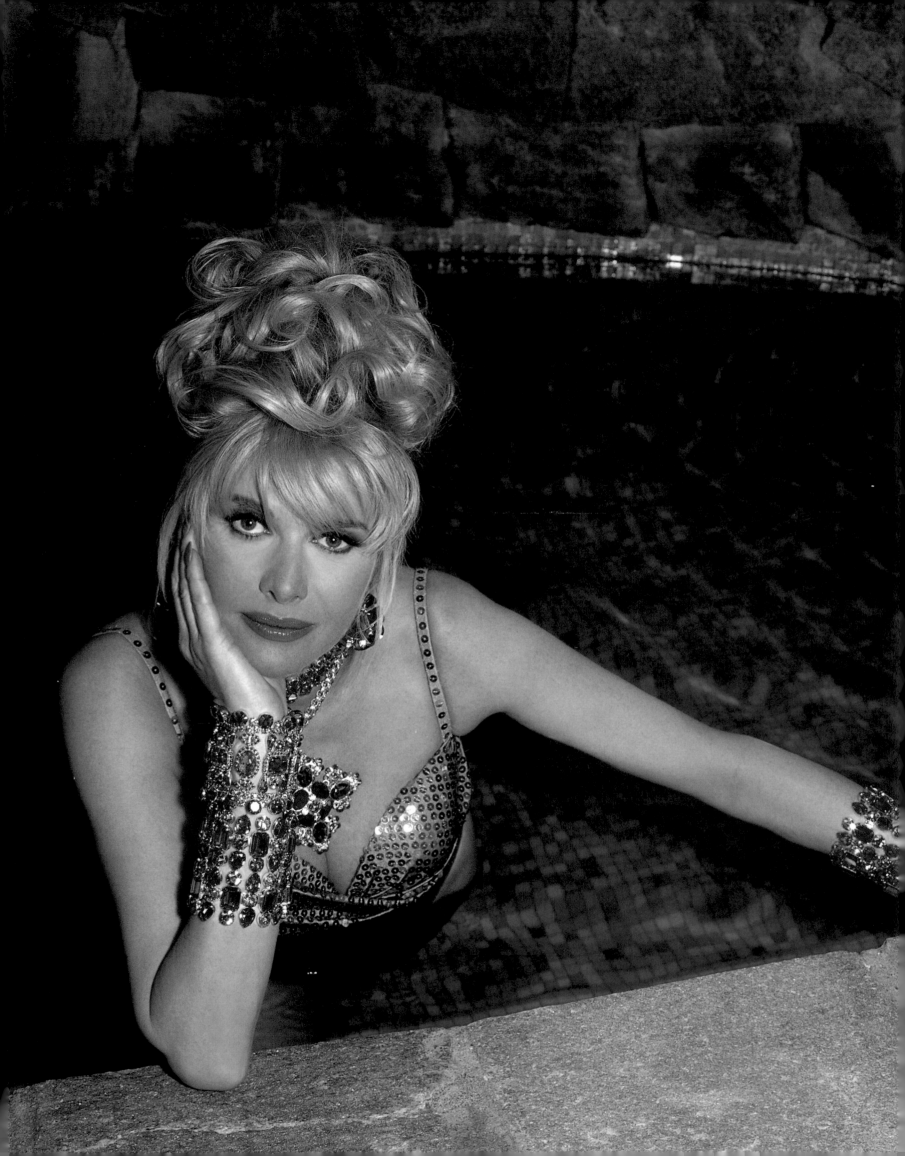

Contents

Ivana Trump

General Notes on Damehood

We know that a dame is a dame is a dame, and that there's nothing like one. Botanically speaking, if you will, a dame is on the other end of the scale from the shrinking violet. A dame takes command of her life, with ambition, initiative, determination, courage, and perseverance—and the conviction that there's nothing not feminine about that.

The man who is unable to respect a dame for what she is would be best advised not to pursue her romantically. A dame can be quite a handful. On the other hand, many of the men who do not pursue women romantically often have a special fascination for the breed and manage to form mutually satisfying friendships with its members.

The desirable coronet of damehood cannot be applied for—it is earned. Portrayal by this photographer in no way advances the prospects of admission to the rank. It rather works the other way around. By that I do not mean, of course, that a portrait would diminish such chances, but that it is the anointed dame who risks my descent upon her likeness.

It has thus been my great privilege to encounter the dames in this book, and I salute them all.

—Eric Boman, New York, 2005

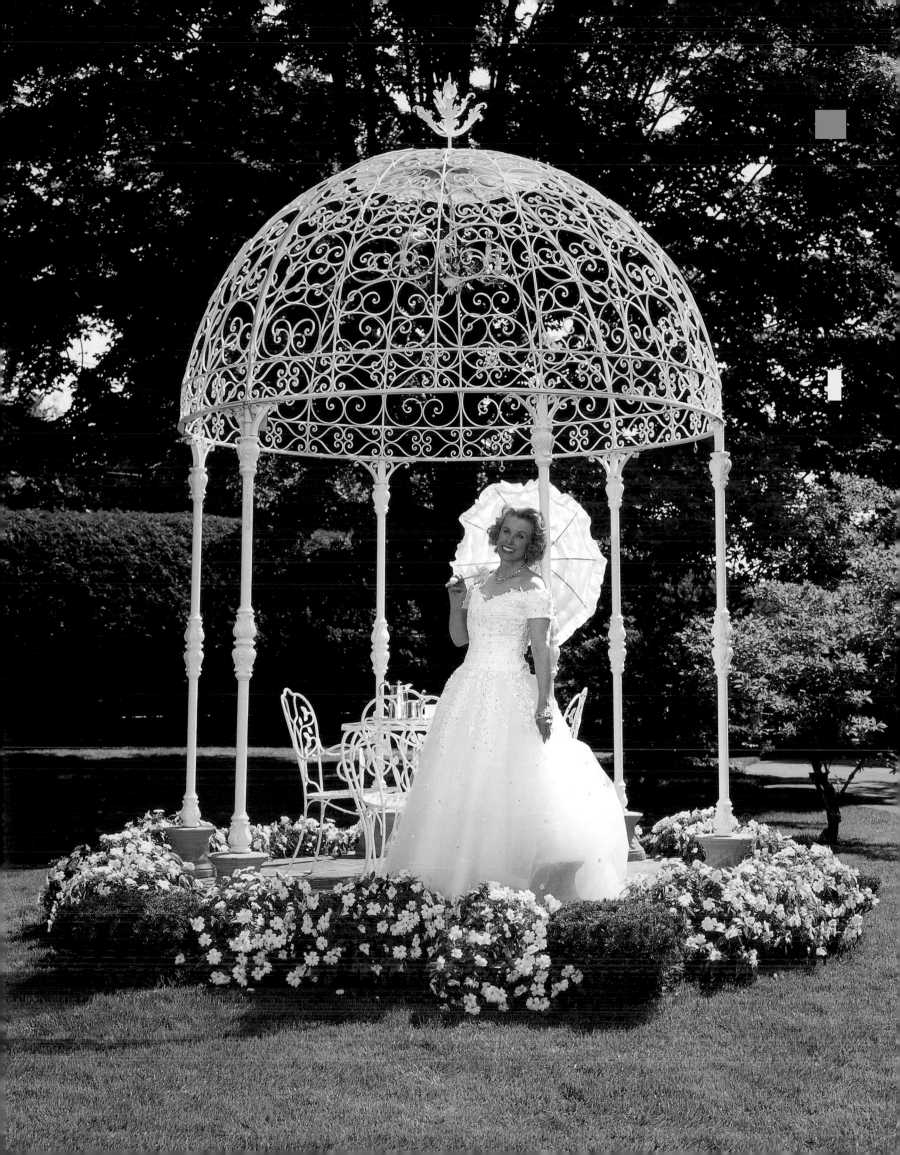

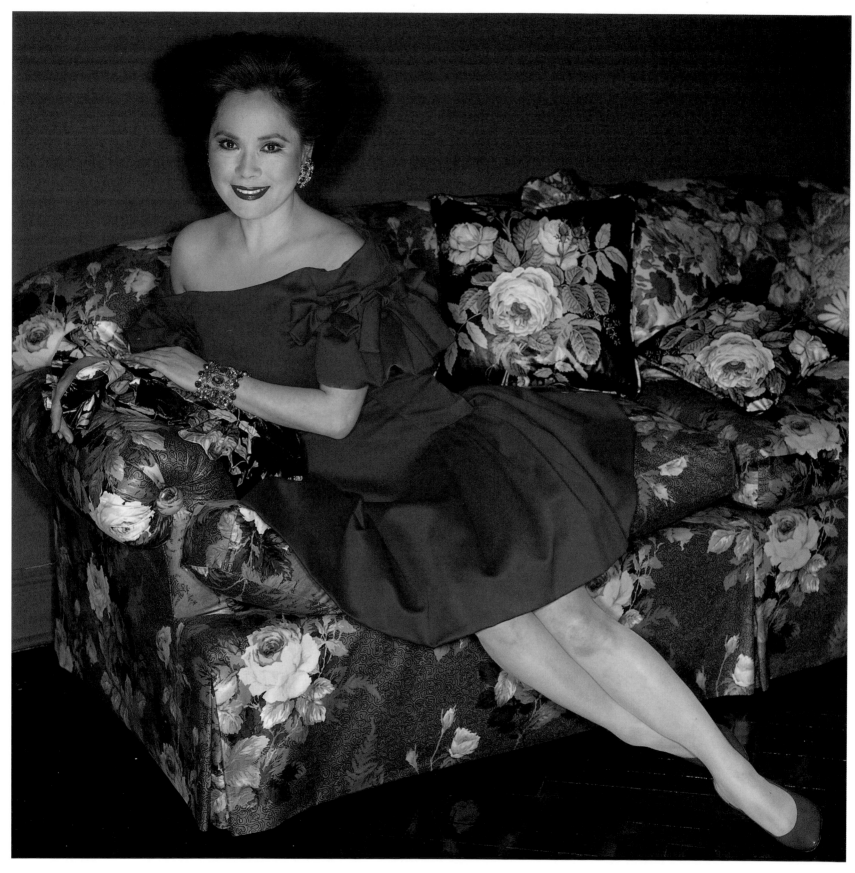

Dewi Sukarno

Introduction
Bob Colacello

"I'm mixed European, twenty-eight years old and you've never heard of me. I draw and take photographs and design fabrics and do a little writing when I'm asked, for London *Vogue* and for Paris *Marie-Claire*, but mainly for *Vogue*. I live in London and work in Paris and came to England eight years ago to go to the Royal College of Art and stayed on because it was more exciting than Sweden, where I went to high school."

So said Eric Boman in an interview with himself in the July 1974 issue of Andy Warhol's *Interview* magazine. It was a "Great Britain Special" issue, so Charlotte Rampling shared the cover with an English bulldog belonging to then editor-in-chief Rosemary Kent, and inside there were interviews with the film director John Schlesinger, the rock crooner Bryan Ferry, the model-turned-fashion-editor Grace Coddington, and the up-and-coming shoe designer Manolo Blahnik (who listed Gucci and Vuitton as his "ultimate dislikes"). To illustrate his self-interview, Boman photographed himself in a mirror. It was all quite narcissistic, but that was part of the point, as the young Scandinavian, tall, flaxen-haired, and strikingly handsome, was sought after as much for his beauty as for his talent. In his self-portrait, he looks androgynous but strong in an impeccable white T-shirt with a rolled-up

sleeve showing off a nicely shaped bicep; his Leicaflex camera is pressed against one eye and the other is ever so slightly made up. "People thought it was like that famous Horst self-portrait," Boman says, "which I didn't even know about at that point."

In any case, it was hardly the self-image one would have expected from the grandson, son, and brother of ordained Lutheran ministers. "I was the only one who managed to sneak away," Boman says. "I'm the secular son. Sitting in church was just torture for me, although it did foster a love of architecture and organ music." As a boy, Eric found his male forebears impressive—his grandfather was Swedish vicar of Johannesburg, South Africa, where he learned Zulu and brought Christianity and medicine into the bush; his equally devout father was cultural attaché to Sweden's embassies in Paris and Brussels and "gave all of his money away to the needy." But he was closest to his grandmother, Karin Boman, whom he nicknamed Fava. "It sounds like a bean, but it was actually my baby word for grand-mama," he explains. "I guess you could say that she was my first dame. And what a dame she was."

"My grandmother was a very stylish woman," he continues. "Every room in her house was done in very strong colors, and it was all done for her own pleasure. It was an eighteenth-century manor house that she had bought from a famous Swedish weaver—my grandmother was a member of the Swedish arts-and-crafts movement. She was very into furniture and the decorative arts, and she did it all without any encouragement from anyone, because all the Lutherans thought she was severely materialistic. I just worshipped her."

Because of his father's diplomatic career, Eric was born in Copenhagen and grew up in the Paris suburb of Neuilly and the medieval city of Ghent, in Belgium. "All the years we lived abroad, however, we went back to my grandparents' house in the south of Sweden for holidays and summer vacations," he says. "And my grandmother was such a dame that when she was about to have the Christmas tree decorated, she would invite all her friends in and set them to work. She'd sit in a chair—and she always had a cane because she broke her foot in 1929 and kept it as an excuse for the rest of her life—and she'd point where they should hang the ornaments. She was very, very particular about it. Her Christmas trees were amazing: one year all the ornaments were white, another year they were all gold."

After completing high school in the small town of Helsingborg, Sweden, Eric spent six months at Konstfack, the Stockholm art school, "which I couldn't stand—it was like kindergarten." He transferred to London's Royal College of Art, graduating in 1969 with a degree in graphic design. He got his first break from *The Sunday Times* women's page editor, Molly Parkin, who had him doing "little black-and-white drawings, mostly of shoes," as he recalled. From this Warholesque beginning, he soon moved on to British *Vogue*, where his drawings "got bigger and bigger, but it was quite slow really. I got very impatient about doing drawings for magazines and started thinking that I really had to do something else." He briefly tried painting, and then "started doing photographs because I can't draw people . . . and I guess I never picked up anything so quickly, except maybe for swimming."

In 1972, *Harpers & Queen* editor and art director Willy Landels asked Boman to illustrate four pages of lingerie. "I said to Mr. Landels that I didn't want to draw four pages of underwear—I'd rather take pictures. But it didn't seem to click, so I said, 'Could I have a model to photograph and then draw from the photographs?' And he said yes, so I thought, I'll make the pictures nice so he'll use them and not drawings. And he loved the photographs and used them, and I didn't have to do the drawings, and two months later he asked me to a do a cover. That's how I started taking pictures for magazines . . . and switched careers in mid-assignment. Then Beatrix Miller, the editor of British *Vogue,* called, and said, 'Darling, why are you working for the competition?'" From then on Boman would be exclusively associated with various Condé Nast publications, including the American, British, French, and German *Vogues, House and Garden, World of Interiors, Mademoiselle, Self, Vanity Fair*, and *The New Yorker*, producing dozens of covers and countless pages of sumptuous rooms and gorgeous women. (And, in many cases, gorgeous women *in* sumptuous rooms; see the São Schlumberger portraits in this volume, for example.)

The single exception was *Interview,* where I worked from 1970 until 1983, when I became a contract writer for *Vanity Fair.* Although Boman's 1974 self-interview-and-portrait marked his first appearance in *Interview,* he had met Fred Hughes, Warhol's style-obsessed manager three years earlier in London, and was a regular at the impromptu teas Andy and Fred gave at the Ritz Hotel whenever they were in London, where they threw together fledgling designers, photographers, and designers with baby Lambtons and Guinnesses. I think that was where I first encountered Eric, though I also remember him bringing some photographs for me to see at Andy's apartment in the Rue du Cherche-Midi, in Paris. In those days, he seemed to always be in a casual white suit worn with a T-shirt, usually white, too, a simple look that made his shock of ultra-blond hair all the more striking.

A few months after we put out our special British issue, Eric became one of our contributing photographers, joining a roster of rising stars, including Chris von Wangenheim, Bill King, Peter Beard, Robert Mapplethorpe, Christopher Makos, and Berry Berenson, who were willing to work for peanuts in exchange for having their pictures run full-page or double-page without being cropped, collaged, or festooned with flashy type, which was the prevalent style then, particularly at Condé Nast's fashion magazines under the artistic directorship of Alexander Liberman. (Andy set very few rules at *Interview,* but two of them were: Don't Put Words on Photos and Make Every Photo, including Party Snaps, as Big as Possible.) By then I had taken over the magazine's helm from Rosemary Kent, and would frequently assign Eric to photograph what we called "Viewgirls," pretty young things who were just starting out as actresses, models, singers, or socialites. We also featured a hunky young "Interman" or two each month, but I don't recall ever asking Eric to take those pictures.

The fact of the matter is that Eric Boman has always been a woman's photographer, in the same way that George Cukor was a woman's director. Like that legendary and refined MGM filmmaker, Boman "gets" women—he likes them, he may even identify with them, he certainly knows how to

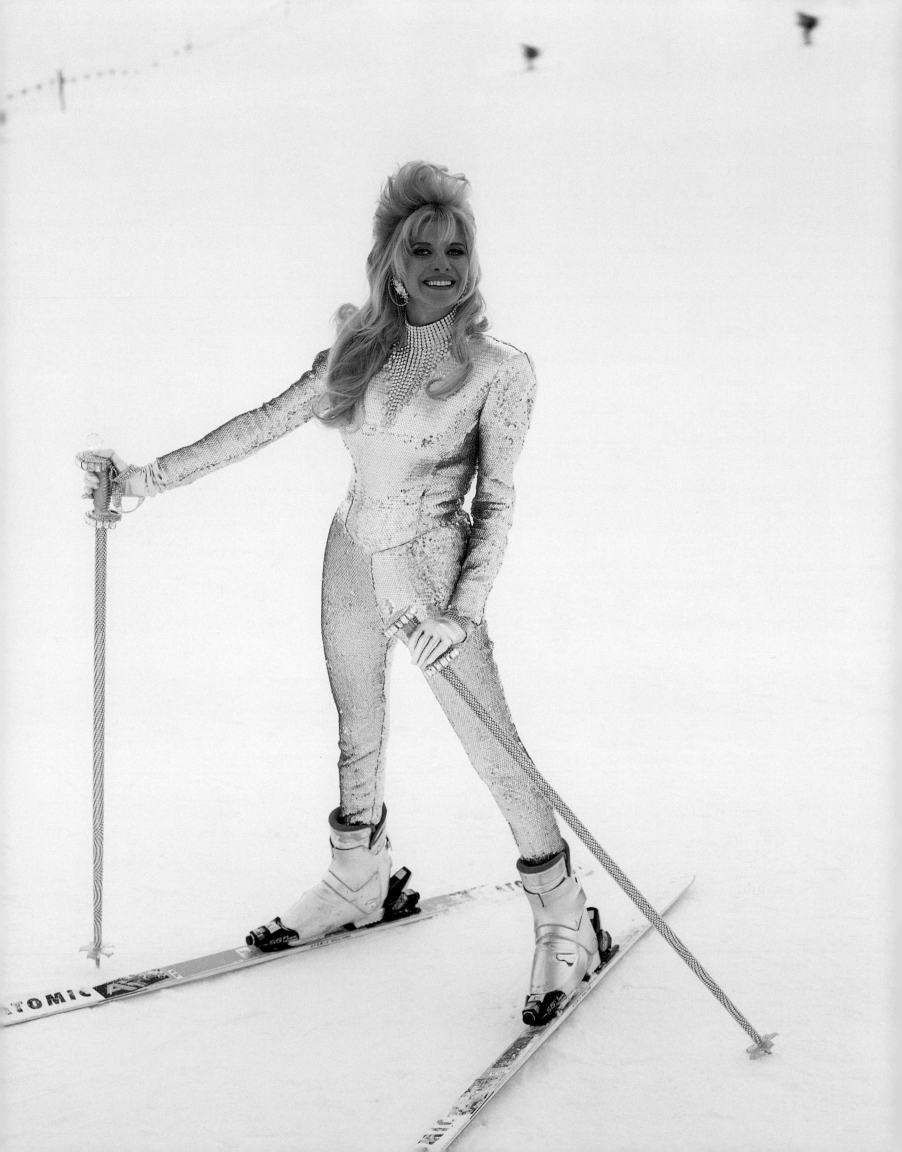

make them appear beautiful. As with Cukor, who elicited the most extraordinary performances from Jean Harlow, Greta Garbo, Joan Crawford, and Katharine Hepburn, among others—Boman's women not only look their best, they also give their best: his camera somehow draws their inner emotions to the surface without becoming melodramatic, obvious, or tacky. As a result, his pictures can be both glamorous and meaningful, even at their most contrived and "fashion-y."

In his self-interview Boman said that his favorite photographer was Helmut Newton, which makes perfect sense, and declared, "I like pictures that look real, as if it's believable—the people, the situation, the light—even if it's crazy. Or corny. I like pictures that verge on the corny. I guess I always like pictures to be beautiful, basically. I like people to look really good and I think I have made the people I've photographed look good, generally speaking. I tend to ask people to lie down and close their eyes because it's stunning what it does and I find people look best lying down with their eyes closed."

From his *Interview* work, what stands out in my mind are two covers of the jewelry designer Paloma Picasso and a double-page black-and-white portrait of the actress Angelica Huston lying on the floor and talking on the telephone. Both women were and still are good friends of his; Eric likes to surround himself with women who are doing things, who, like him and his partner of many years, the artist and potter Peter Schlesinger, are consummate professionals as well as creative spirits. Several are portrayed in this book, including the multitalented Marina Schiano, who styled many of the photographs originally done for *Vanity Fair,* including those of Ivana Trump and Parisian social queen São Schlumberger, which accompanied articles I wrote for the magazine. (I'll never forget Marina calling me in Zlín, Czechoslovakia, Ivana's hometown, where I was researching the first Mrs. Donald Trump's early years, from St. Moritz, Switzerland, where Eric was photographing her. "Darling, hurry up and get your story in," Marina urged. "Eric is taking the most fabulous pictures of La Trumpette on top of the mountain with rhinestone ski poles I had made especially for our shoot. It's a cover for sure, unless you miss the deadline, darling.")

Eric and I also teamed up for profiles of Francesca von Habsburg, the Thyssen steel heiress and arts philanthropist, and Dewi Sukarno, the alluring widow of the Indonesian strongman, who managed to get herself arrested after a contretemps with the Filipino president's granddaughter at a New Year's Eve party in Aspen. Working with Eric has always been a pleasure; though he specializes in prima donnas, he is not, unlike some of his well-known colleagues, a prima donna. He is, however, a wonderful mimic, which may stem from speaking five or six languages at an early age and which, to my thinking, is a sign of empathy for the person one is imitating. Then there is the matter of his ever-evolving accent, an intentionally entertaining mélange of Mayfair, Locust Valley, vintage Hollywood, and contemporary Condé Nast, with, much to his annoyance, a persistent trace of Swedish huskiness. It's all part of his sense of humor, which very much informs his work. Boman rarely indulges in out-and-out caricature or camp, but in looking at the pictures in this book one senses a definite desire to amuse.

These delightful images were made, of course, within the rather strict and limited parameters set by the codes and rituals of glossy, upscale magazine photography, which aims to attract, sell, and

Ivana Trump

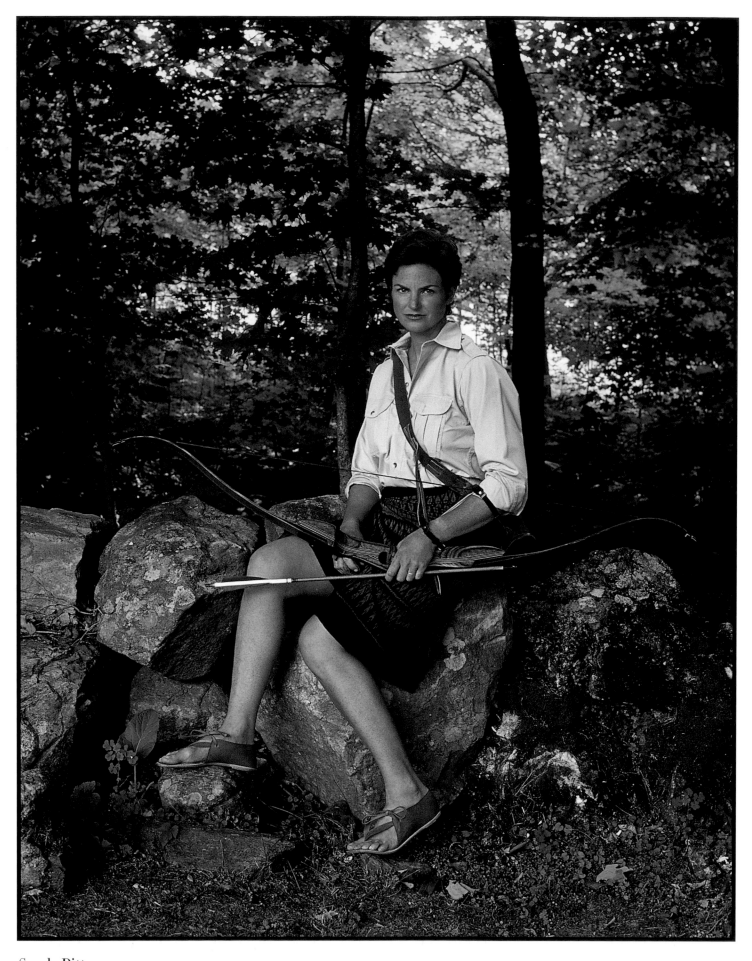

Sandy Pittman

sparkle. Editors and art directors must be pleased, subjects must be flattered, all must be left content enough to extend a return invitation. Revelation, when it occurs, is a by-product of this process, not its principal goal. What's more, the photographer has rarely chosen his subject and most often is meeting her for the first time when the shoot begins. As Boman has told me, "These are pictures of people I have photographed almost by fate."

Nonetheless, after two decades of cheerfully or reluctantly taking the assignments he was given—"I don't think I've ever turned down an assignment," he says. "I've always had too many bills to pay"—he found that a theme had emerged. His subjects were dames, women of "rank, station, or authority," according to Webster's dictionary, strong women, ambitious women, independent women, modern women who manage to be feminist and feminine at the same time. The range is remarkable, from boldface powerhouses such as Barbara Walters, in a smart short version of a reporter's trench coat; Georgette Mosbacher, hand on hip in her palatial drawing room; and Elizabeth Dole poised in yellow amidst a sea of stately gray décor; to such exemplars of high style as Mica Ertegun, Chessy Rayner, Nan Kempner, Isabel Eberstadt, and Elizabeth de Cuevas, posed together in their Madame Grès couture gowns at the Metropolitan Museum of Art.

There are pictures that echo Slim Aarons (Barbara de Kwiatkowski at home in Greenwich), pictures that are pure Jeff Koons (Madame Sukarno at Rumpelmayer's ice-cream parlor), and pictures that are simply Boman at his beautiful best (the close-up of Carroll Petrie in silvery pearls and a golden McFadden; the full shot of Carolyne Roehm in ecclesiastical purple taffeta against a purplish green hedge). And so many surprises: I have never seen Tama Janowitz look so chic, Carolina Herrera so sportive, Françoise de la Renta so pensive. Who knew that Marilyn Quayle, the former vice-president's wife, was a huntswoman, or that the mountain-climbing Sandy Pittman was also into archery? Both of Boman's bosses are here, too: *Vogue*'s Anna Wintour, looking cunning and confident, and Tina Brown, formerly of *Vanity Fair*, cunning and eager.

One could go on and on through these wonderful pages, noting the wit or wiliness behind each image. Suffice it to say, however, that from the mad Marylou Whitney looking like a tiger on her bearskin rug to the savvy Diane von Furstenberg posing as Nefertiti in her bathtub, from the sublime Isabella Rossellini caressing a rose to the divine Jean Howard throwing open her doors, this is a book about women with an extra dose of personality by a photographer with a plentiful supply of originality.

Performing Dames

In *Grand Hotel*, at her wits' end, Garbo sighs, "The performance!" suggesting that not only has the dancing of her character taken over her life, it has taken on a life of its own, as she finds herself sidelined. The magic of the performance is a powerful lure: the opportunity to hold people's attention, and getting lauded and rewarded for doing it well. The time when the word "actress" was a polite term for a woman of compromised moral values has been eclipsed by a celebrity mania where the performing dame rules.

When I looked over *Vanity Fair*'s clothes rack for Annette Bening, only one outfit amused me. Annette hated it. I pleaded with her, even if it was made for someone less statuesque, and she uncomfortably complied. The picture was intended for a spotlight on an up-and-coming young actress, but Annette moved faster than a magazine's lead time and it instantly became redundant. End of story? Now, I see what she did: she managed to overpower the vulgar jumpsuit by simply sailing above it, innocently radiant, irresistibly fresh—the triumph of talent!

As I approached to greet Joan Rivers in the studio dressing room, she put her hands over her face and said through her fingers, "I'm not ready!!" Now, of course, I understand what she meant. In her early, really mean years, hating her looks spiced her monologues with outrageous wit, yet somehow she was vulnerable and loveable. Nasty just happens to be a lot funnier than nice, but this trooper has real stamina, and we haven't seen round three yet....

If your husband buys you a rundown motel in Las Vegas as an investment, don't accept it. That's what happened to Debbie Reynolds, who after her husband's death gamely tried to resuscitate the venture by

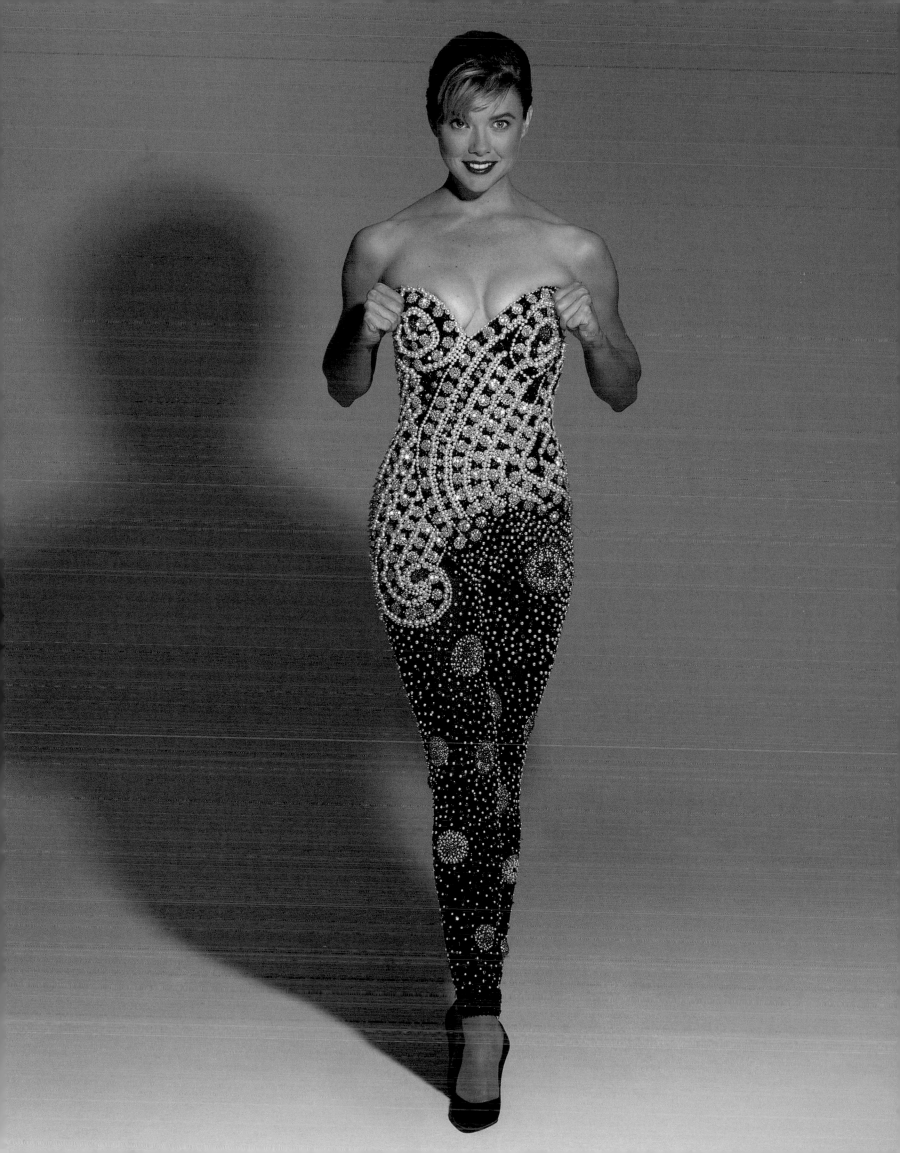

annexing it to a museum housing her great collection of movie costumes, and hanging the splendid chandeliers from *Marie Antoinette* in the lobby. She also put on a perky nightly show, with many Eddie Fisher–Elizabeth Taylor innuendoes, and showed clips from *Singin' in the Rain*, where, out of context, she strikes one as a new, modern breed of actress.

When Jean Howard published her great photo book *Jean Howard's Hollywood*, *Vanity Fair* sent me to photograph her in her Coldwater Canyon house. Being part of the legendary set that was Hollywood Society in its glory days, all she had to do was take along her camera, and unquestionable talent. I found her as beautiful in her eighties as the ingénue actress I saw in pictures from the 1930s, and rather opinionated about what makes a good picture.

As a fashion photographer back when models acted the parts of imaginary women, created by editors for their magazine's readers to identify with, I had worked with all but two in the Debutante group picture here, taken to announce their celebrity status. Donna Mitchell projected magic. Lisa Taylor and Patti Hansen were the reigning supermodels when I came to New York, Patti on the cover of *Vogue* every single month. Marisa Berenson, Lois Chiles, and Dayle Haddon were models who made the transition to the silver screen, and Shelley Smith, whom I photographed first of all on a visit from London, became a scientist.

Going from teenage Maybelline model to being a terrific actress in film and television, Cybill Shepherd had worked out an original way of juggling work and life. From a vast truck, which served as mobile office and sometime home, she could stay on top of business while having her hair and make-up done, and be with her kids all the while. The white behemoth rolled up to our *Vanity Fair* location, and there she was, looking just as you'd expect from seeing her in *The Last Picture Show* years earlier.

Movie stars are often on a smaller scale, physically, than they appear on film—the camera does close-up work. The theatre is another matter. Fanny Ardant walked in, a strapping square-shouldered six feet, and her presence made me understand how she can project the subtleties of a wistful expression from the stage.

This is a feeble anecdote, but a witness to how beauty has the power to fascinate in itself. Carole Bouquet asked if she could see her pictures before they ran in German *Vogue*, something photographers are not supposed to allow. Look at her picture here, and imagine saying no! She sweetly came to my hotel room and told me she liked them. I hear she now lives on an island in the Mediterranean and makes very good wines, and I like her even more for that.

At tea at the Hotel Meurice with Salvador Dalí, I met a rangy blonde model, Dalí's muse Amanda Lear, who became my friend and "big [now little] sister." She smartly assessed that being a muse might not be the most reliable career, and became a disco diva with the argument that if she could make a living from her worst asset—her voice—it should be smooth sailing. Here she's smoothly diving into a friend's pool in Saint-Tropez. She also paints, daintily wearing little white cotton gloves, just like Gina Lollobrigida!

Photographing subjects of a certain maturity can make you feel like a kid. Not the case when I worked with Ione Skye. I remember how her father, Donovan, helped usher in the Dylan era in Europe with folk hits when I was in high school!

Penélope Cruz came to most people's attention with the film *Belle Époque*, a story set in provincial Spain at the turn of the last century, where she played a young woman discovering love. Dressing for this photograph, she was sweetly embarrassed to change in front of the stylist—a breeze from another culture that made us realize how clique-y our little world is.

We all want to be what we're not. Luckily for German *Vogue*, Stephanie of Monaco briefly wanted to be both a model and a rock star, when many a young girl in her place would happily have settled for princess.

My introduction to Anouk Aimée was seeing her in Federico Fellini's *8 1/2*. It happened at a time in my life when its message went straight home, and somehow changed everything for the better. I have seen it thirty-odd times since then, not entirely for Mlle. Aimée I confess, yet meeting her in person had a special magic. Fellini had tried to make Anouk look frumpy by giving her short hair, glasses, a white shirt hanging over a short black skirt, and flat shoes—in contrast with the rococo curves and feminine attire of Sandra Milo, who played the mistress. That was in 1962. Today, the film makes Aimée look beautifully modern and Milo like an old-fashioned doll. Cheekbones could have something to do with it.

Isabella Rossellini first came to my studio as a model, wearing a man's tweed overcoat, and instantly seduced me with her smartly opinionated, down-to-earth wit. From that day, we often worked together. Once, when another model broke into tears for no apparent reason, Isabella said, in her matter-of-fact Swedish voice, "What's her problem? We're all beautiful!" Isabella bought a country house around the corner from mine, and asked if I would take delivery of some plants in her absence. They were rosebushes from a Danish breeder who had named the hybrid "Ingrid Bergman," for Isabella's mother. We potted one, and photographed mother and daughter for *House & Garden*.

Many years ago, at the Club Sept, in Paris, Grace Jones asked me, "When are you going to take my picture?" She was a big girl at the time, and I managed to get off the subject by saying, "Soon." By the time I moved to New York, she had reinvented herself as the uniquely visual disco phenomenon with a cult following that we know, and I was begging to photograph her. Here she is on the inside foldout of a record, the cover of which had her head bandaged like a mummy.

The first time I worked with Brooke Shields, we spent a week photographing her wearing the Italian collections in my living room. She was still a schoolgirl and brought her aunt as chaperone—and to make sure she did her homework. Brooke was learning French at the time, so we turned the sitting into a conversation class for the duration, having a lot of fun. Going from child actress to Broadway star during a very long time in the public eye, Brooke has never strayed from being her intelligent, levelheaded, and considerate self—and disproved my theory that you're either beautiful as a child or as a grown-up but never both.

As soon as she arrived at the studio, Catherine Deneuve gave the driver detailed instructions for a number of errands she'd like him to run while she was being photographed. They were all to top Paris food purveyors, each one with a special request, for a cheese, a jam, a vegetable, a coffee... This condensed richness of subtle, inadvertent information made me feel I could hardly have learned more about France's great movie star in a year. Towards the end of our sitting when I apologized for taking yet another roll of film, she said in her perfect English, "Oh, I was married to a photographer, you know," referring to David Bailey—who'd been very nice to me when I started out at *Vogue* in London.

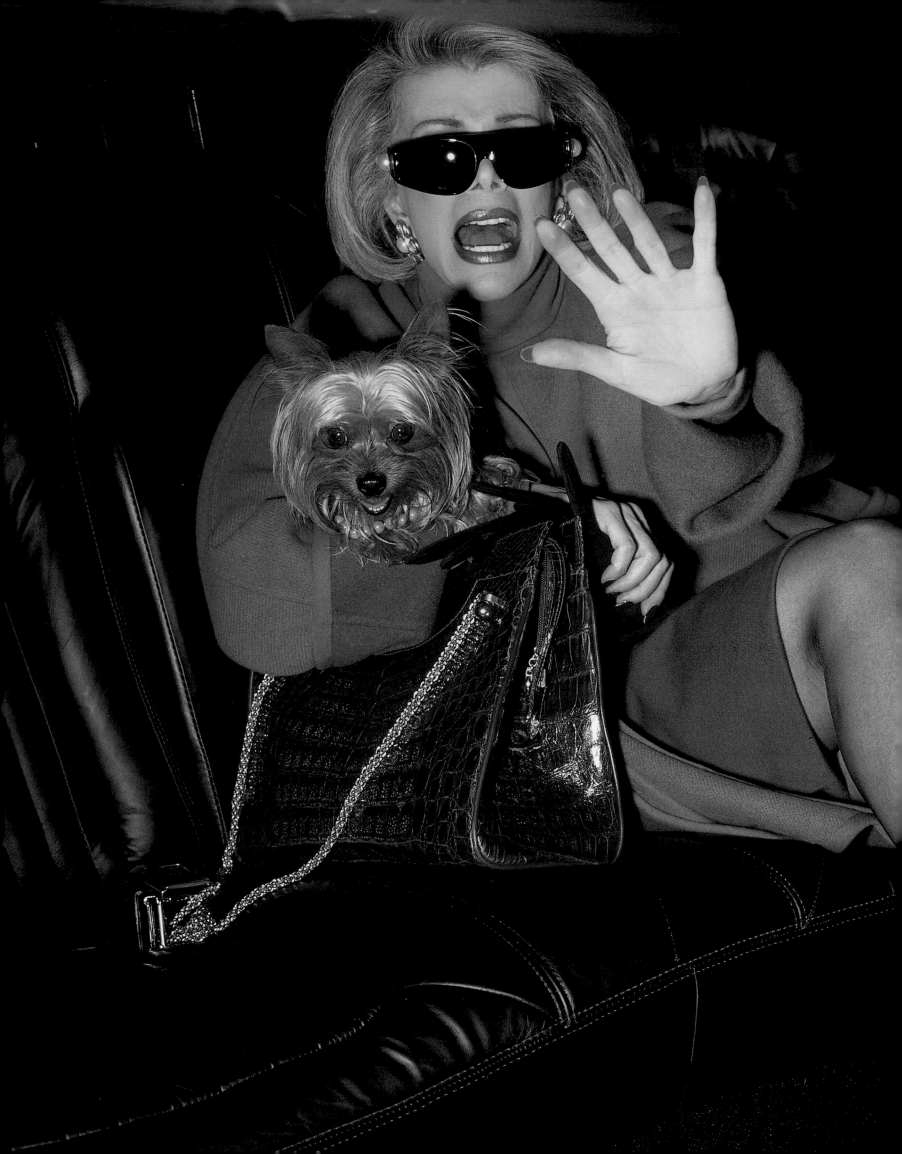

Joan Rivers

Joan Rivers

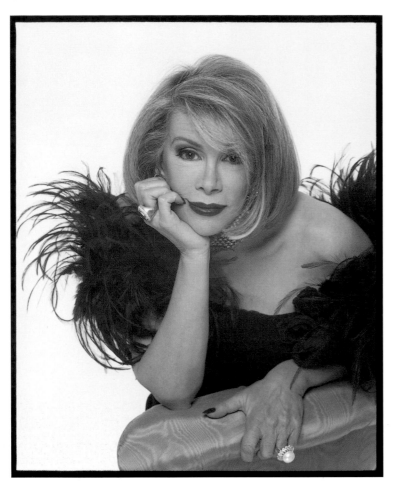

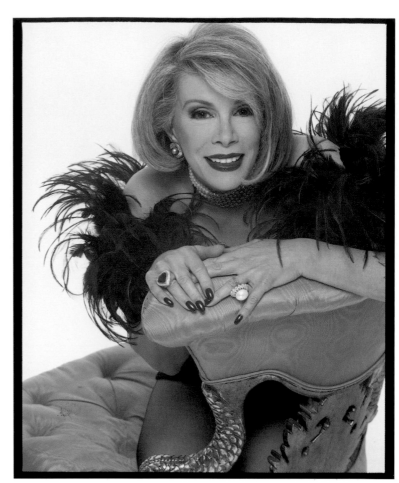

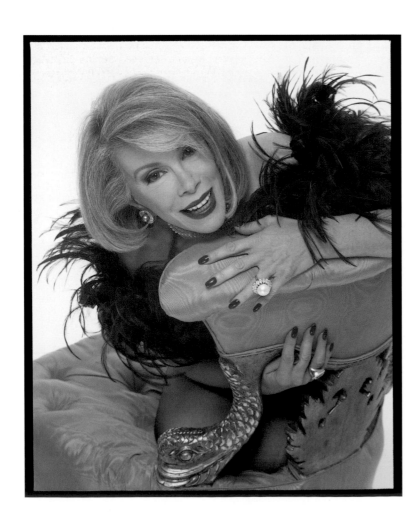

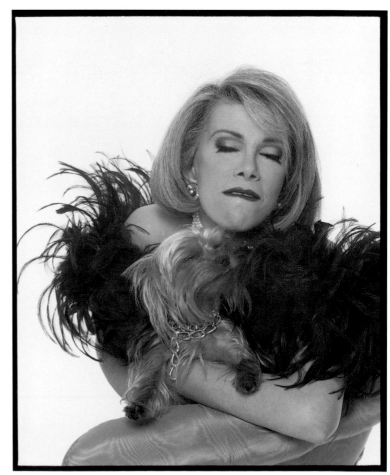

Debbie Reynolds

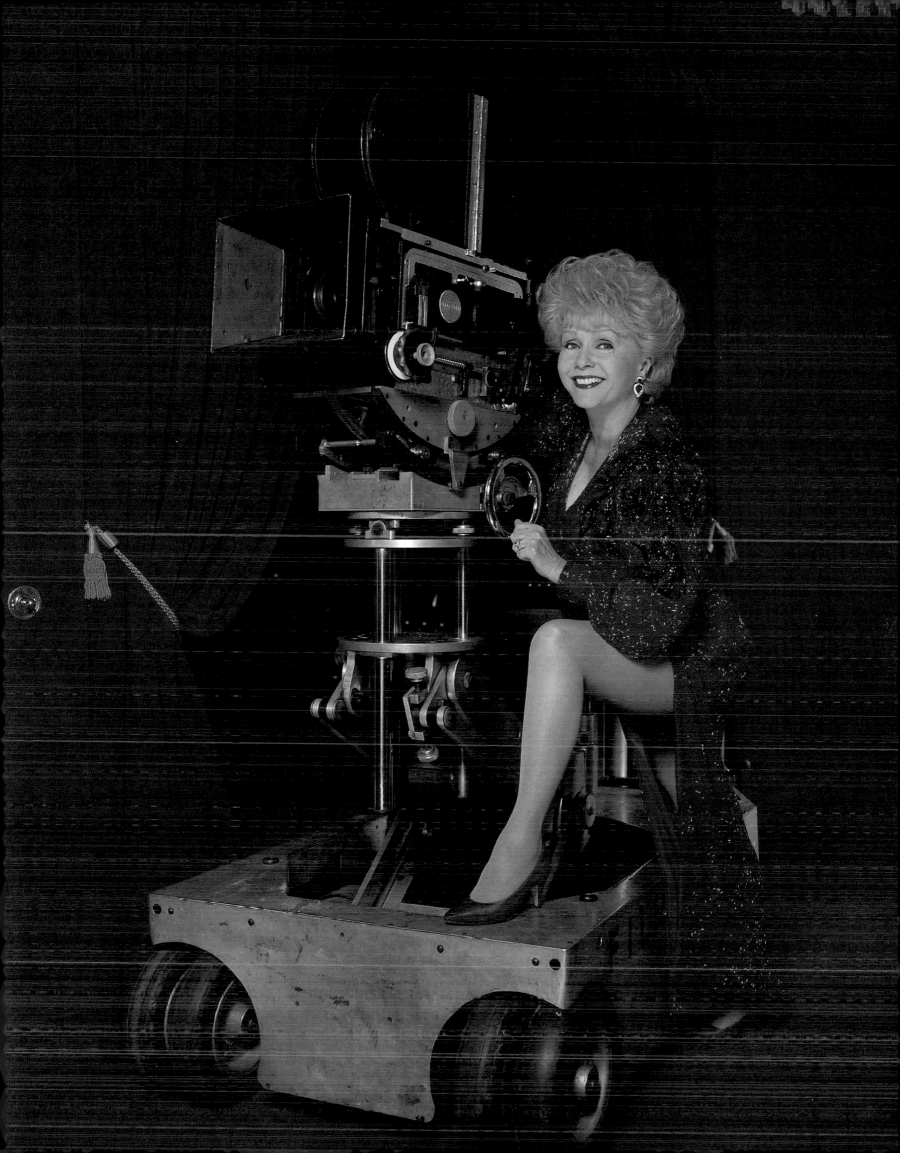

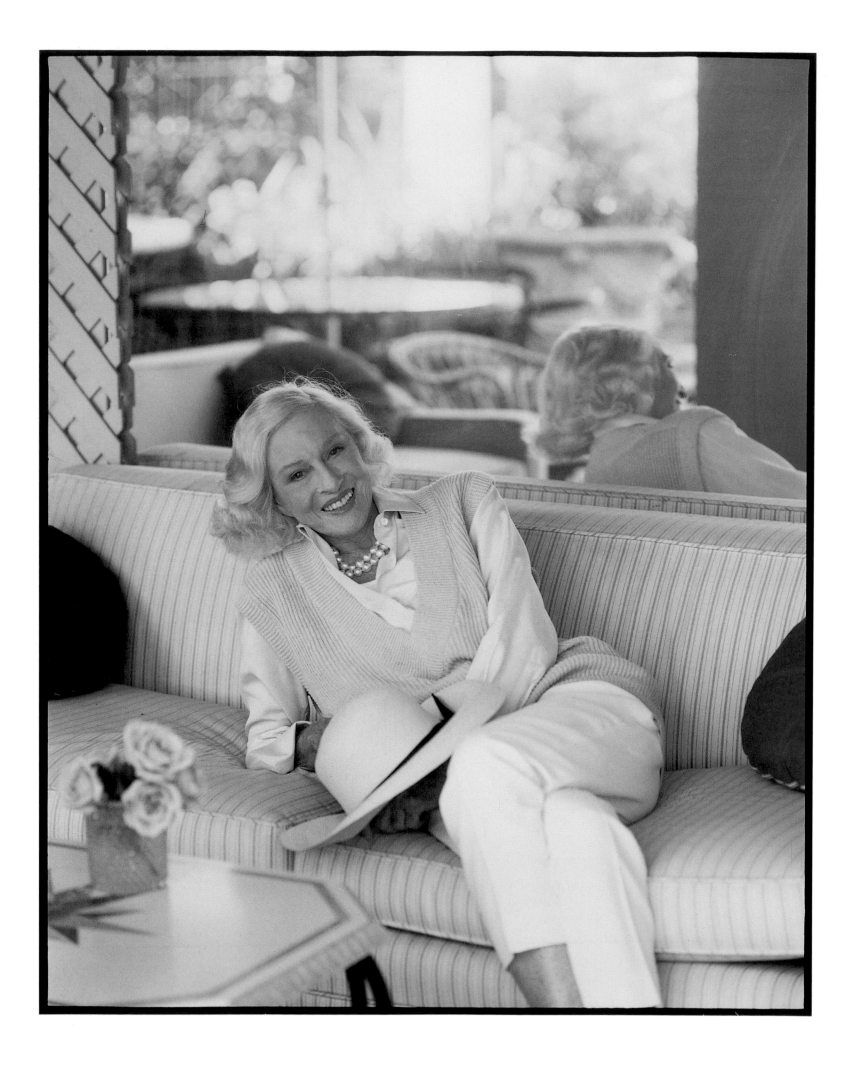

Jean Howard

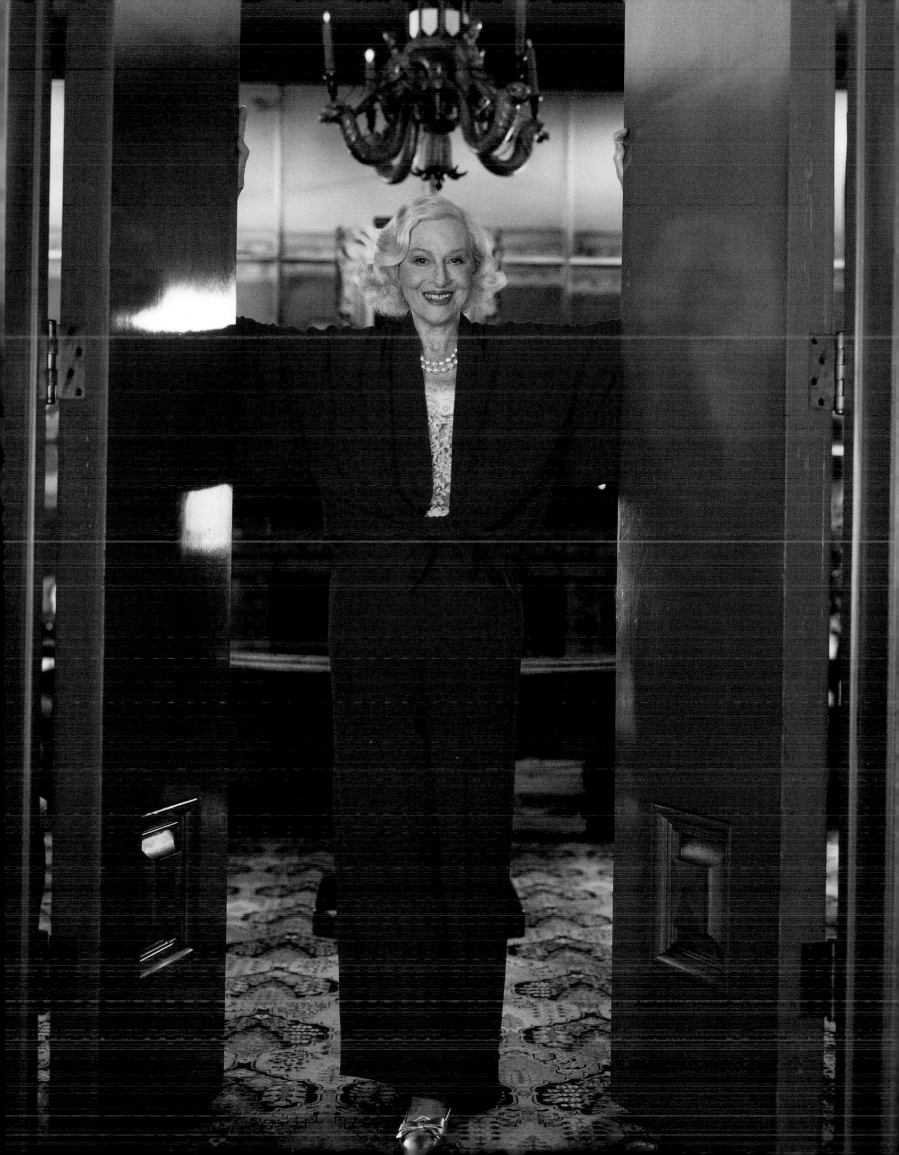

Susan Forristal

Patti Hansen Lisa Cooper

Janice Dickinson

Lisa Ryall Sean Casey

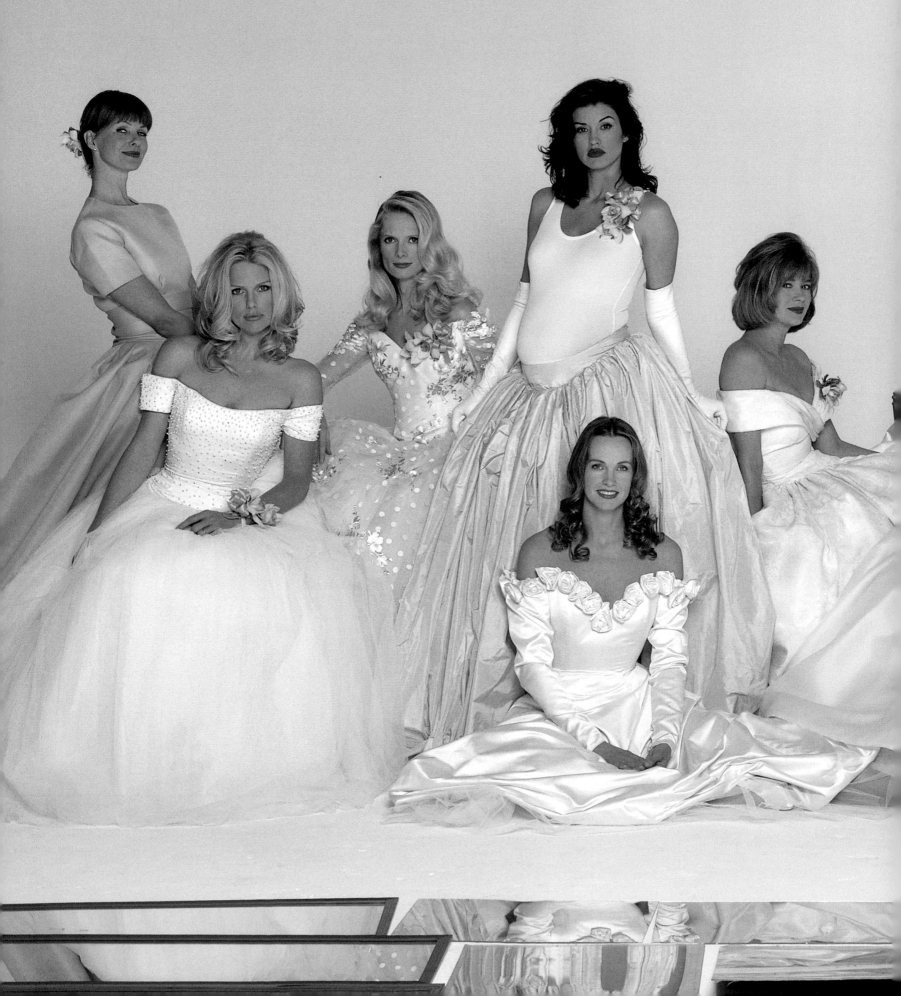

Bitten Knudsen Lois Chiles Marisa Berenson

Dayle Haddon Donna Mitchell Lisa Taylor Shelley Smith

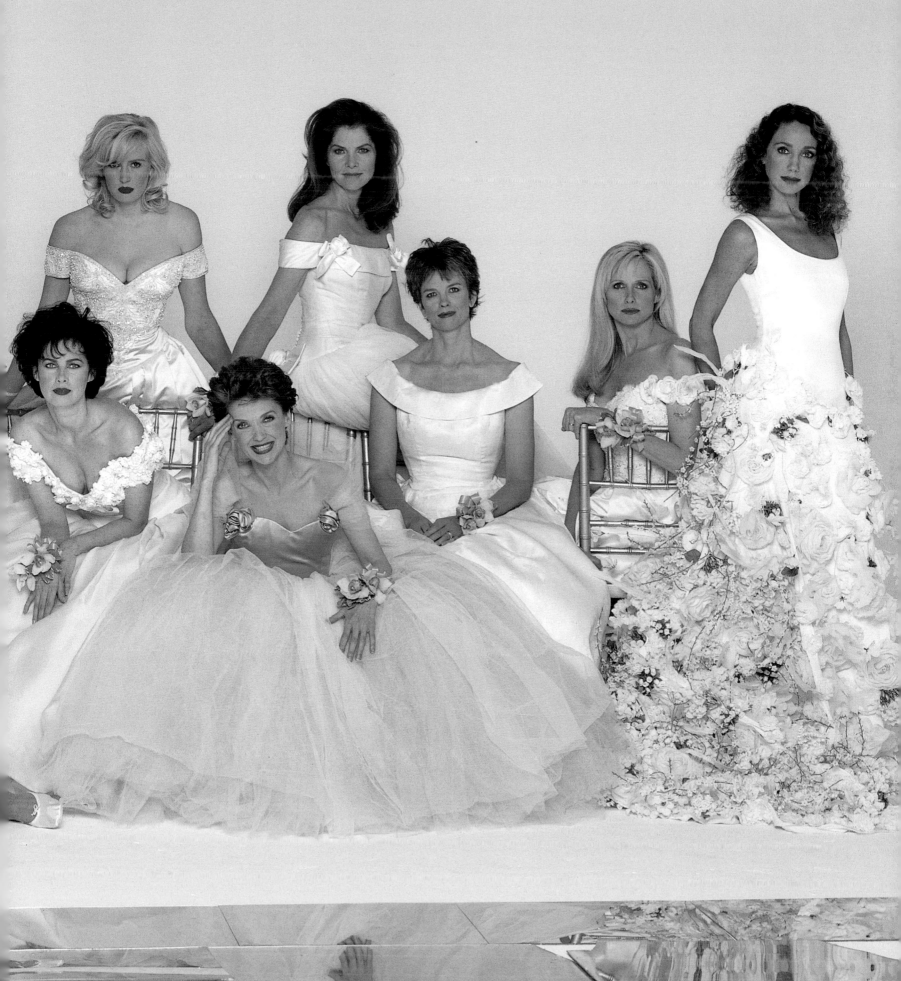

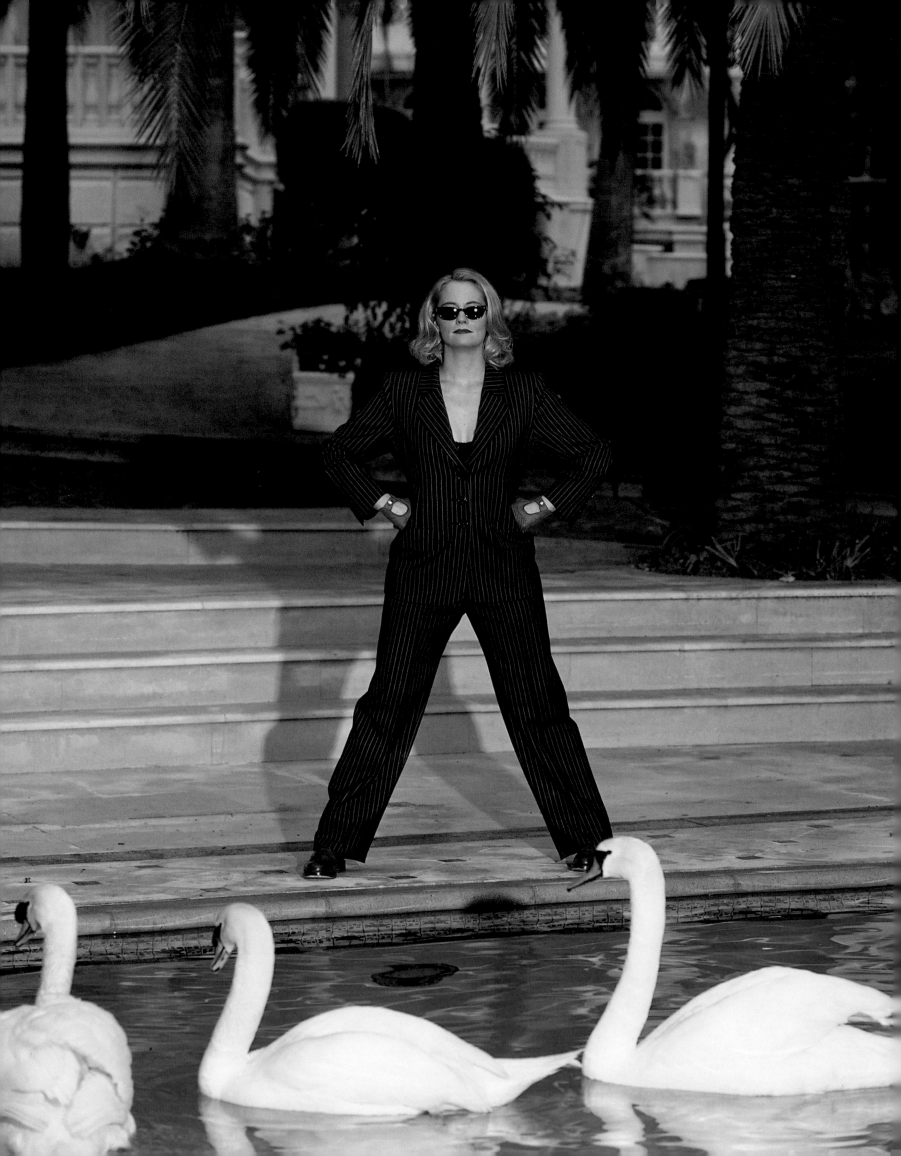

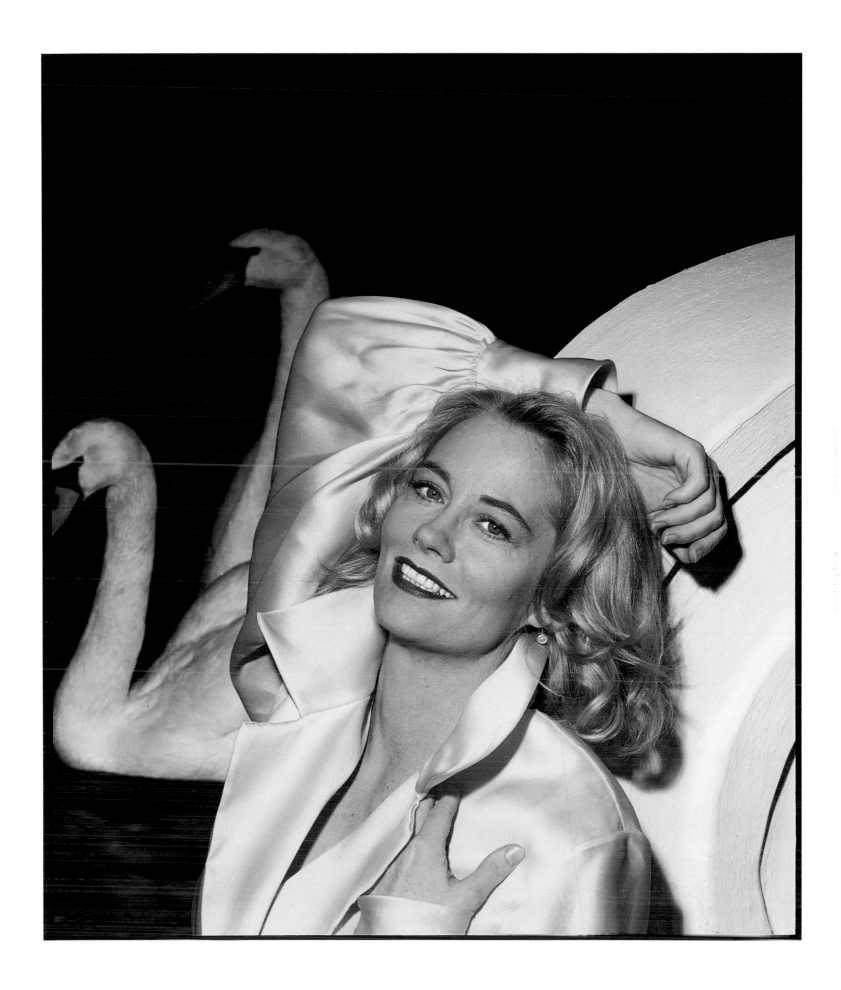

Cybill Shepherd

Fanny Ardant

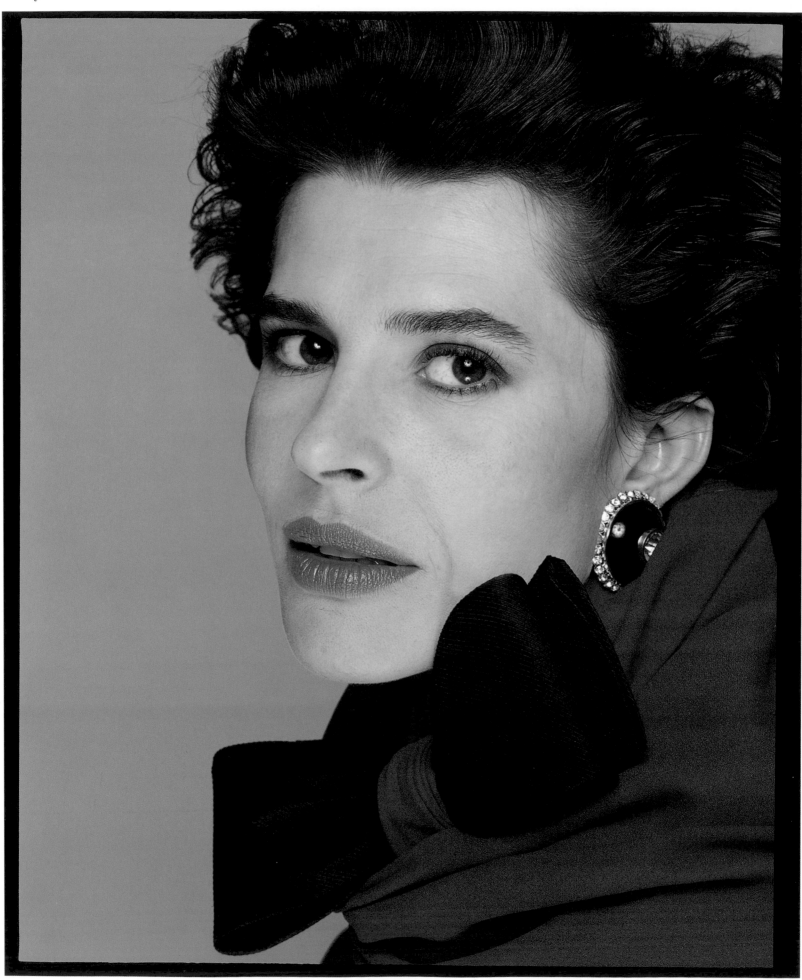

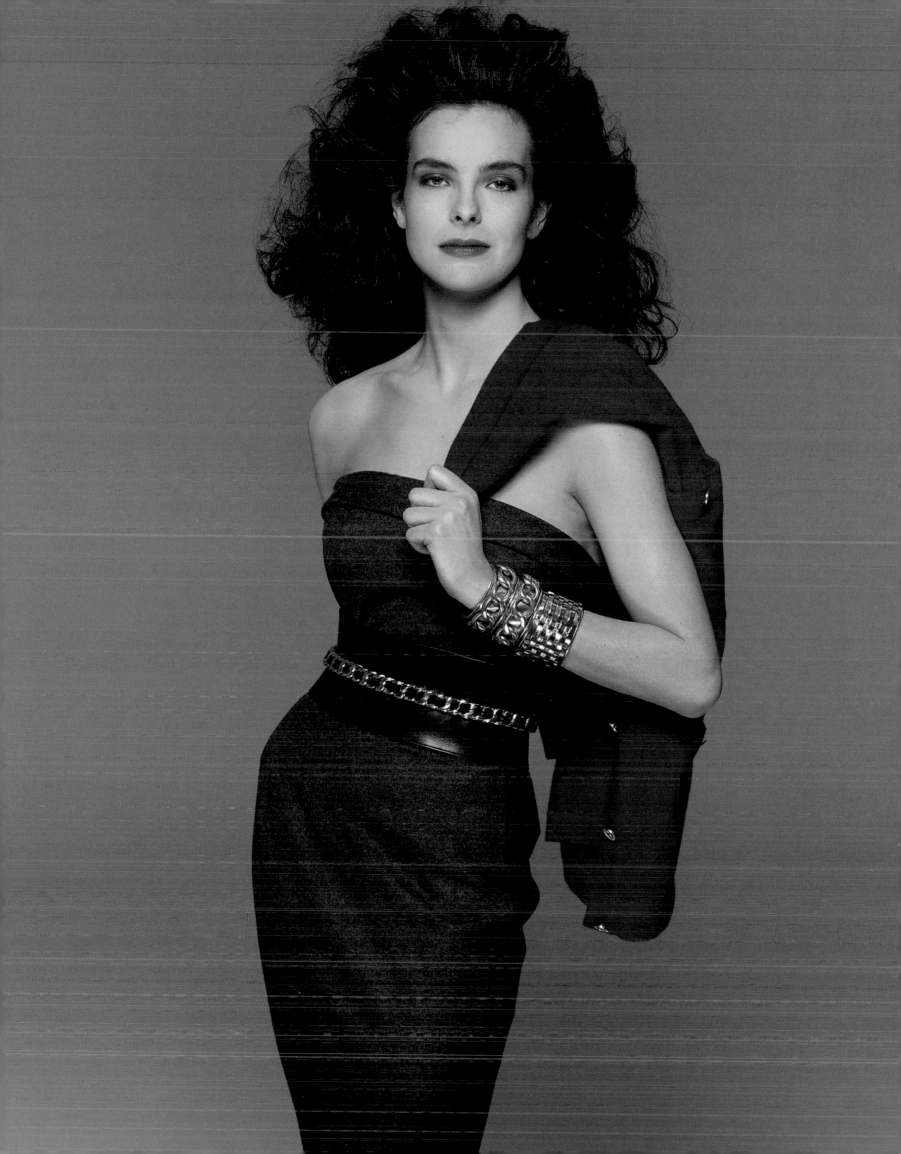

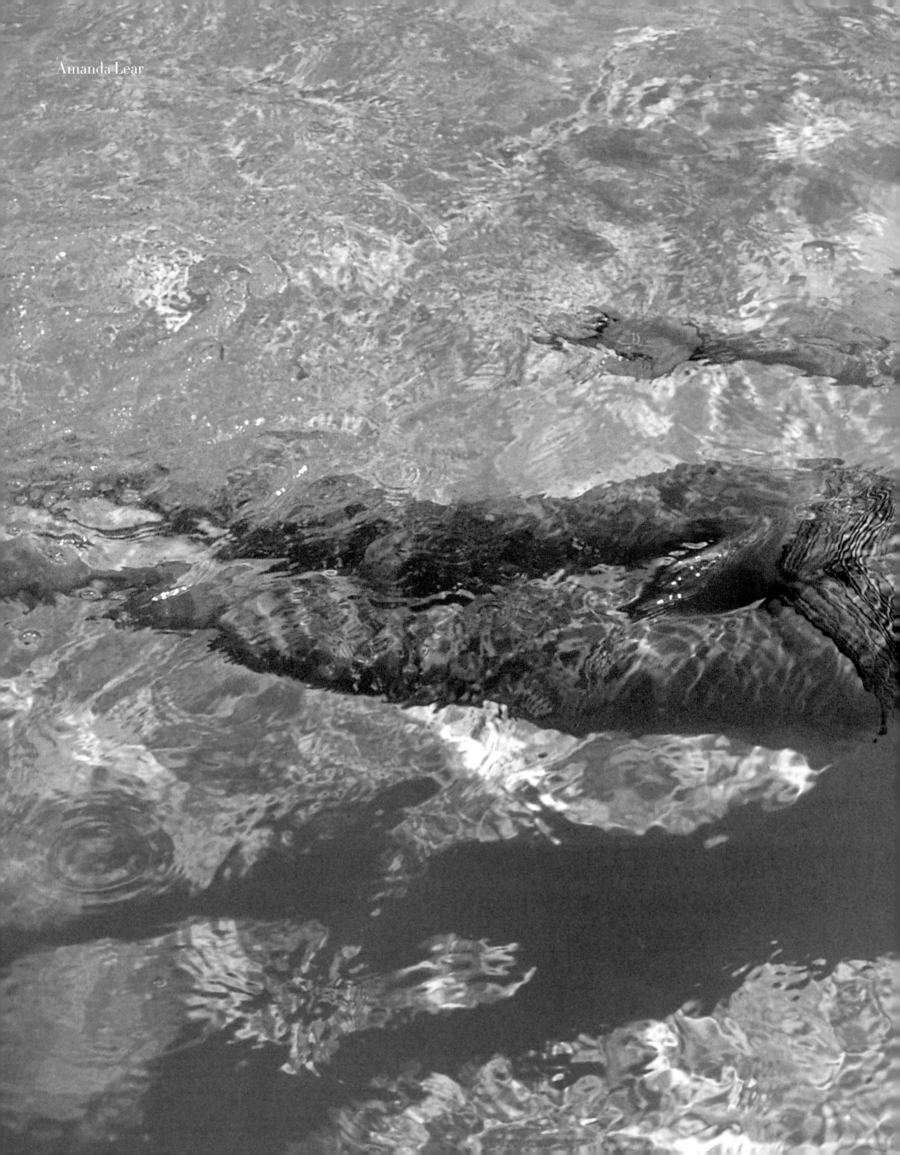

Amanda Lear

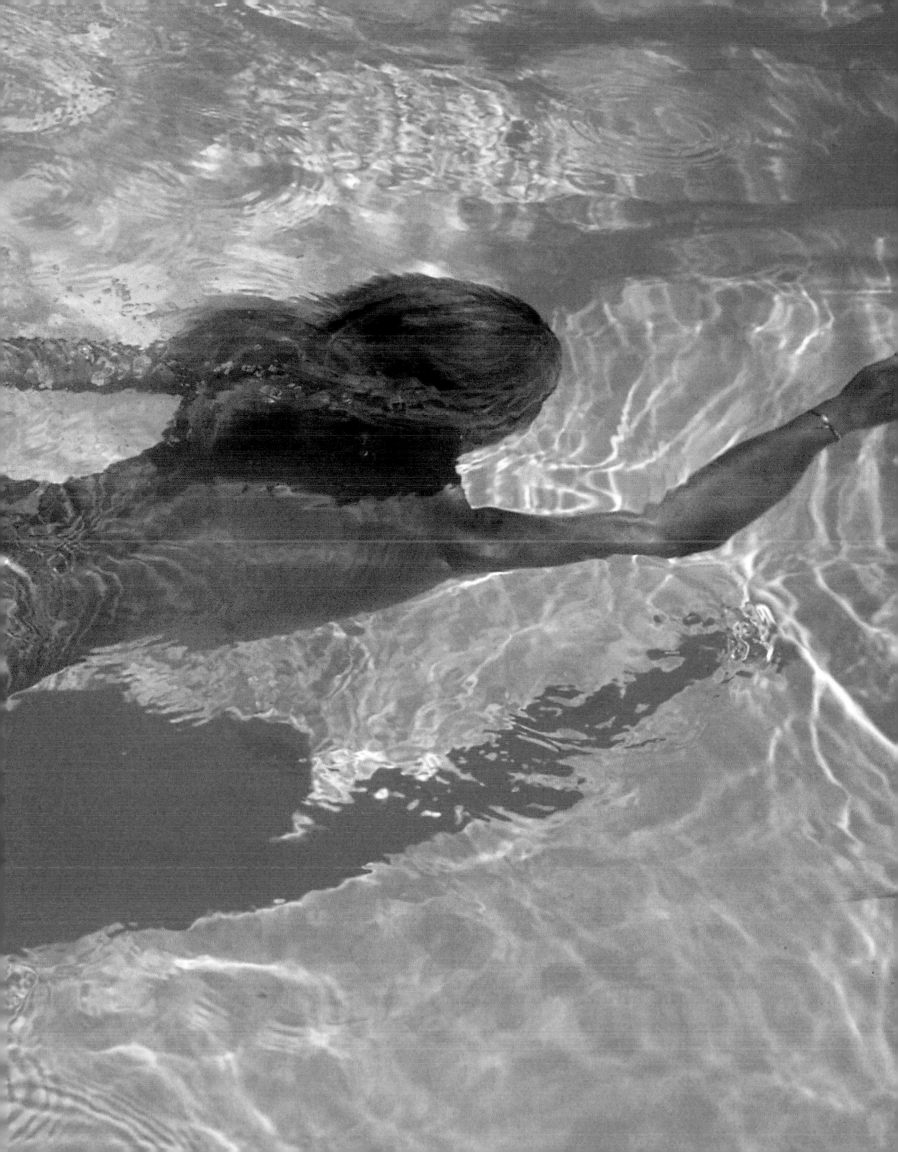

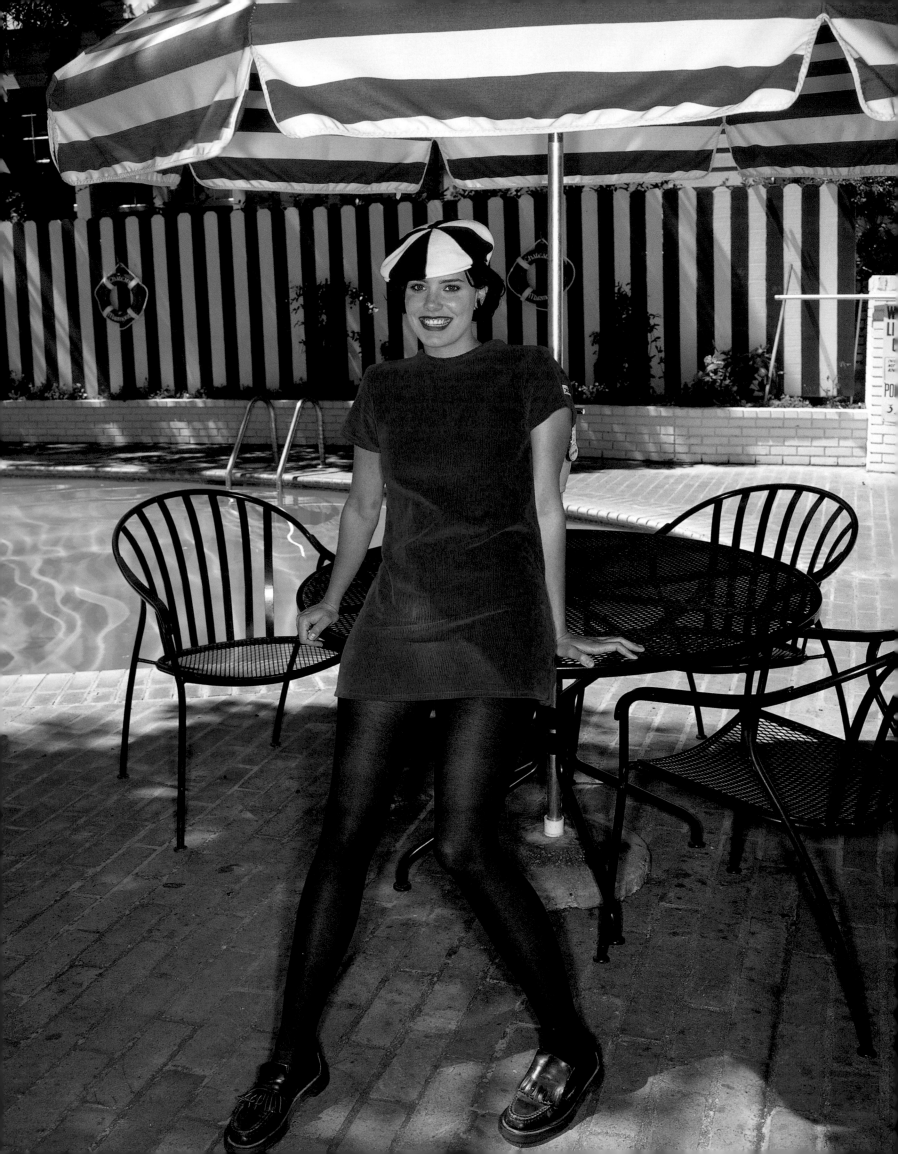

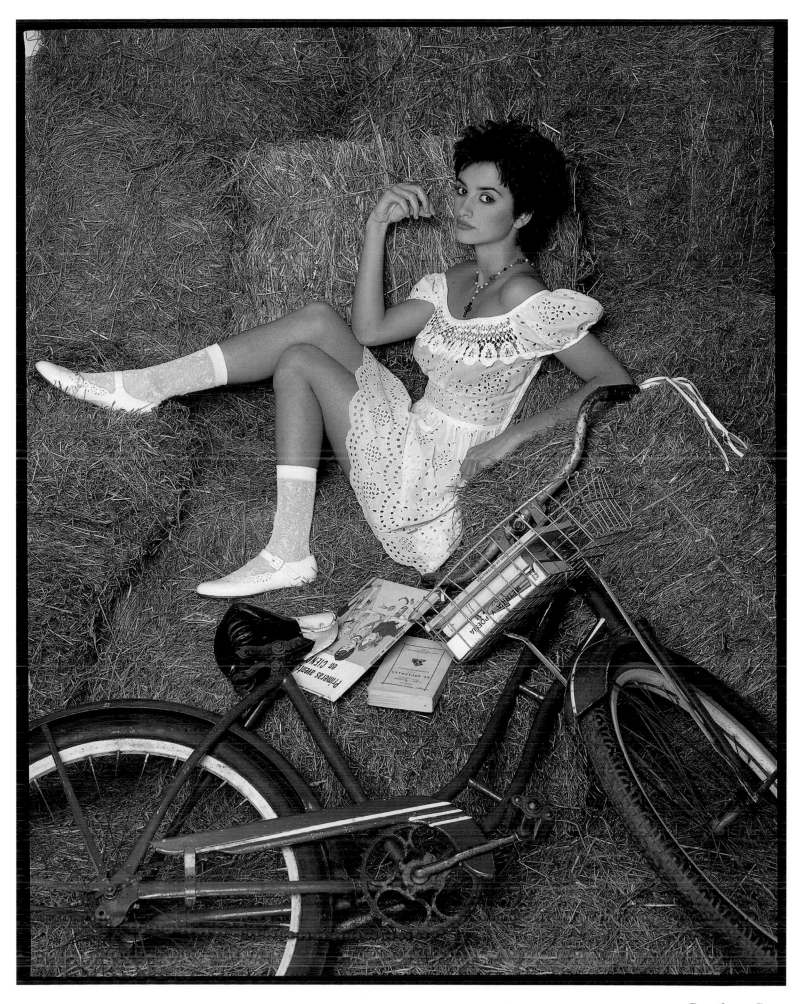

Stephanie Grimaldi

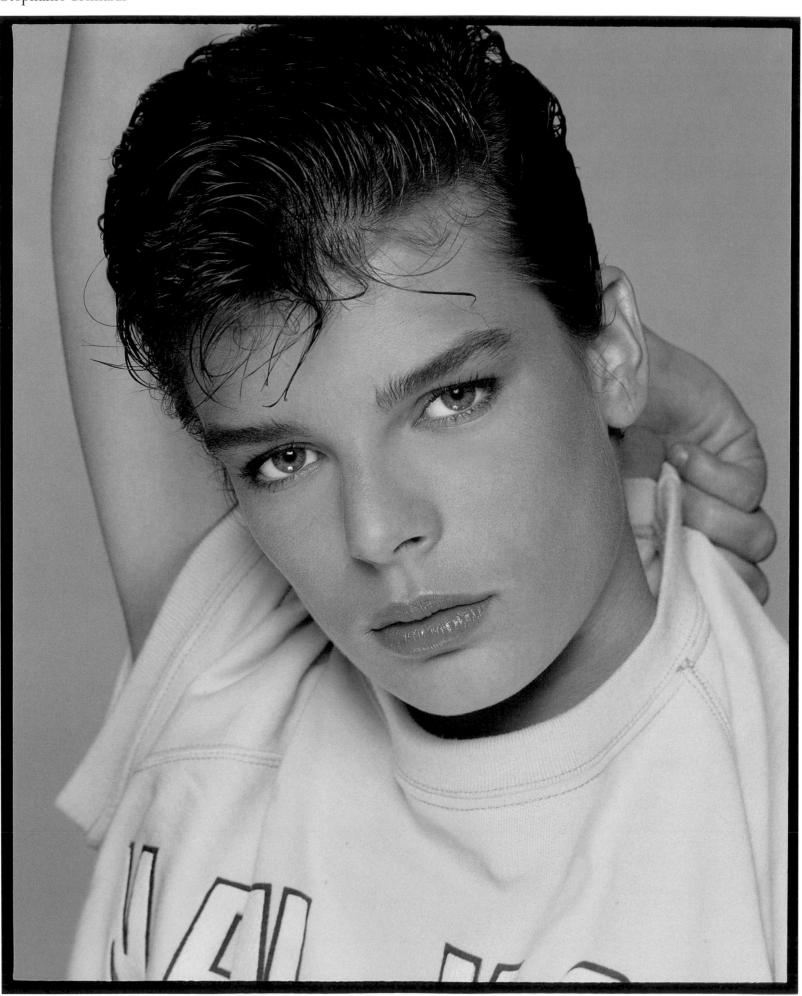

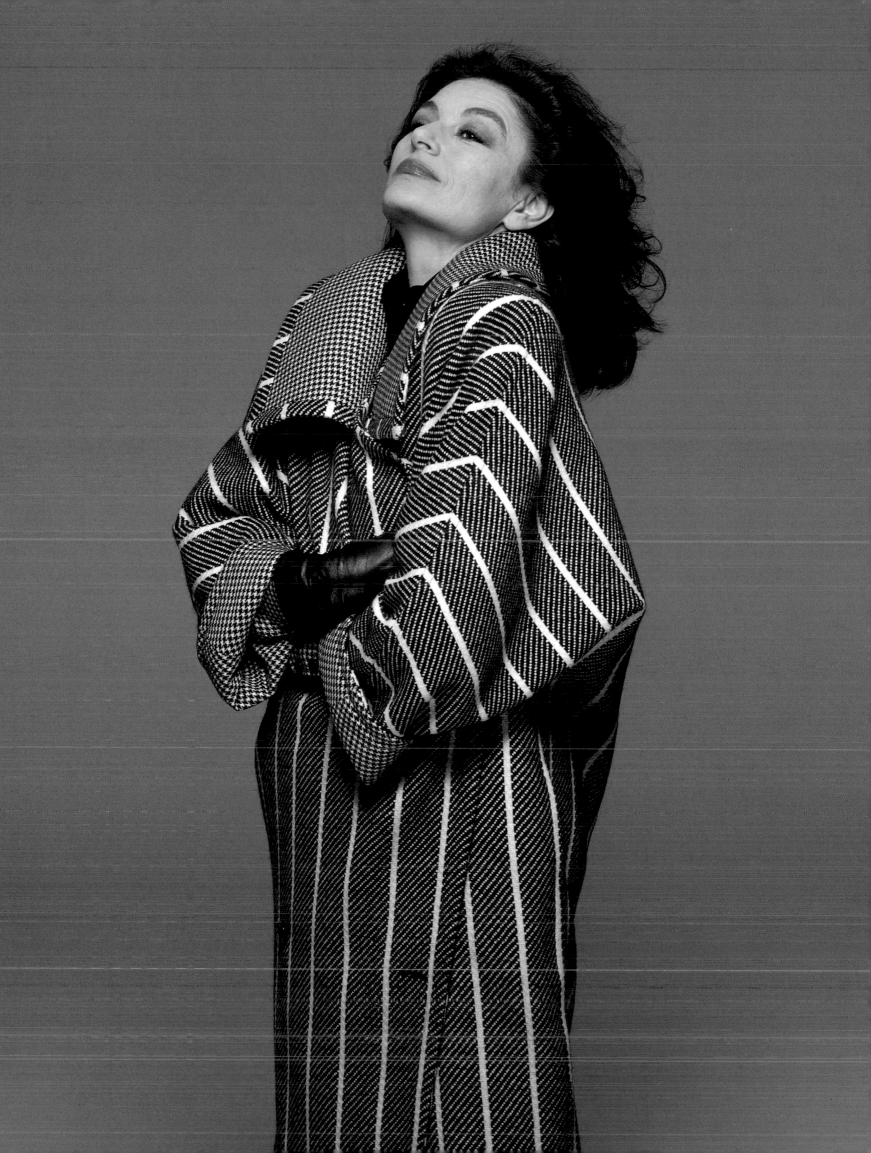

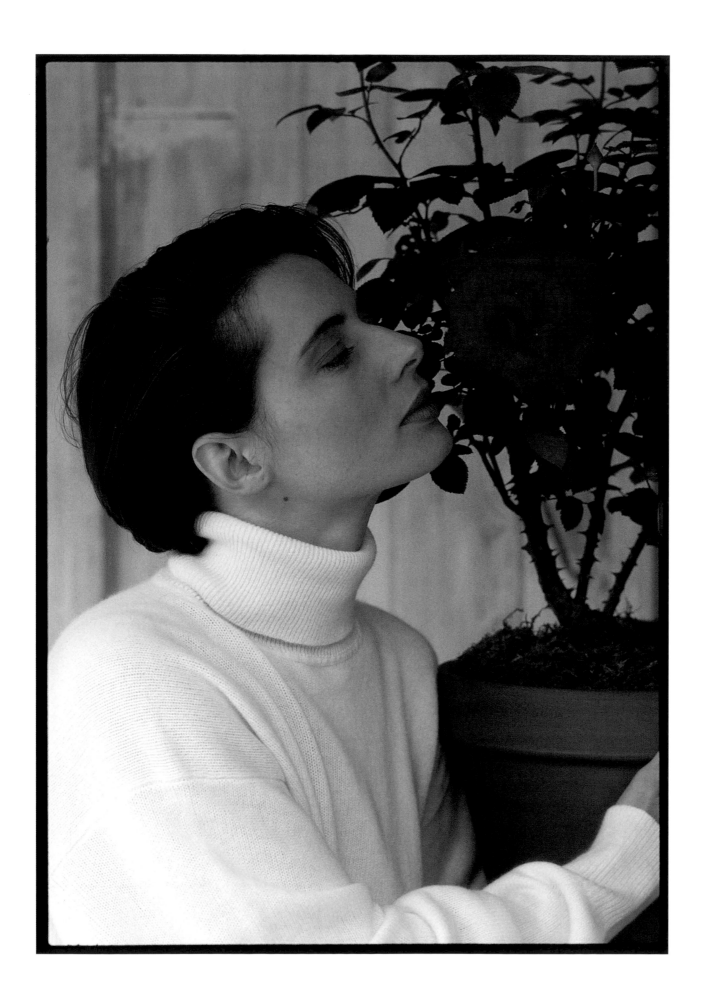

Isabella Rossellini

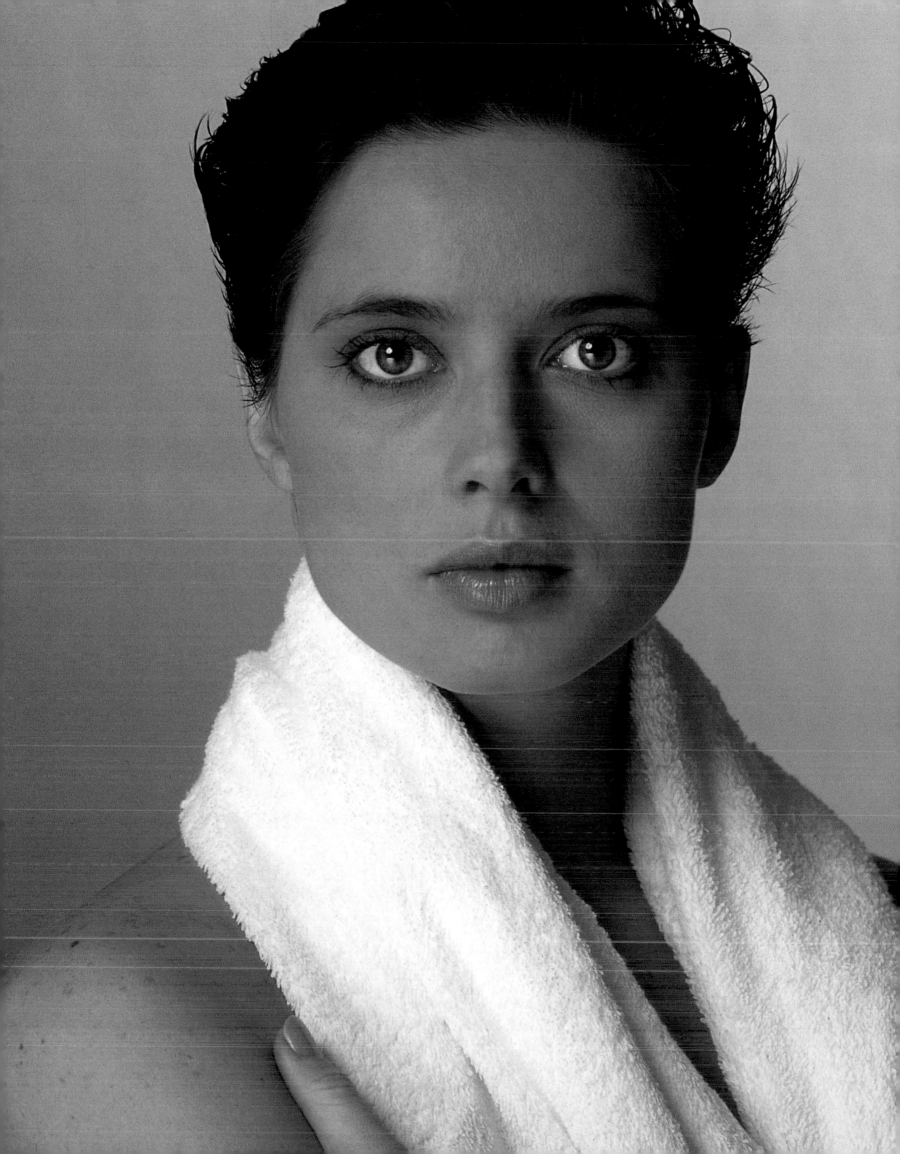

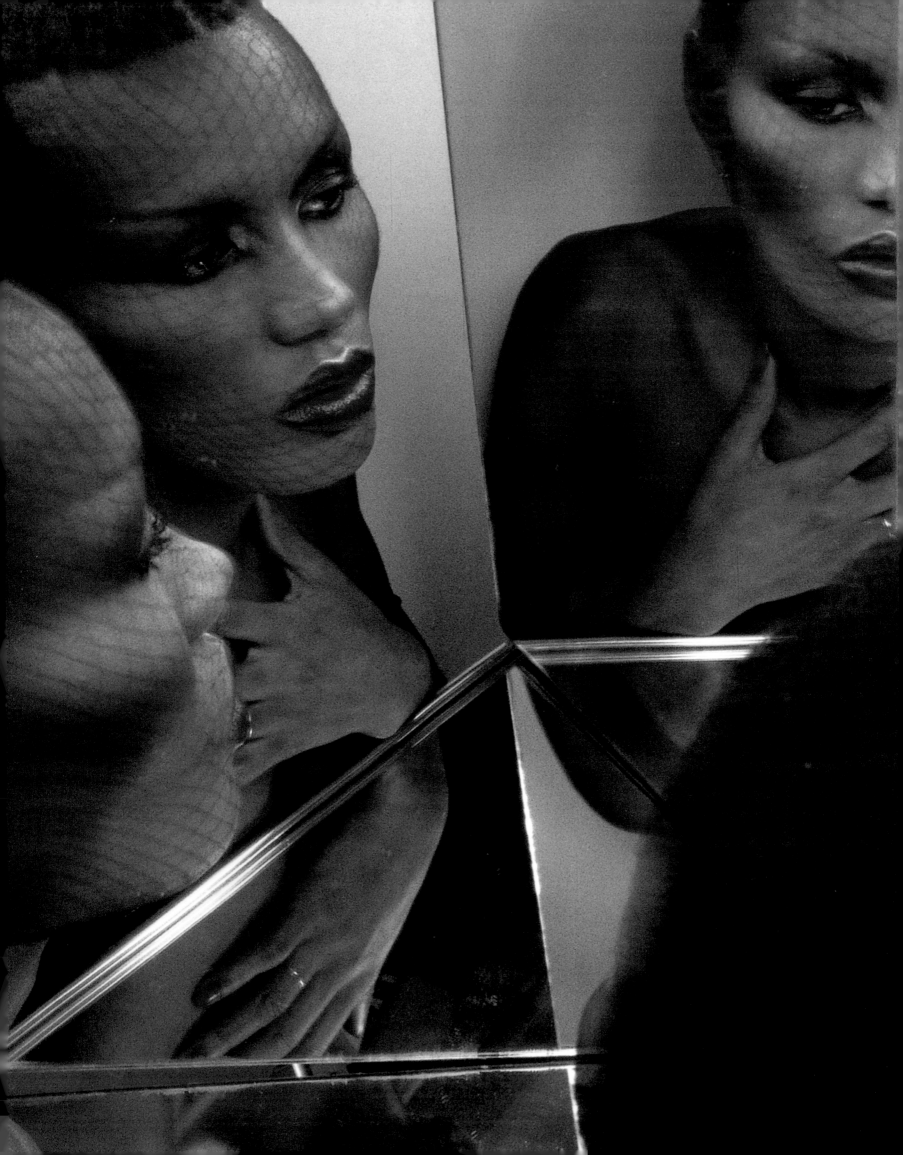

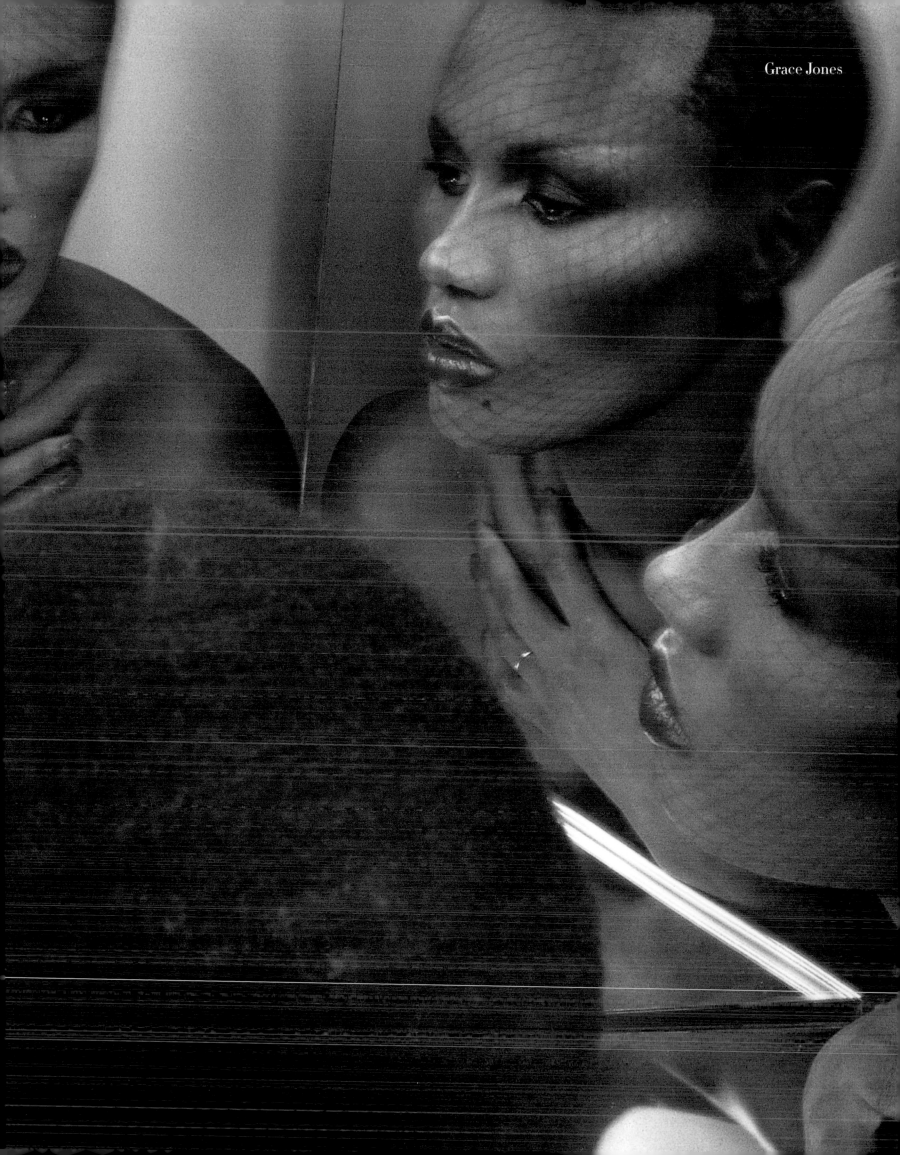

Grace Jones

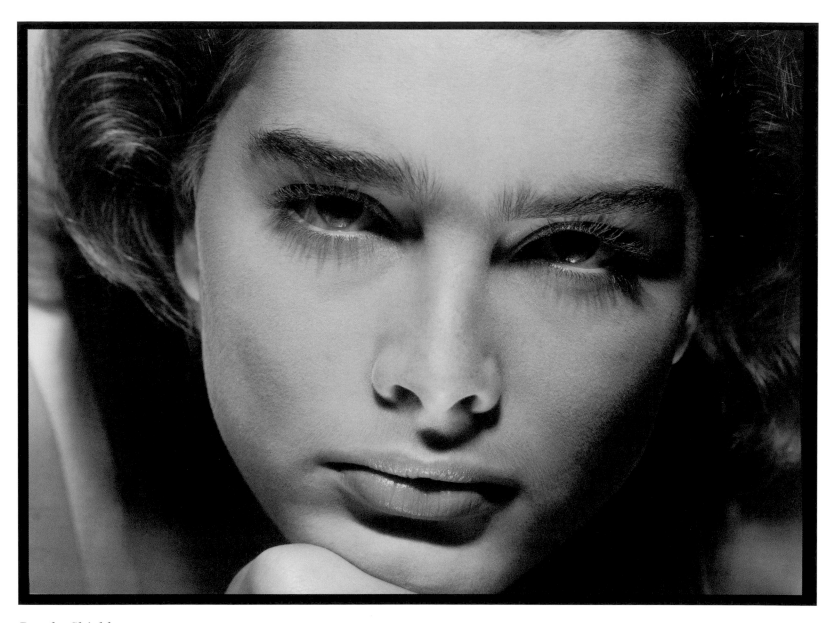

Brooke Shields

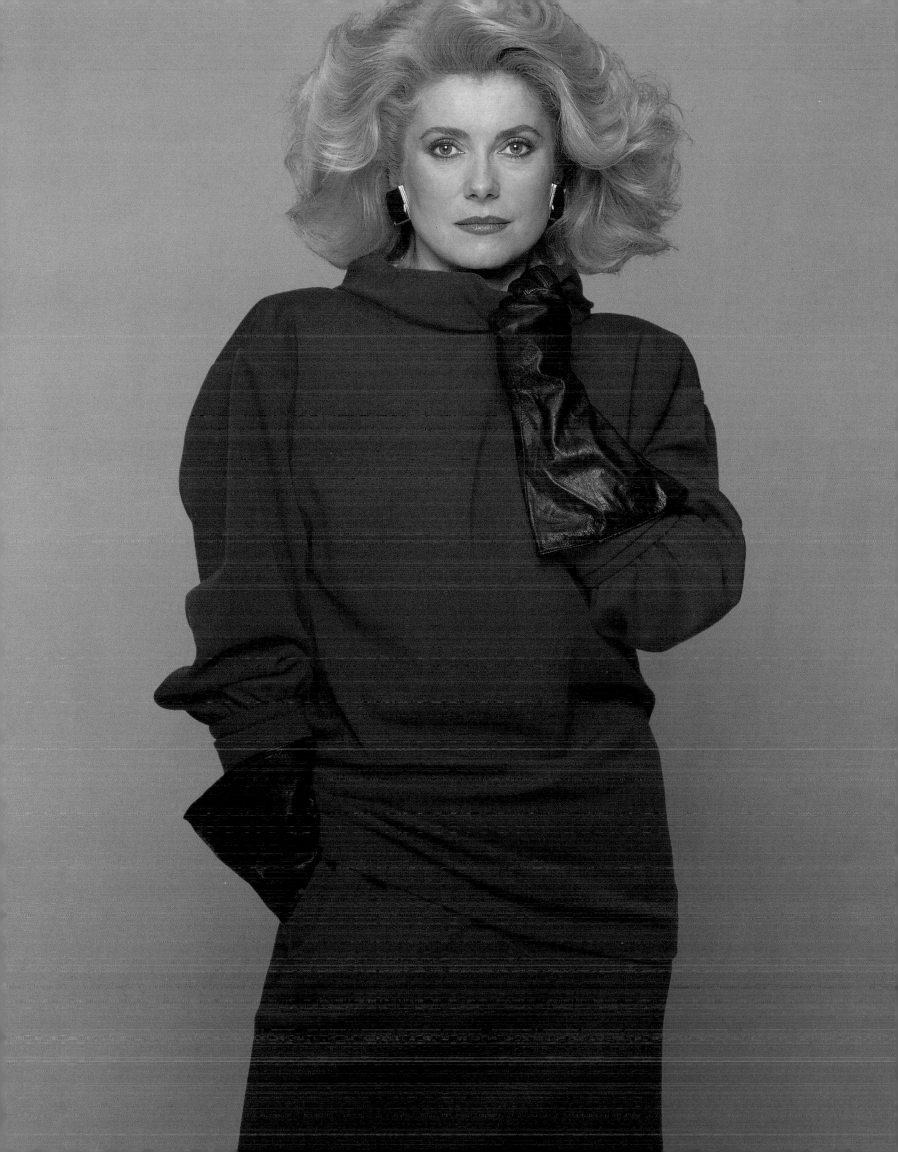

Artistic Dames

The blessing of artistry touches not only painters, sculptors, writers, and architects, but also muses and collectors. Some of these overlap, as with sculptors who paint, painters who write, and artists who collect the work of their peers. Some artists are even the muses of their artist partners....

The painter Jennifer Bartlett and I were friends long before I became her house photographer. She built a house and studio to fit her disciplined work routine. Despite having the orderly rigors of a school, it also surprises with flamboyant touches like a birch grove on a ledge, a pinetum on a deck, and a lap pool on the top floor—Jennifer typically defying both nature and gravity. Her autobiography, written early on, has the modest title *The History of the Universe*, and is a great read.

My most convenient assignment ever was photographing Lenore Tawney, known to have "liberated weaving from the loom." She lives in my building, in a vast and orderly white space, filled with rows of graduated pebbles, mists of threads hanging from canvas squares in the ceiling, and chests with tiny numbered drawers with their secret contents, like bird skeletons and love letters, sometimes both, collaged together. Lenore once bought an early Bible from an antiquarian bookseller and, while her credit card was being processed, quietly started to tear the pages apart along the lines of wood-type indentations. The sales clerk nearly had a heart attack. She is now ninety-eight and blind, but recognizes me "by aura" in the elevator.

Louise Bourgeois plays games with you, whether you're looking at her work or trying to take her picture. We spent an afternoon playing hide-and-seek in her studio, and in most of the frames she hid. Louise flirtatiously applied a fresh coat of girly pink lipstick, only to teasingly turn away from the camera, coy at eighty-two.

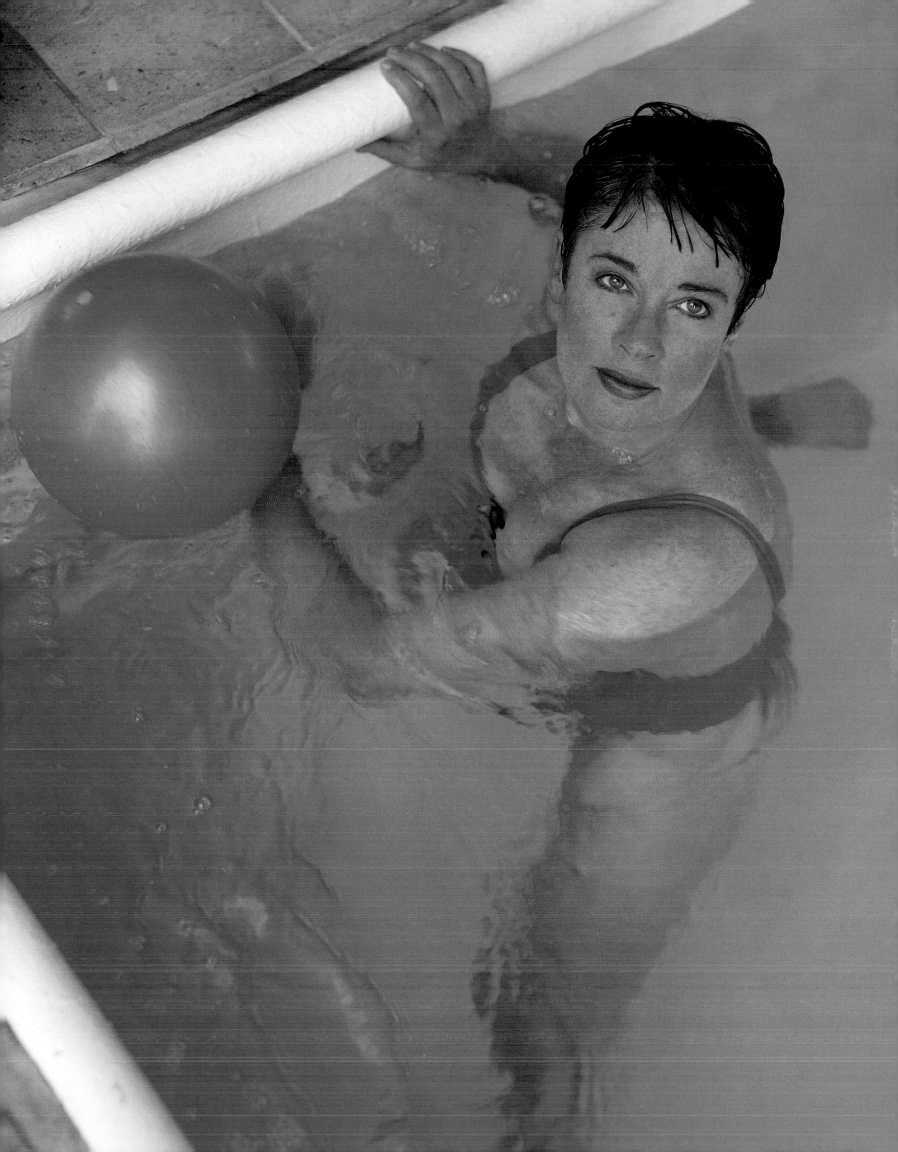

Susan Rothenberg told me never to photograph an artist working, because it would only be a pose. Pat Steir had no such qualms. I spent an afternoon recording her throwing buckets of white paint on blackened canvases in her trademark way. Afterwards, she looked at them and thanked me, saying that the six-pack of beer and my presence had provided good inspiration—my muse moment.

The painter Susan Rothenberg herself, not pretending to be working, but photographed with a recurrent subject, the horse, in New Mexico, where she had just moved with Bruce Nauman. They were recently married, and like the bouncing, high-voltage light over the landscape, little sparks of happiness seemed to be flying when they were together.

"Artist's wife" is a nomenclature that denotes staunch support regardless of discomfort and under-appreciation, all qualities that applied to Annalee Newman, widow of Barnett. "Love made it easy," she explained when *Vogue* did a story on her. She fixed her limpid blue gaze in the distance, and said, softly, "Such a doll, Barney . . ." I've looked at his work in a different light ever since.

Once a model, the highly respected architect Deborah Berke has taken the best of the vernacular aesthetic and made it her own brand of pure but unthreatening minimalism. Unlike the threatening skies over the beach at Seaside—where she built many of the cottages with a 1920s feel, without ever resorting to pastiche.

When Baron Hans Heinrich von Thyssen-Bornemisza, perhaps the last art collector in the grand tradition, moved to Madrid with his new Spanish wife and much of his collection, his daughter, Francesca von Habsburg, took over what remained of the museum he had created at the Villa Favorita on the shore of Lake Lugano. Bob Colacello and I went to cover it for *Vanity Fair*. There was tension between father and daughter, and I took Bob's contributor's picture next to a sign saying "No Picnic."

Anna Wintour recommended me to take a portrait of Jayne Wrightsman, who is notoriously camera shy. Mrs. Wrightsman was very accommodating and we did a number of different pictures one afternoon in her beautiful art-filled apartment, itself a treat to see. At the end, she told me she would need about a dozen two by one and a half inch prints, adding, when she read my expression, that she'd called me because she needed new pictures for her Russian visa, her Amis du Louvre card, and her passport. Coming from someone who famously does everything with the most exquisite taste, I could of course only be flattered.

After building up a vast modern art collection with her husband Charles, Doris Saatchi bought a small house near mine, and an acquaintance became a good friend. Doris would call and say, "I'm just back from London, and have a side of smoked salmon and a bottle of champagne. Is your boat working?"

Françoise Gilot infuriated Pablo Picasso when she published her account of their years together. Fighting for their children's right to carry his name, she was instrumental in the passing of a law in France, that legitimized the children of unmarried couples. She then married a handsome, poetic young artist, who had an old vicarage with an overgrown garden in the country, and later she married the inventor of the polio vaccine. Quite a life—and all along, she's kept on painting.

An art dame is not necessarily an artist—she can be an artist's muse, like Alba Clemente is for her husband, Francesco. But Alba is more than that: here Alba the actress was photographed for *Vanity Fair* when she starred in a black-and-white movie where she lit up the screen, doing nothing more than drinking champagne on a yacht circling Manhattan. Imagine *The Last of Sheila* as directed by Antonioni and set on the Circle Line!

Well before the collapse of the Soviet Union, the writer Tatiana Tolstoya signaled that things were indeed stirring behind the curtain. She also saw clearly what's undesirable in our free society; on one of her visits, the Bolshevik in her was incensed by the way the help was treated at a number of dinners given in her honor. "Like serfs!" she said.

The magazine *Allure* asked Tama Janowitz, the downtown literary diva, to write about the Upper East Side luncheon set, and gave her this radical make-over so she'd fit in inconspicuously—all oddly prescient of this volume. She reverted to herself at once and with a vengeance, going so far downtown, she ended up in Brooklyn.

Jackie Collins is such a Hollywood fixture, she actually shocks you with her Englishness when you meet her—a naughty Brit wit on a Beverly Hills lot crammed full with the spoils of her successes. One such is the living room fireplace: she proudly showed off how its clean-burning gas flames are remote-controlled, something that had me floored at the time. The cat was entirely real, and guaranteed tame by its trainer, as long as we stayed in our places. . . .

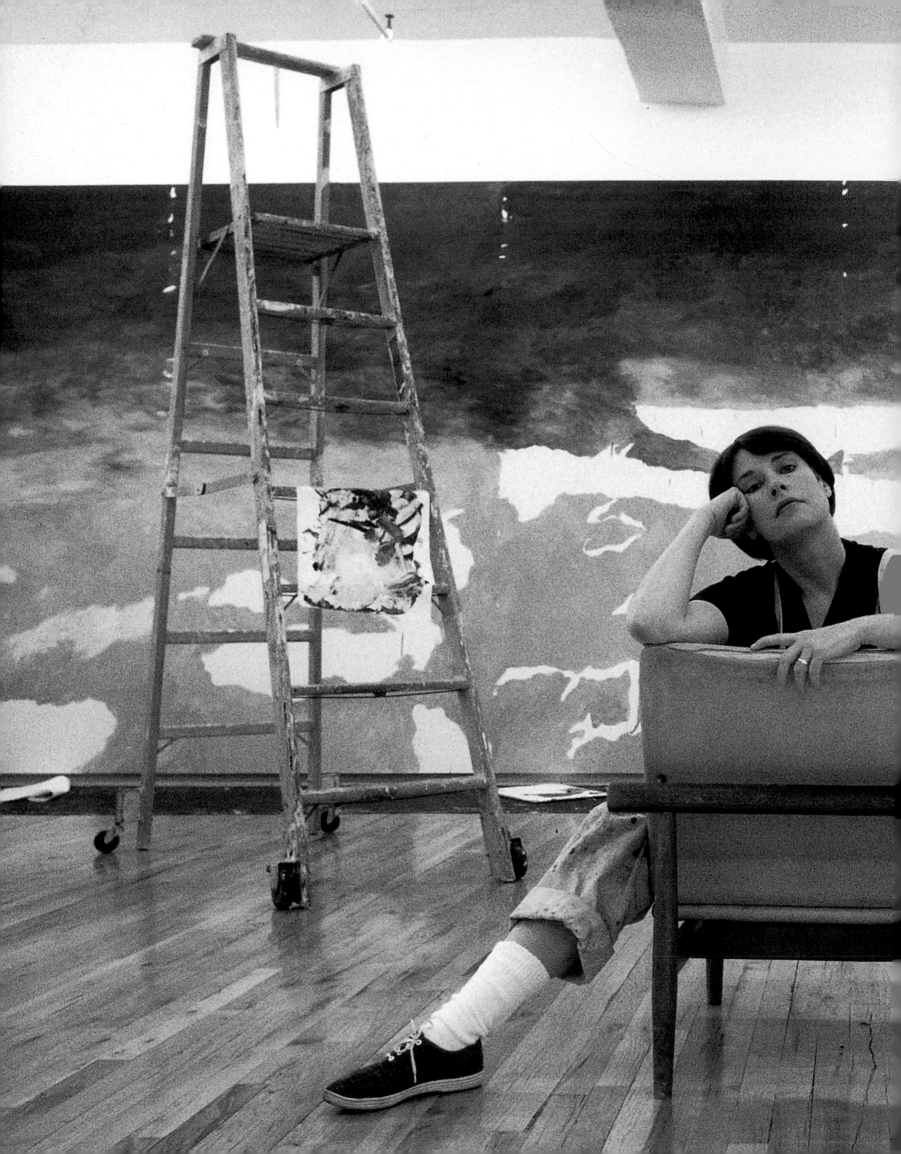

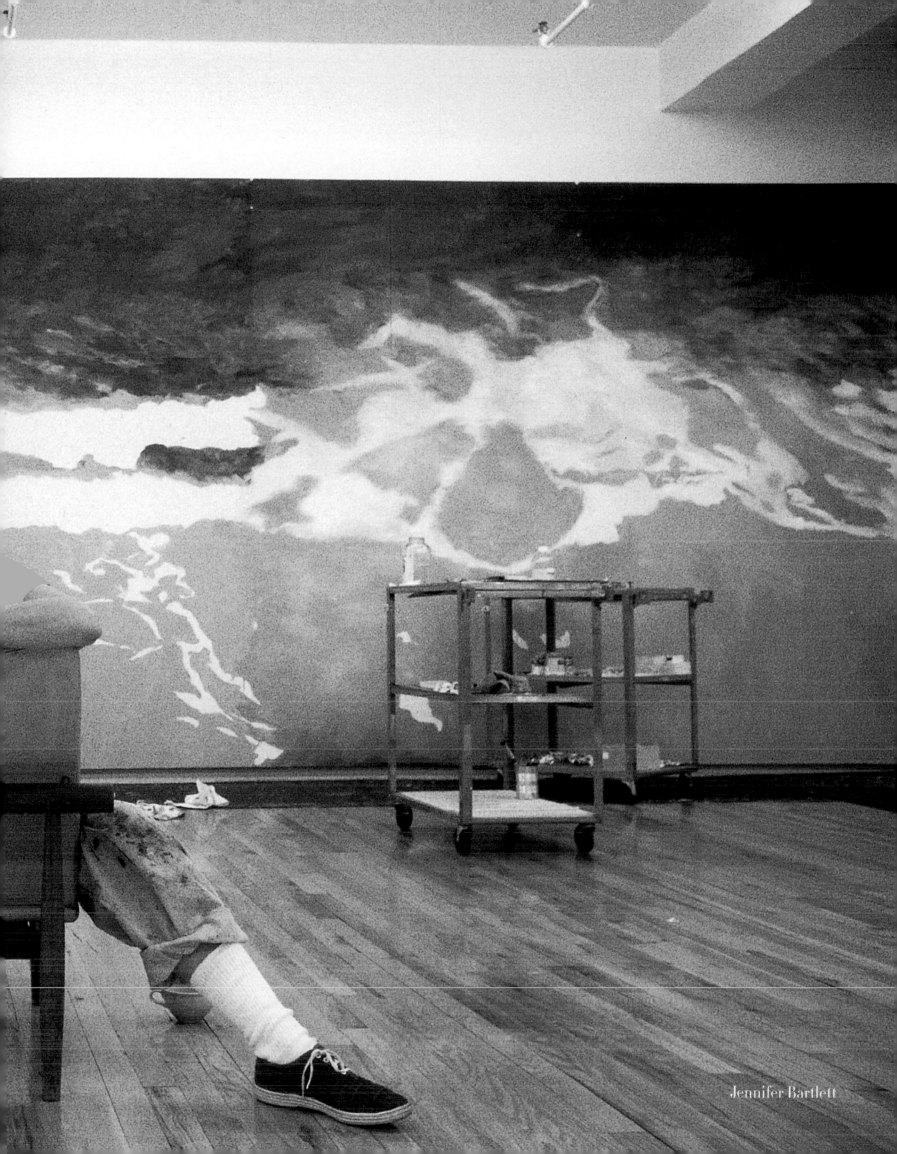

Jennifer Bartlett

Lenore Tawney

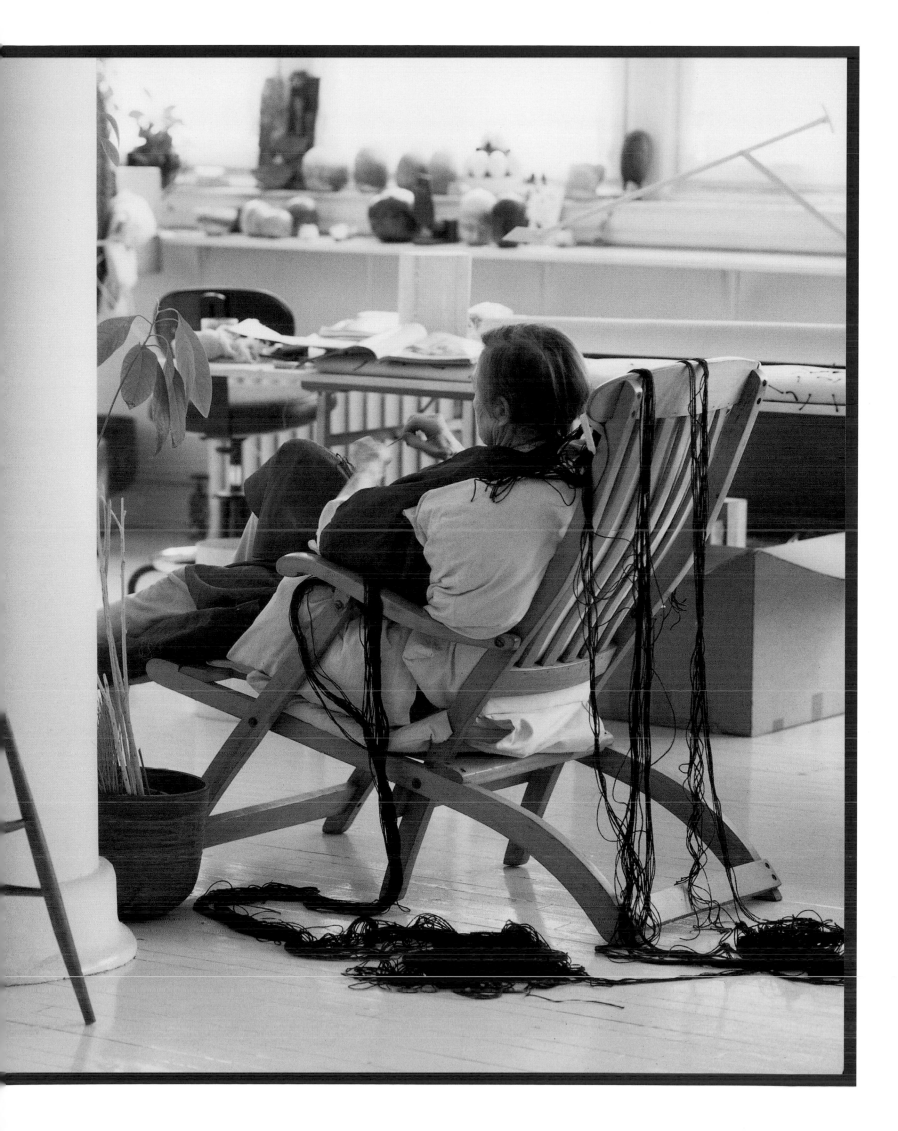

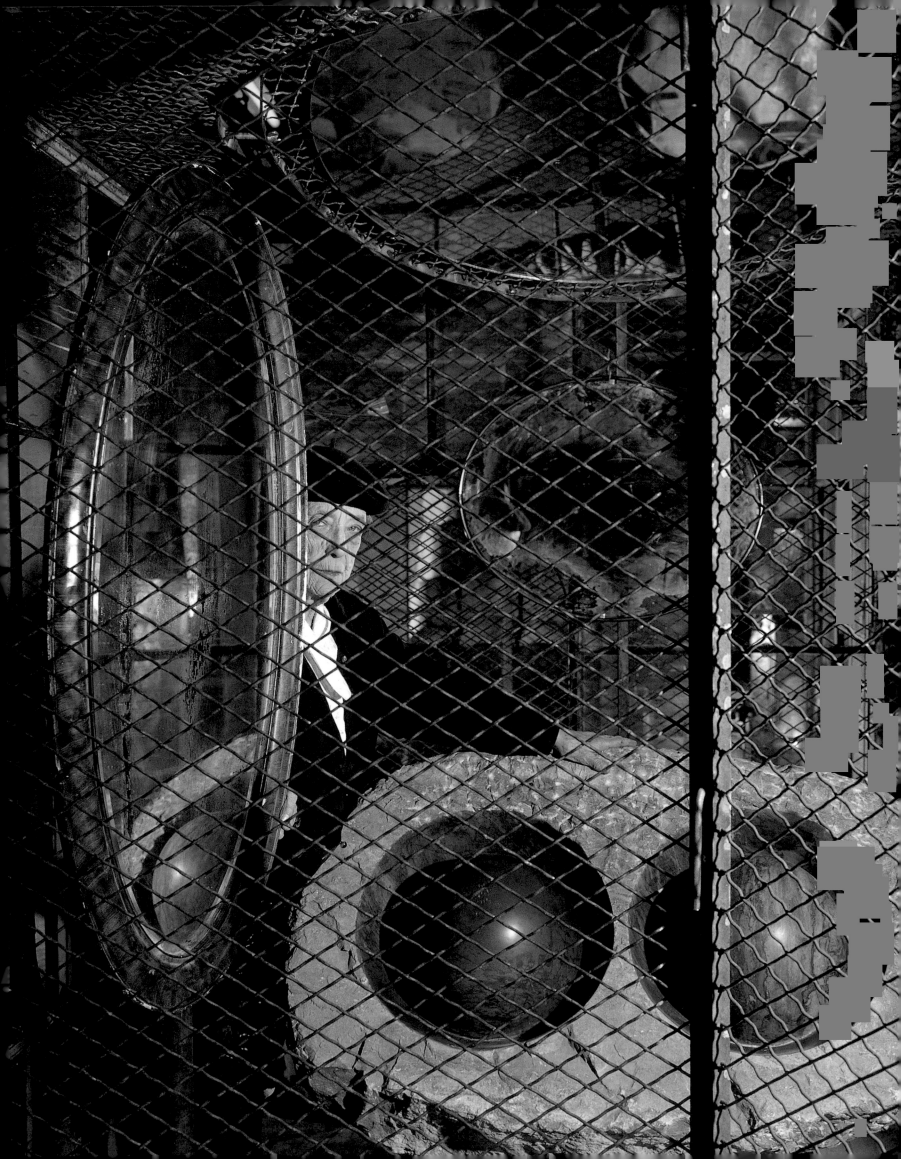

Louise Bourgeois

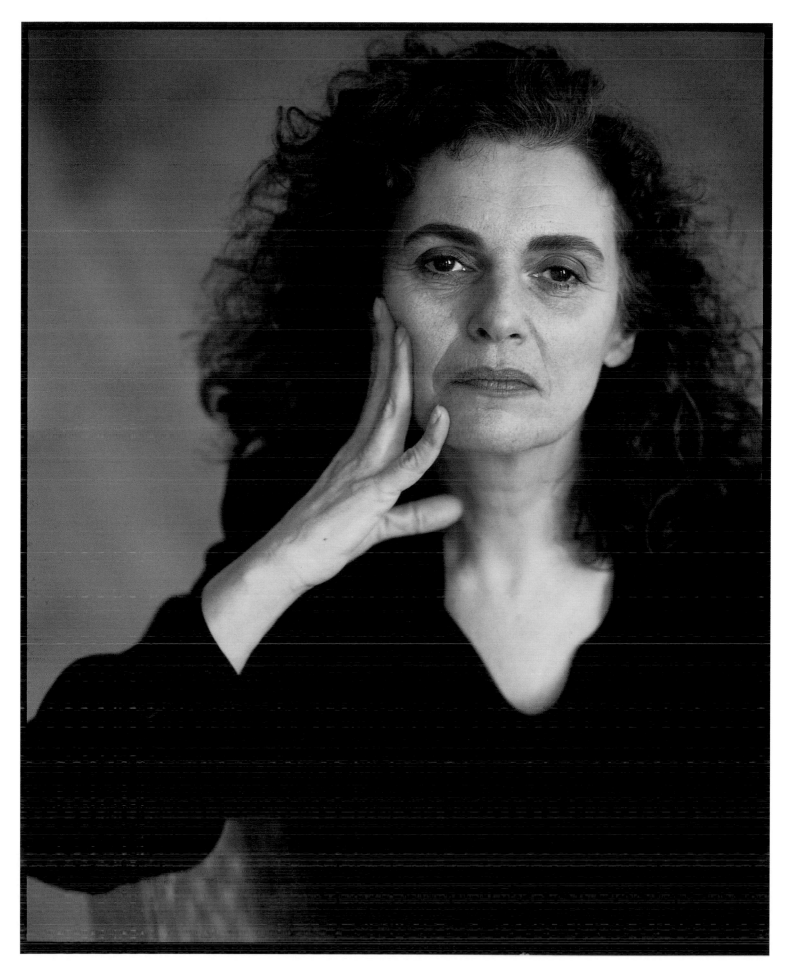

Pat Steir

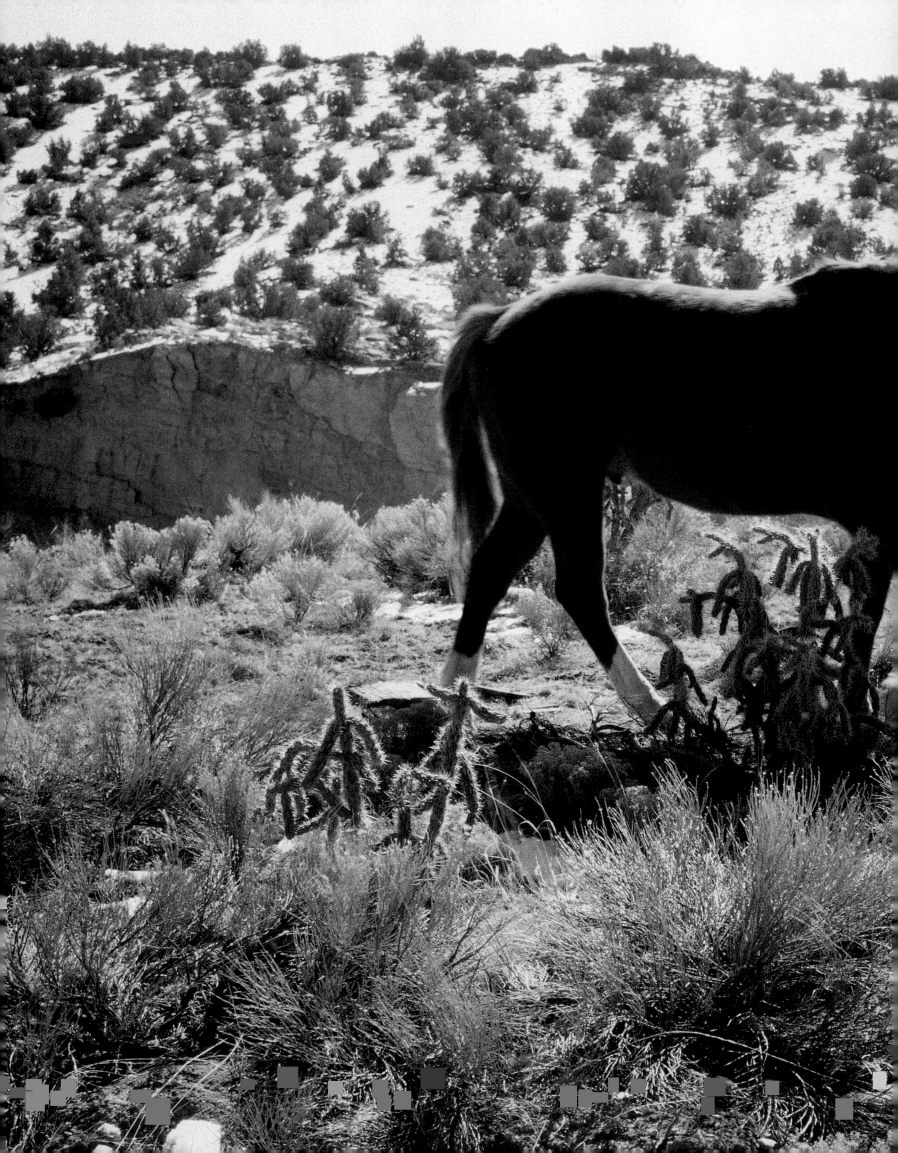

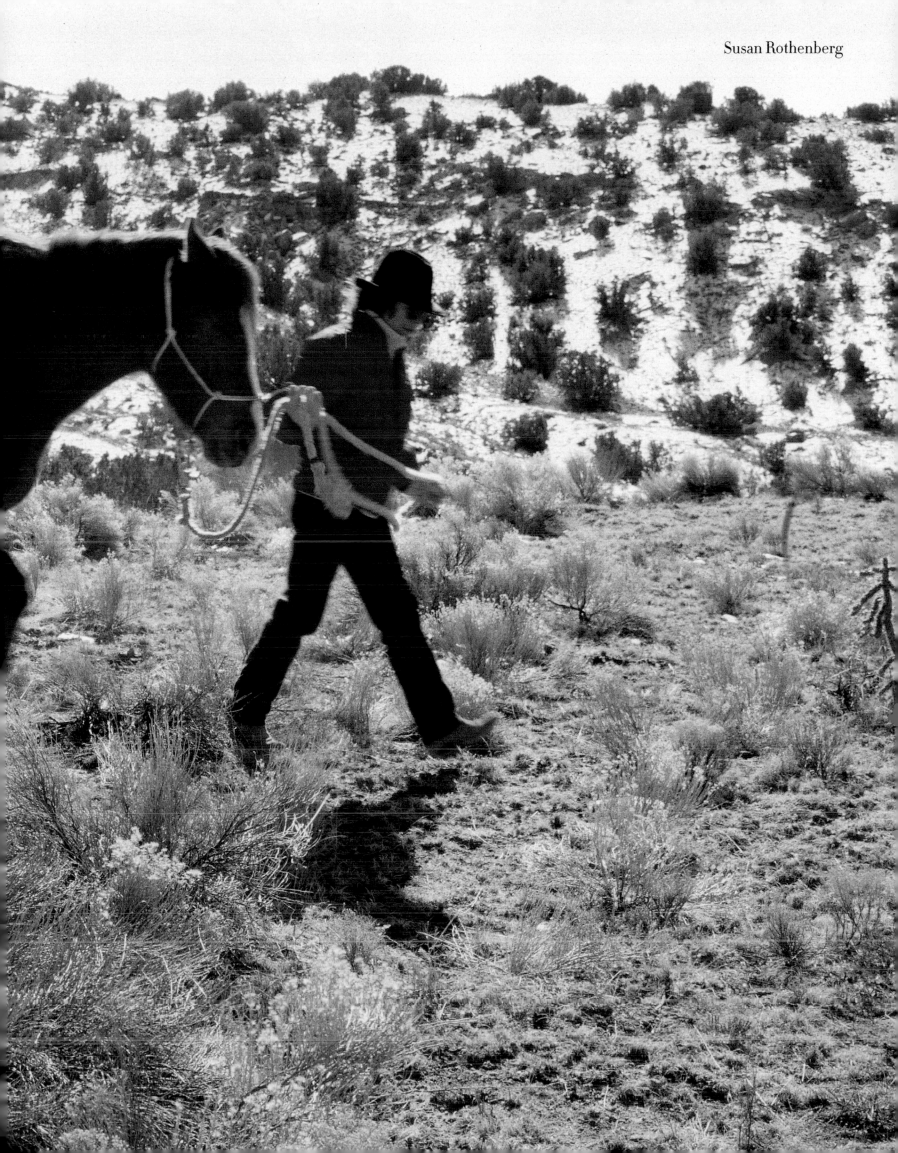

Annalee Newman

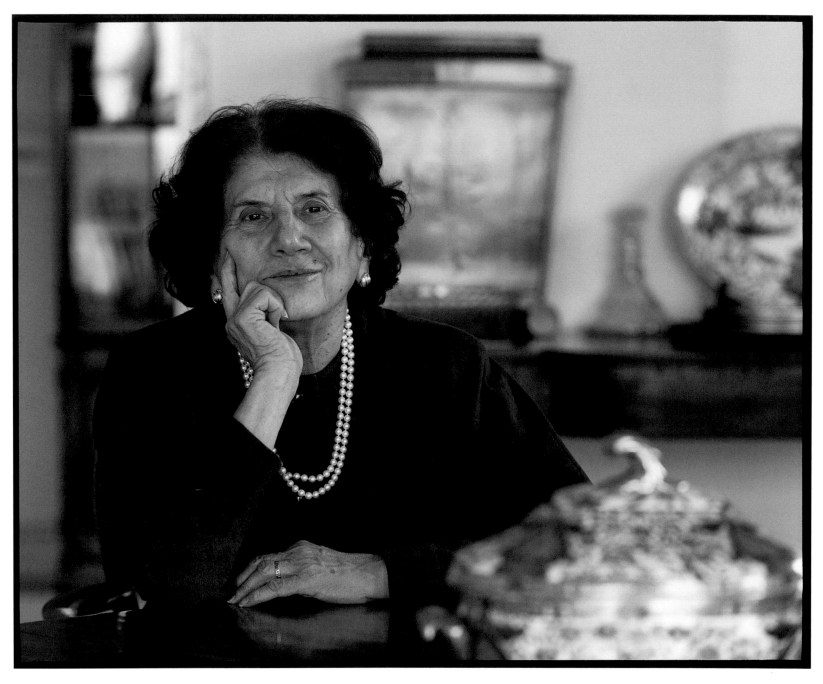

Deborah Berke

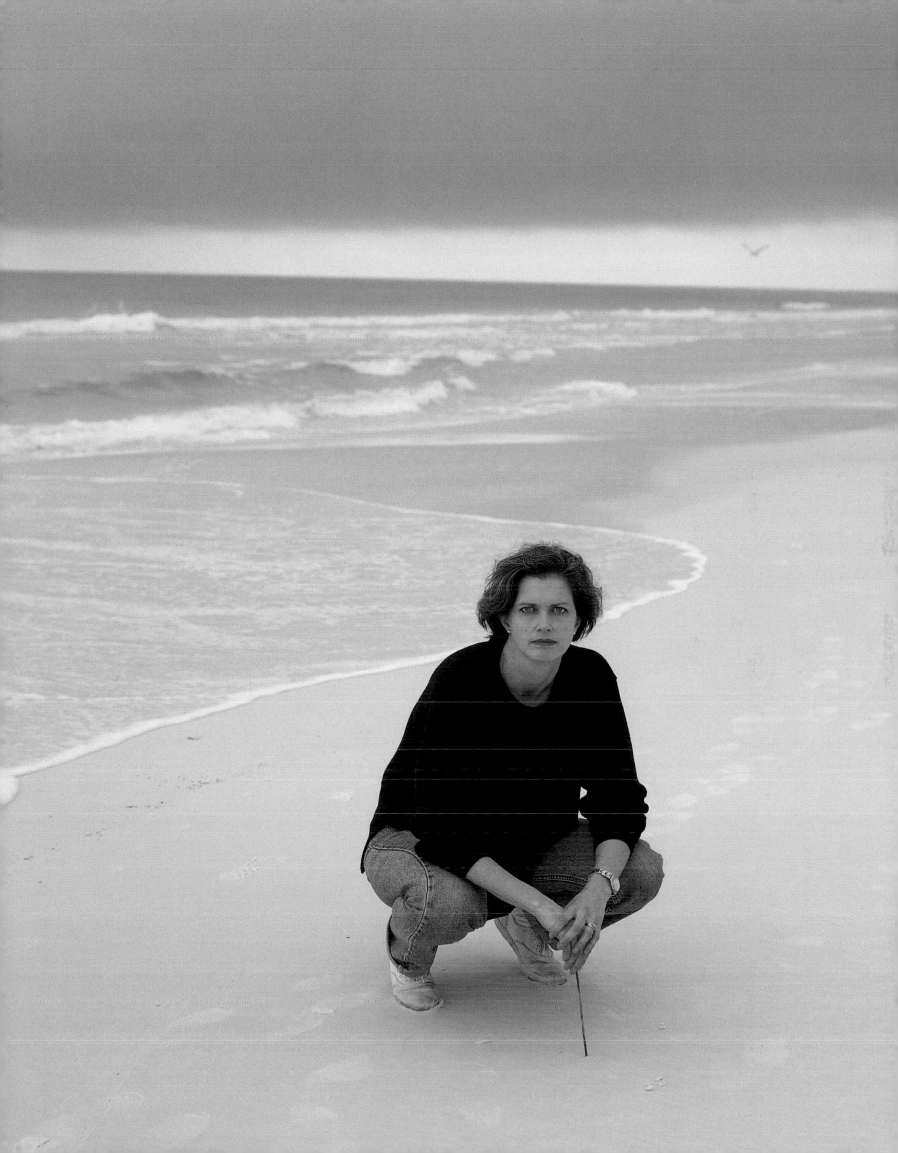

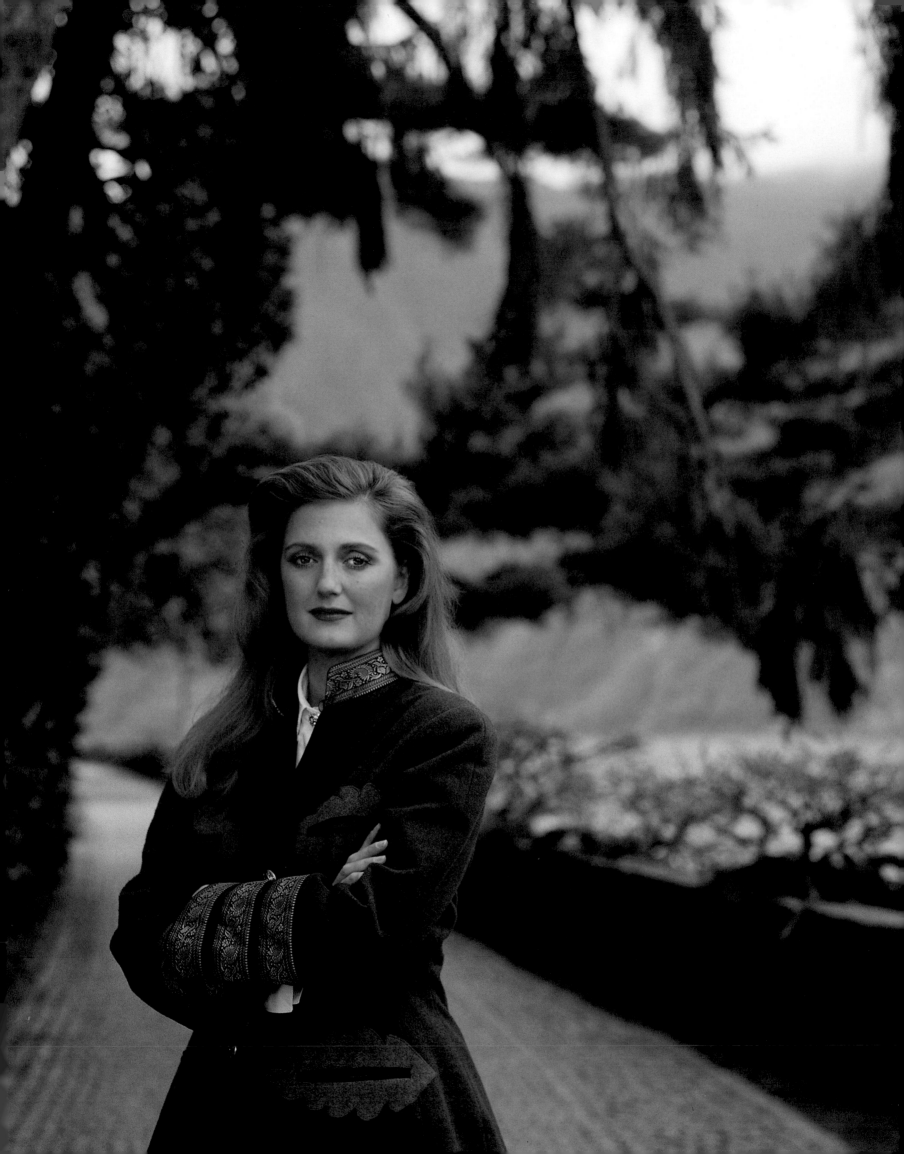

Francesca von Habsburg

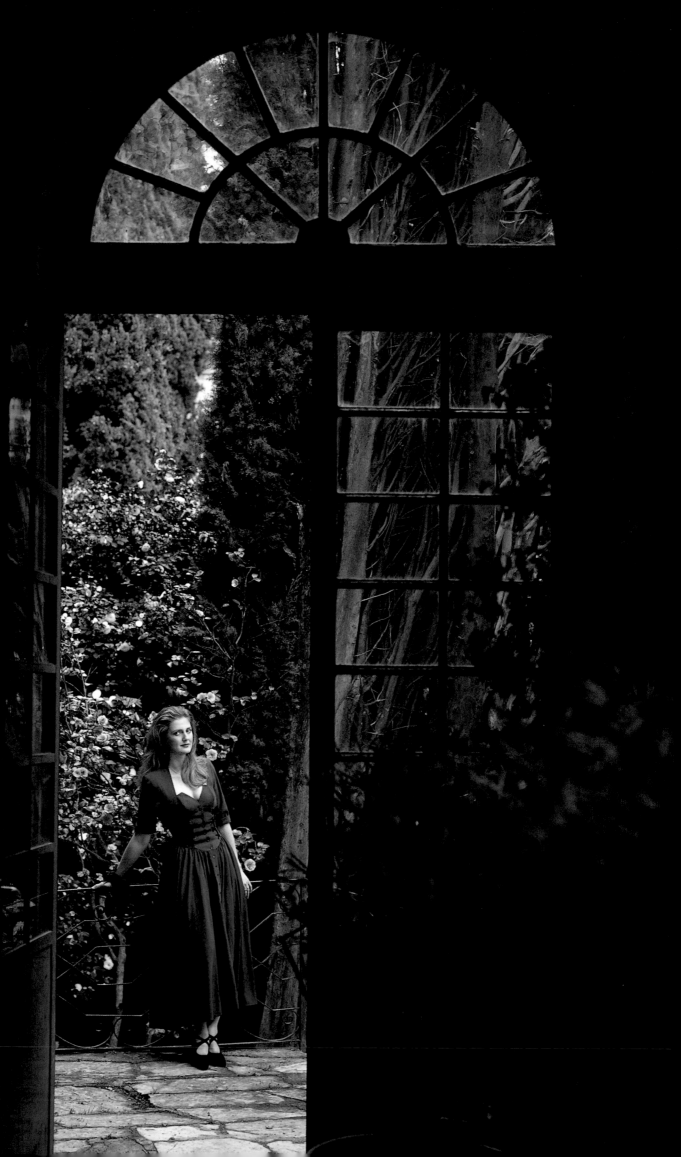

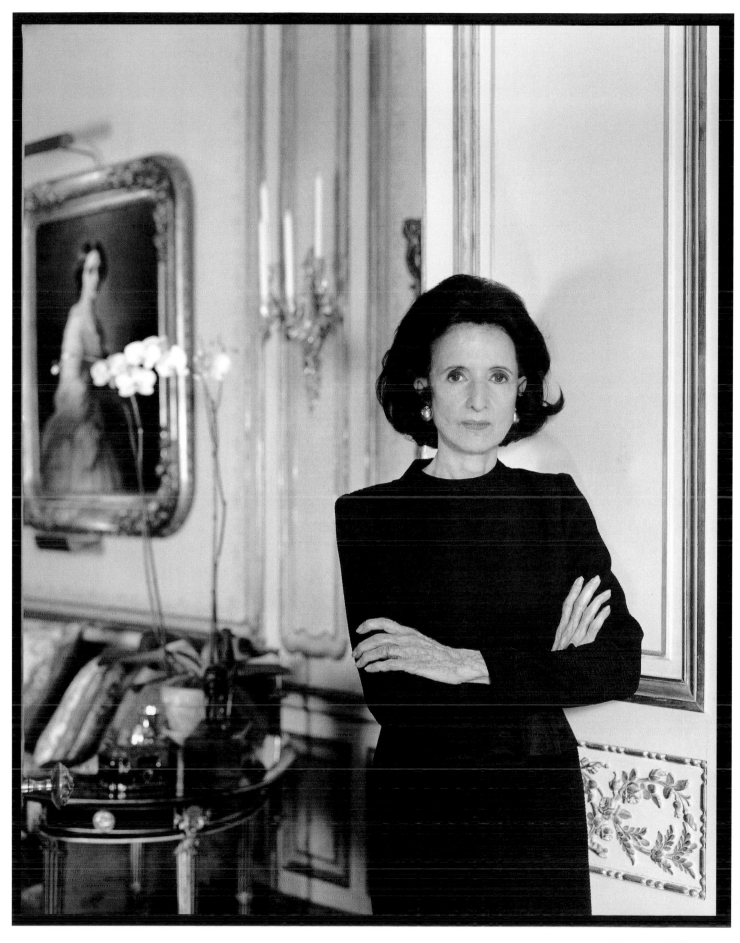

Jayne Wrightsman

Francesca von Habsburg

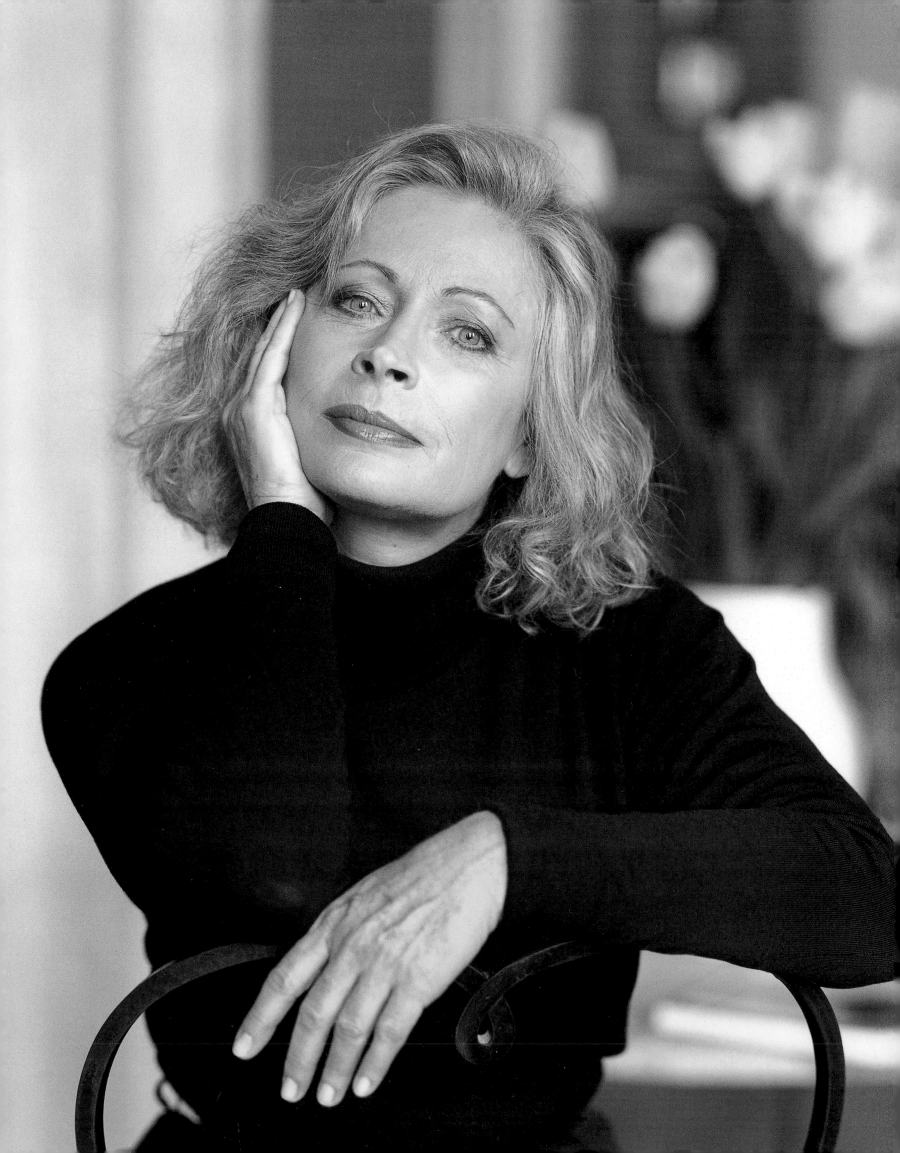

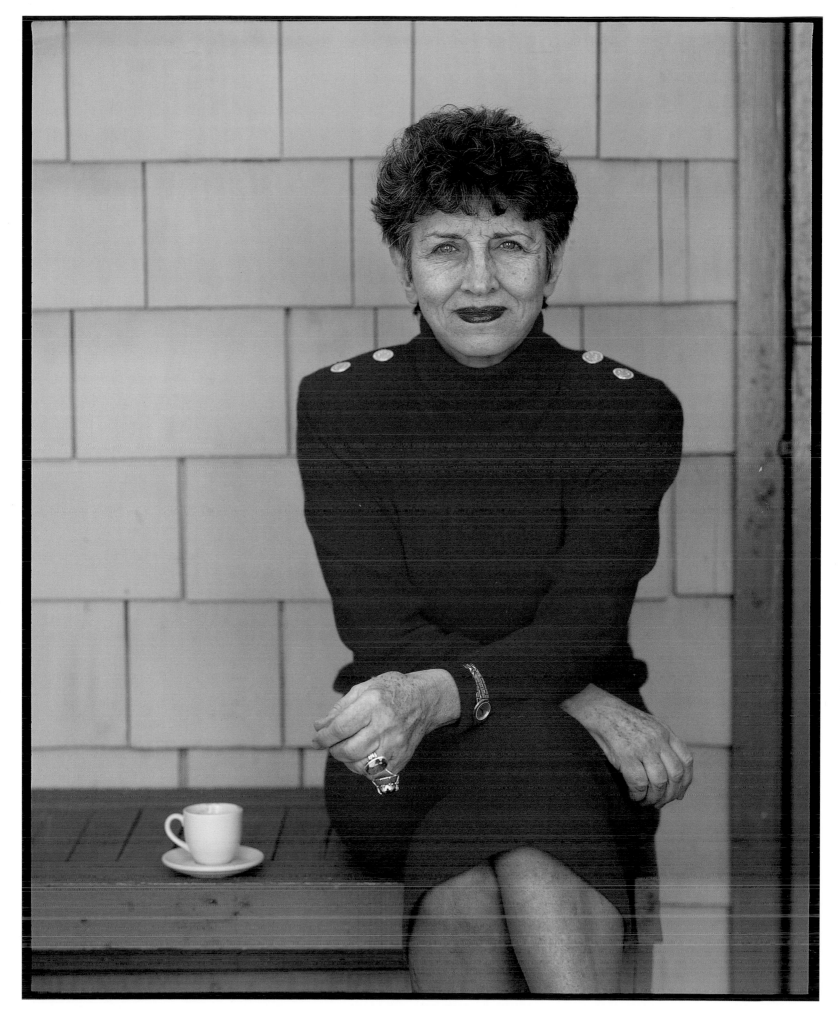

Françoise Gilot

Doris Saatchi

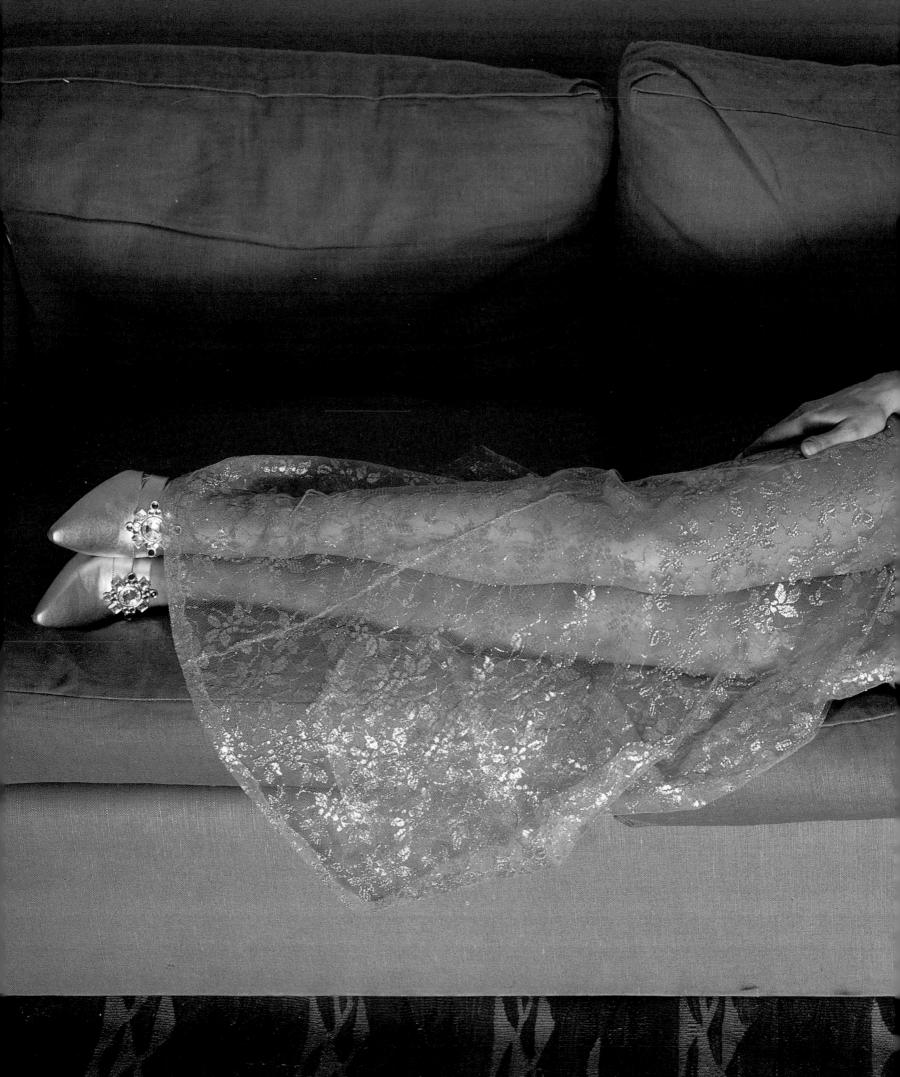

Alba Clemente

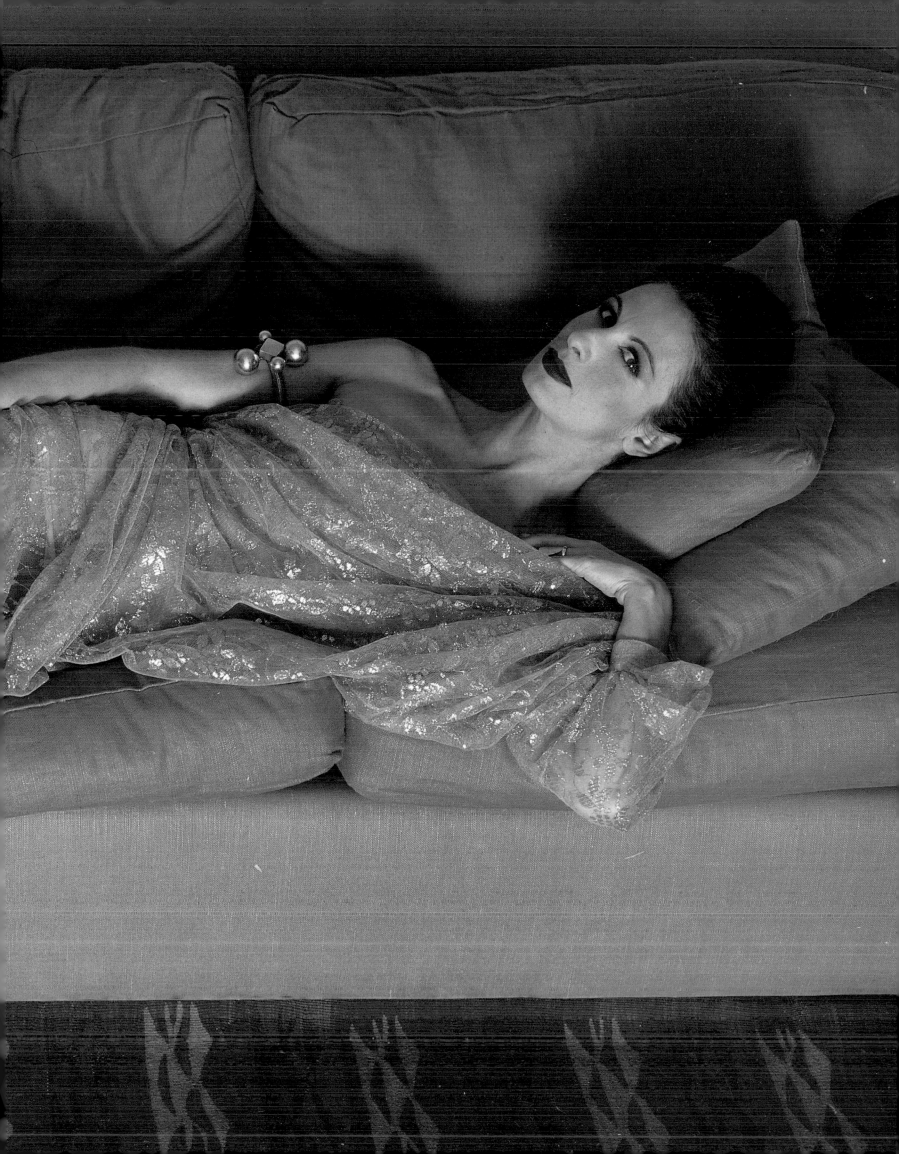

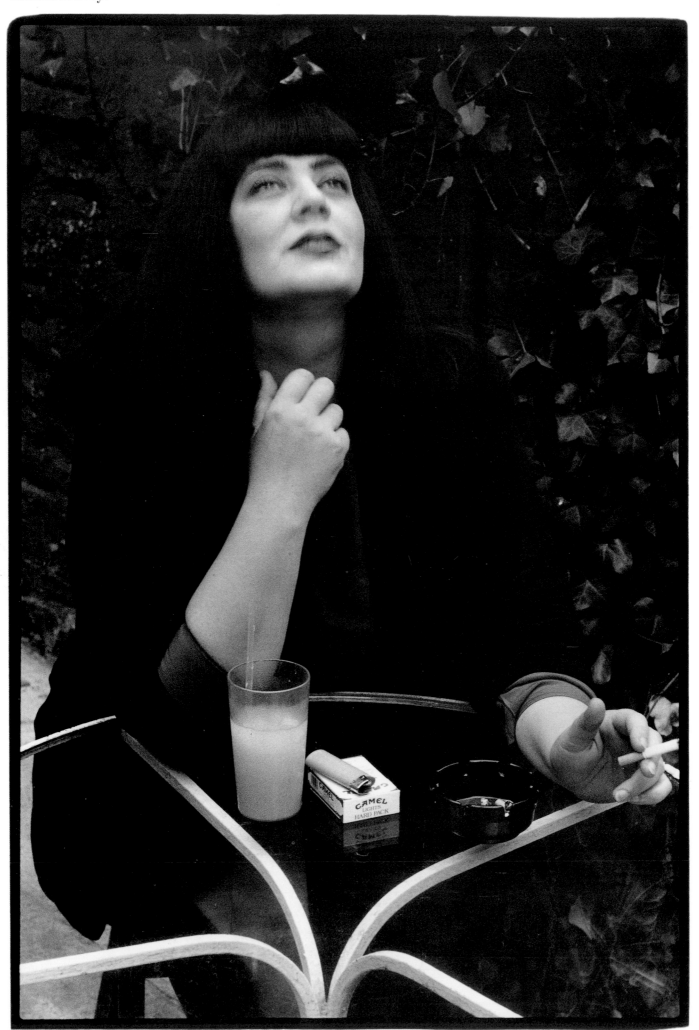

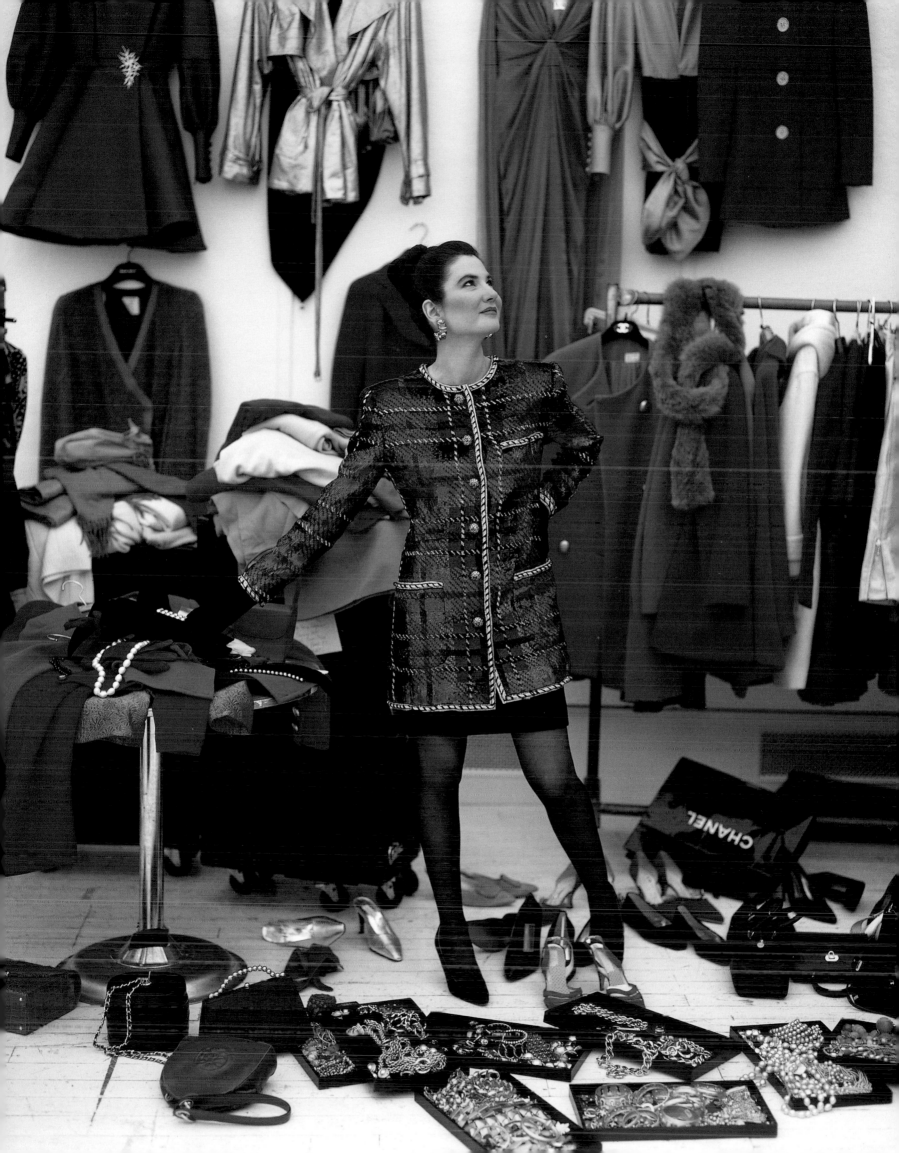

Jackie Collins

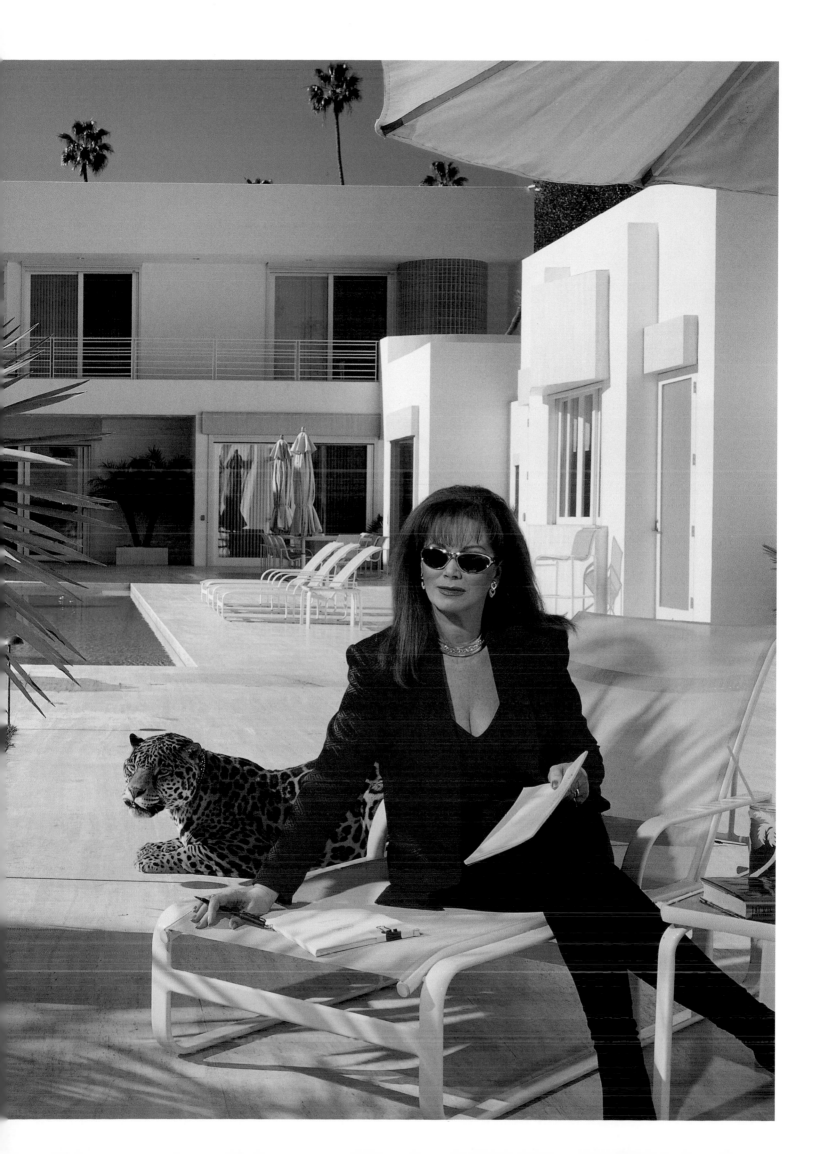

Fashion Dames

No fashionistas these, but creators of fashion, be it the pure notion of it—the personal image as fashion icon—or the notions themselves, such as clothes and accessories for mere women to wear. Or all of these in combination. A woman will present herself in her chosen finery, and somewhere in the back of her head will be the unspoken idea that others might be influenced by how she's put herself together. We know that women dress not for men but for their peers. Women understand women, in a way men have never understood men. Some women take their personal style that extra step: the design and production of effects that can help their sisters accomplish what they themselves already have.

In Hamburg to photograph Jil Sander at a time when she was greatly enlarging her business, I found the Queen of fashion minimalism about to move into two enormous patrician late nineteenth-century houses, which she was respectfully restoring. Renzo Mongiardino was working on the one she would live in, and he was hardly known as a minimal designer. In the midst of this elaborate new setting, Jil appeared even more low-key and soft-spoken. She was still looked after by the woman who had done so since Jil was a little girl—a tender and loyal family relationship.

To mark the publication of Diane von Furstenberg's book *The Bath*, published during a year when women had momentarily stopped wearing her wrap dresses, we put her in a Roman marble tub in the middle of her Connecticut creek, done up as Poppea by her long-time friend, Marina Schiano. In true Poppean style, many backs were strained getting the tub to the creek and back onto the delivery truck.

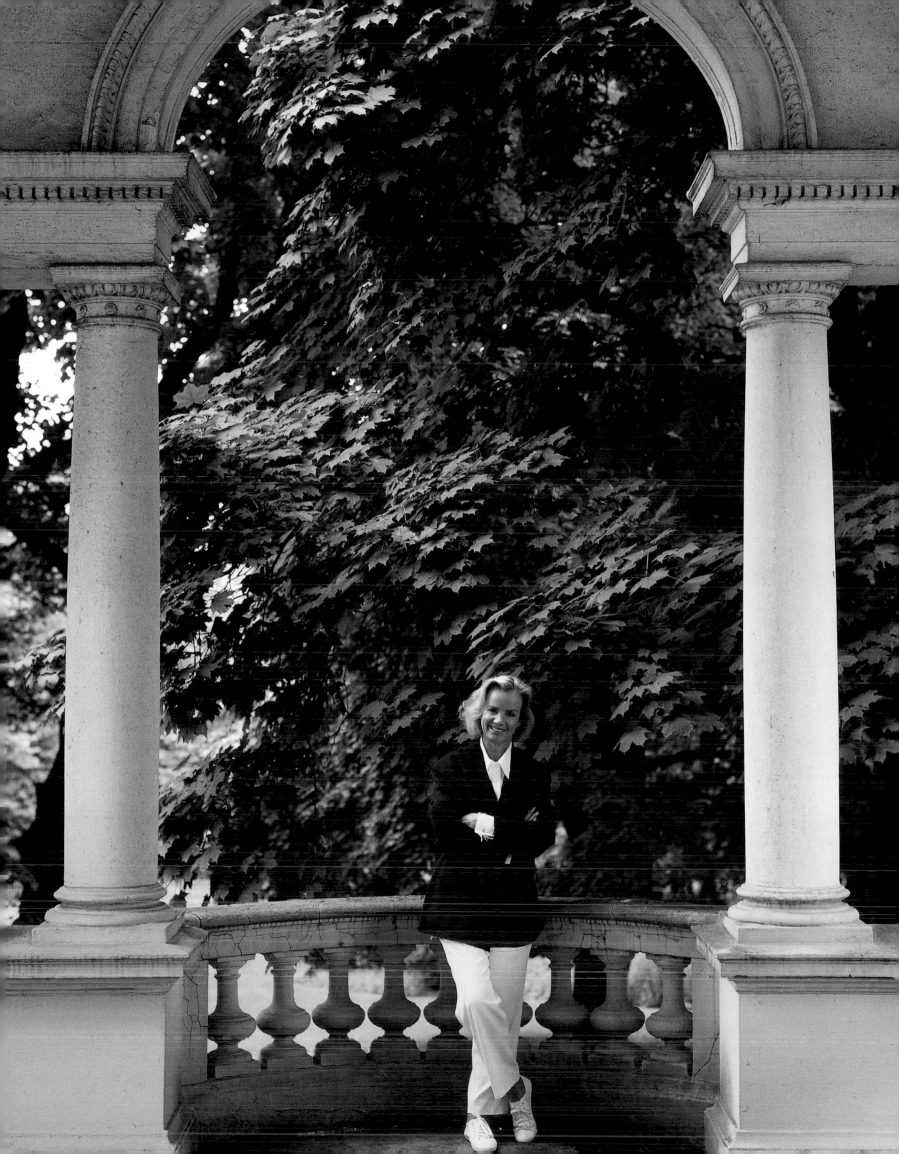

The first of many sittings with Carolina Herrera took place shortly after she started her fashion business. The Herreras were living in a little brownstone that had never been divided into apartments, so it had the staircase winding up through a warren of tiny Victorian rooms, done in a style so compatible that a visit felt like a historical experience. Once I was waiting in the living room, where one of the pictures here was taken, and Carolina asked if I'd like a cup of coffee. Suddenly a door on the landing opened to a tiny kitchen, and a tiny maid came out with a tiny silver tray, all exquisite and in scale. Another time we were on the beach in Southampton, where the *Vogue* editor ran and hid in a sand dune when the clipping blades of a police helicopter were heard. Carolina just said, "Let's finish the picture! This sort of thing happens all the time in South America."

One "de la" attracts another: Inès de la Fressange and Loulou de la Falaise are best pals, and have much in common as ultra-stylish women with a real design sense. Inès had been a model (best legs in Paris) and Karl Lagerfeld's muse when he started at Chanel. These pictures were taken for *Vogue* when she was about to open her own boutique, and had just done her apartment in the Swedish eighteenth-century taste.

When I was just out of art school, I met Claude Brouet one night at a dinner party in Paris. As fashion editor of the then weekly *Elle*, when fashion news came as fast, she was one of the most highly respected people in the business, never running one garment she didn't believe in. Claude had been steeped in that world: she attended fashion shows at Chanel from the age of five, and had her dresses made by the seamstresses at Schiaparelli by the time she started school. Claude's mother was *directrice* of both houses in succession, before going to Jacques Fath—an incredible pedigree! We became great friends: Claude has shown me all that is wonderful about French culture, honing my tastes in food and music. It is appropriate that she should be photographed on the veranda of her grandmother's ancien régime house at tea-time, eating a *tartine* with jam made from berries growing just outside.

Some of our close friends leave us in this life to toil for a while longer, yet not all linger as close in spirit as Tina Chow has done for me. When you speak of her now, you realize how many people she touched, and in unlikely ways. These pictures were taken for Claude Brouet when she was editor of *Marie-Claire Beautés*. Tina's and Claude's sensibilities were so in tune, I wish they'd gotten to know each other better.

Laura Montalban, daughter of Ricardo, worked for years with Bill Blass, America's gentleman sportswear designer. They shared a taste for tailoring—whether in clothes, antiques, or simple everyday choices. Here she is at home, for a story on Bill that ran in *Mirabella*.

Gorgeous, talented, witty, intimidating, or in two words, Marina Schiano! Many of the portraits in this book owe a great deal to her styling, in which she has managed to combine all these qualities. Marina has taken the work of many prominent photographers to new heights, and for this some of them even give her credit. I owe her the constant laughter that is the joy of her presence. My dog Alice owes her every one of her enormous collection of screeching toys. Marina now lives happily in Brazil, with cows and horses and dogs and parrots, and I miss the hilarity of our daily telephone chats.

Manolo Blahnik told me to call Paloma Picasso when I was working in Paris for some months in 1970. Paloma and I have been close friends ever since, and were together when she first met Yves Saint-Laurent at a party, dressed like a forties movie star. Yves based a whole collection on the look, his only flop, which Paloma couldn't help but find hilarious. She lived in her grandmother's wonderful old-fashioned house at Neuilly, with bamboo and camellias in the garden, and a goose in the garage. I was put up in the attic, where a great blue painting by her father acted as a headboard for the bed. There's now an office tower in place of all this, which doesn't seem like progress to me.

We were a group of friends in Paris in the early 1970s, and all of us admired the glamour of Loulou de la Falaise. She threw things on in a totally personal way, a little 1930s movie star, a little sailor boy. She wore hats when nobody else did, twenty bracelets when others wore three, rolled her pants up to mid-calf and wore them with heels, and was generally unruly. The funny thing is, we were aware of something more significant than just a person pulling herself together. Loulou was justly rewarded with a job with Yves Saint-Laurent, whose muse and play-pal she famously became. She was the third of four generations of Birley beauties. So competitive were they that Rhoda, Loulou's grandmother, took to bed when Loulou came down to dinner in an emerald-green taffeta cocktail dress, feeling upstaged by her twenty-something granddaughter.

Because of her great beauty, Maxime de la Falaise, Loulou's mother, was hired as a young woman by Hubert de Givenchy. He was aristocratically handsome, and the two of them tall enough to look down on six-footers. They'd appear in the doorway at parties together, and the din in the room would promptly fade. Maxime has kept it up with generous slicks of carmine YSL lipstick, and major earrings. A food authority, she researched and wrote a book on three hundred years of English cooking, which had everyone in fits of laughter. That aside, the book has proven a thoroughly respectable work, both to read and to cook from. Maxime and Loulou are here at lunch at the beach-house of Teddy Millington-Drake and John Stefanidis on Patmos, where Maxime had me open twenty cans of sardines, which she tossed with lots of herbs on a hot skillet. "Better than fresh," she said.

Pauline Trigère came from France before the Second World War, and never looked back. She had all the qualities of a great Frenchwoman but thought of herself as an American sportswear designer, and so, very soon, did everyone else. Pauline lived in the same small Park Avenue apartment for most of her life, having raised her sons in what became the red study we see here. The day I met her, I wore a bold hounds-tooth coat from the sixties, because I knew she'd like it. To one-up me, she produced her own logo-printed coat with matching bag, an irresistible photograph right there! It was one o'clock in the afternoon, and she offered me a glass of scotch. When I declined, she shrugged her shoulders and said, "Just because you are a stiff, you don't have to deprive your assistant!" From then on, we spoke about once a week on the telephone. She was ninety-one when these pictures were taken, and credited her frog collection with her good luck.

Although highly controlling, Donna Karan is surprisingly easy to work with. I wanted to express her exceptional liveliness in a portrait for French *Vogue*, and ended up with a series of images that make her look like a temperamental diva, perhaps taking the idea a bit far—yet not necessarily too far from the truth.

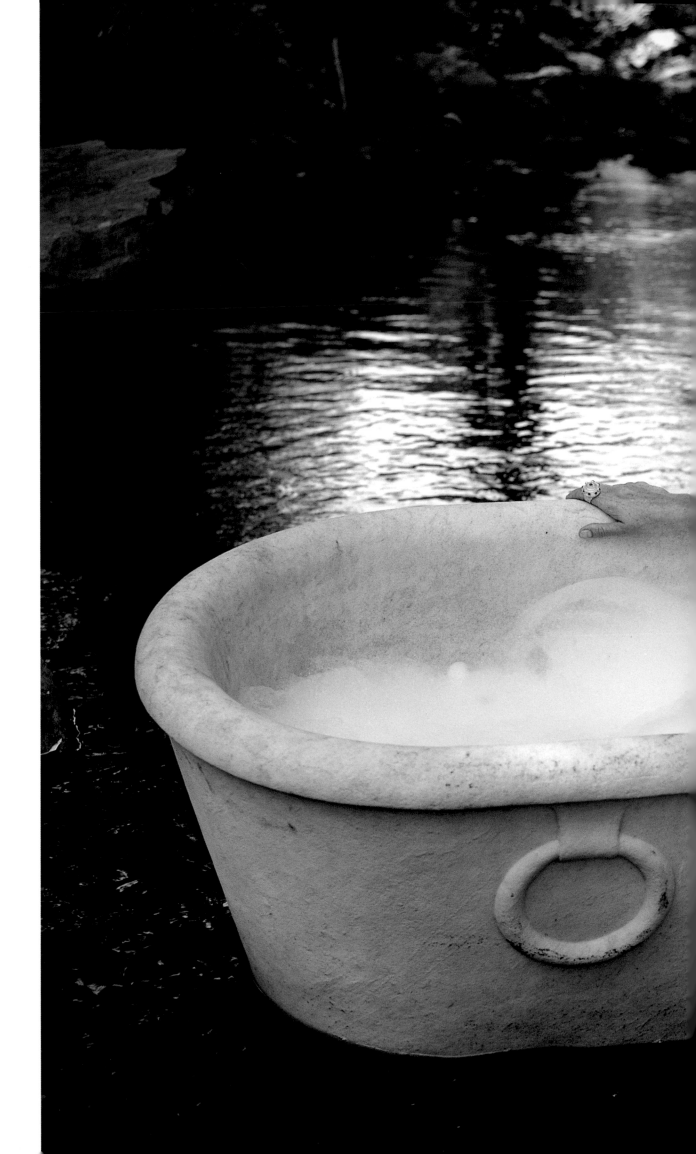

Diane von Furstenberg

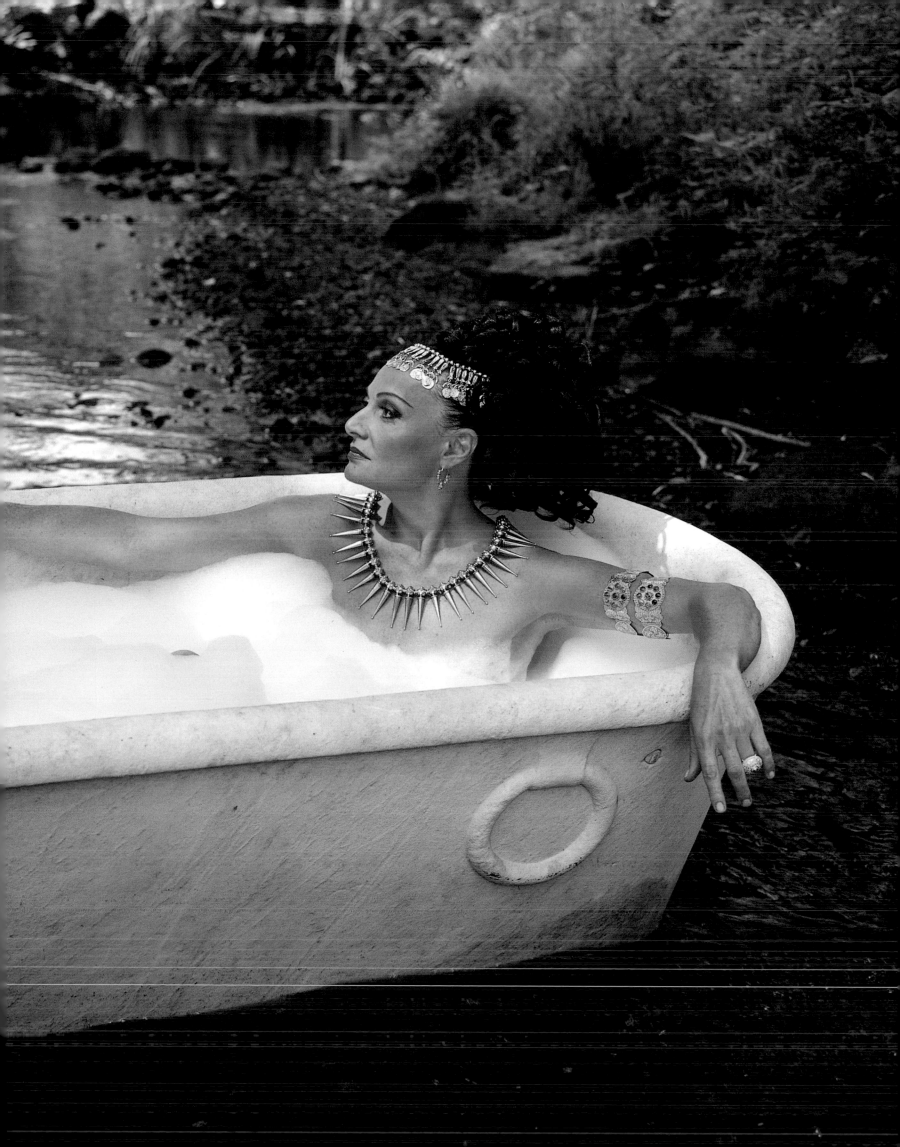

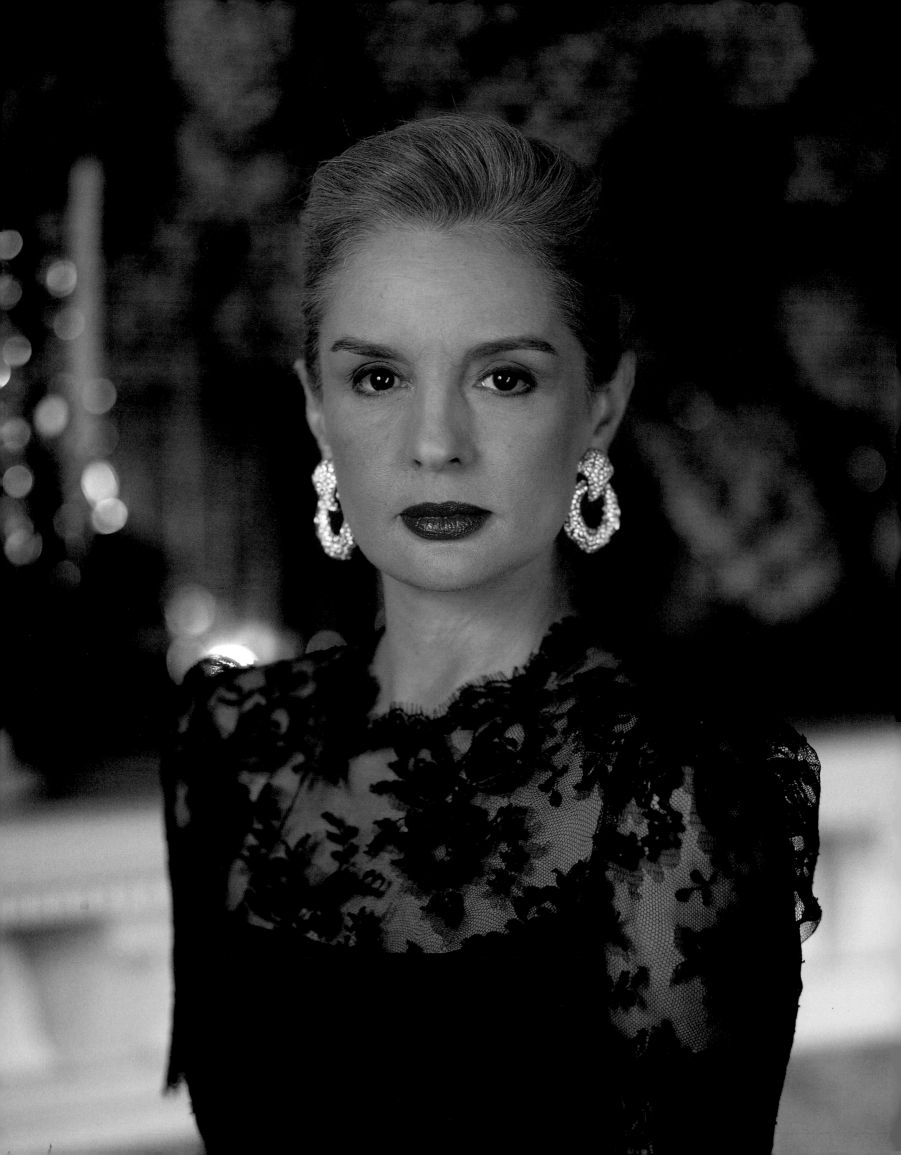

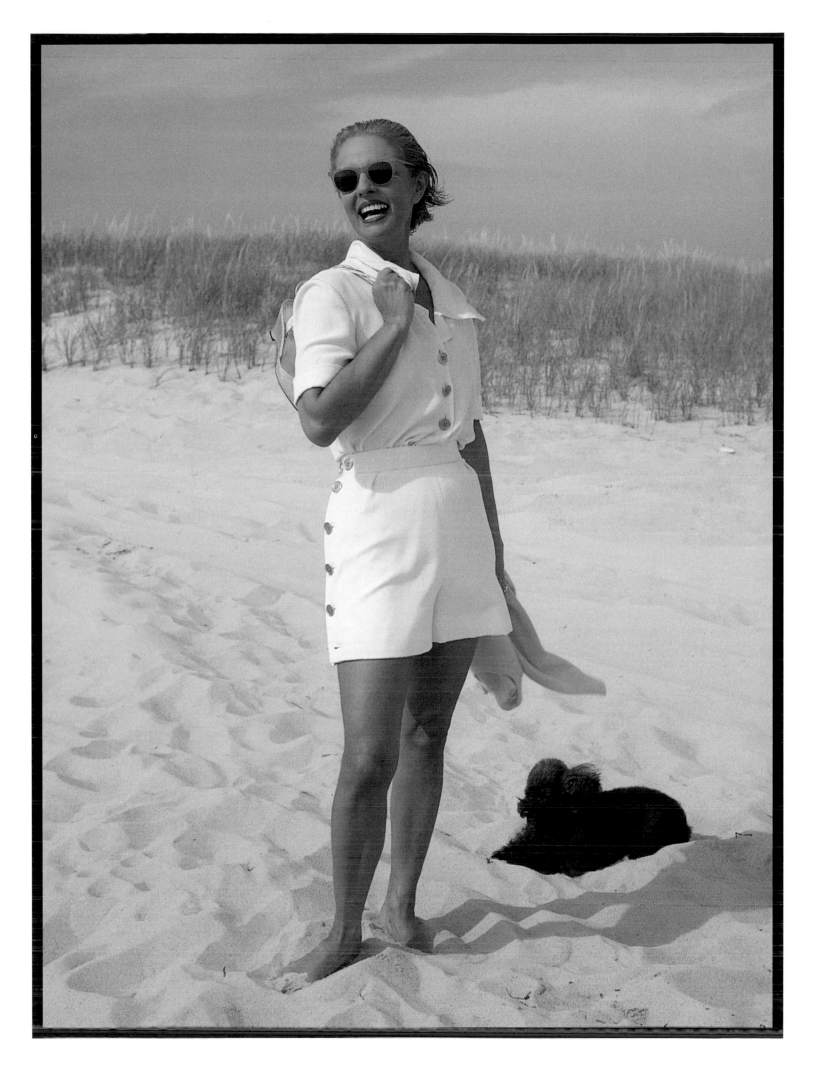

Carolina Herrera

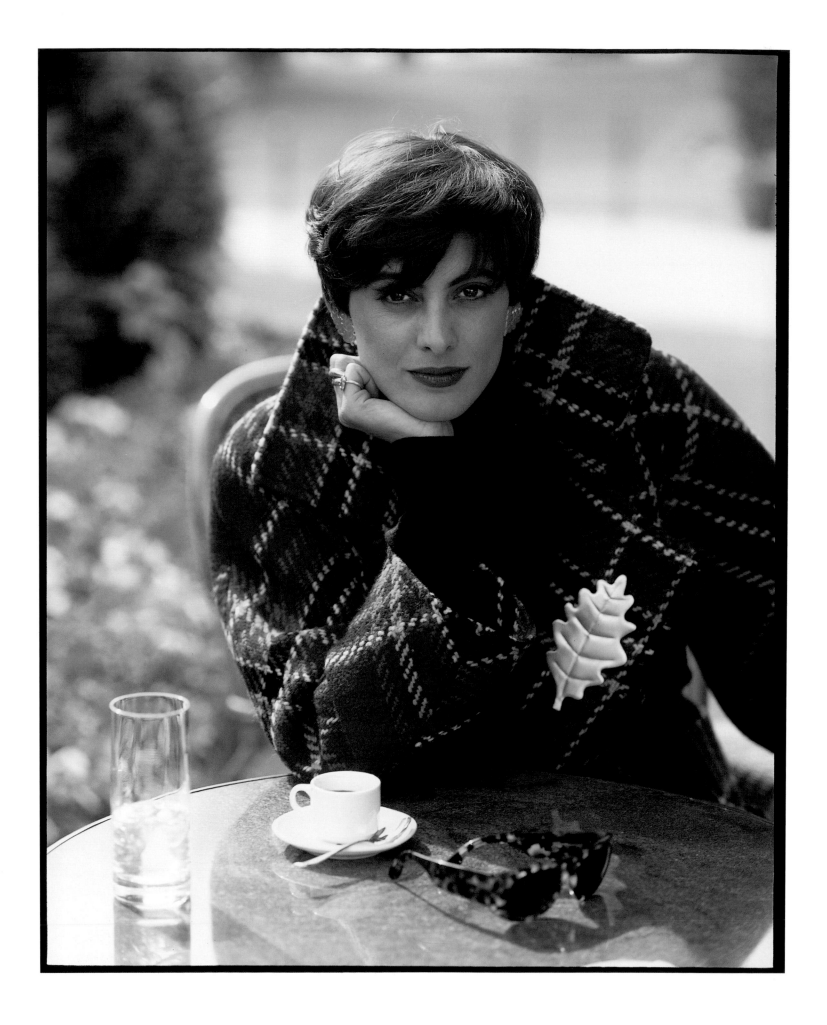

Inès de la Fressange

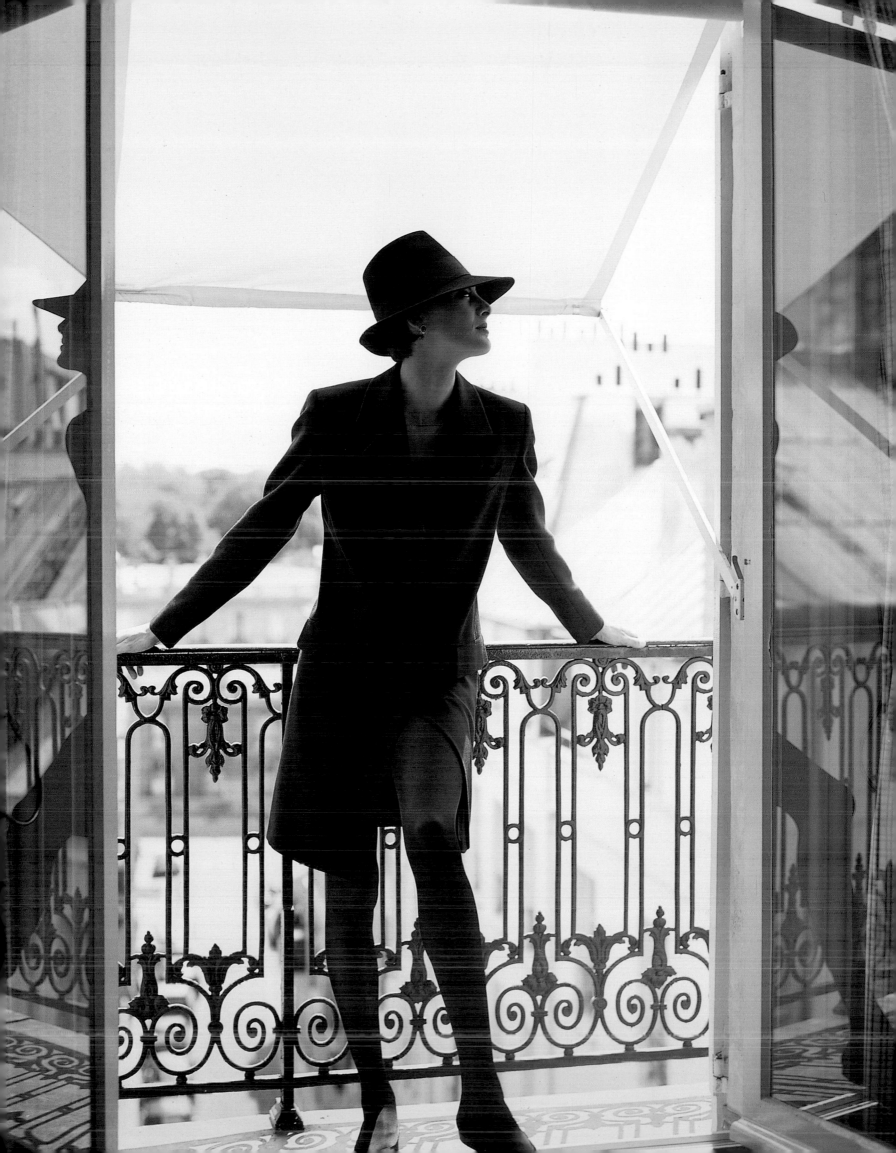

Inès de la Fressange

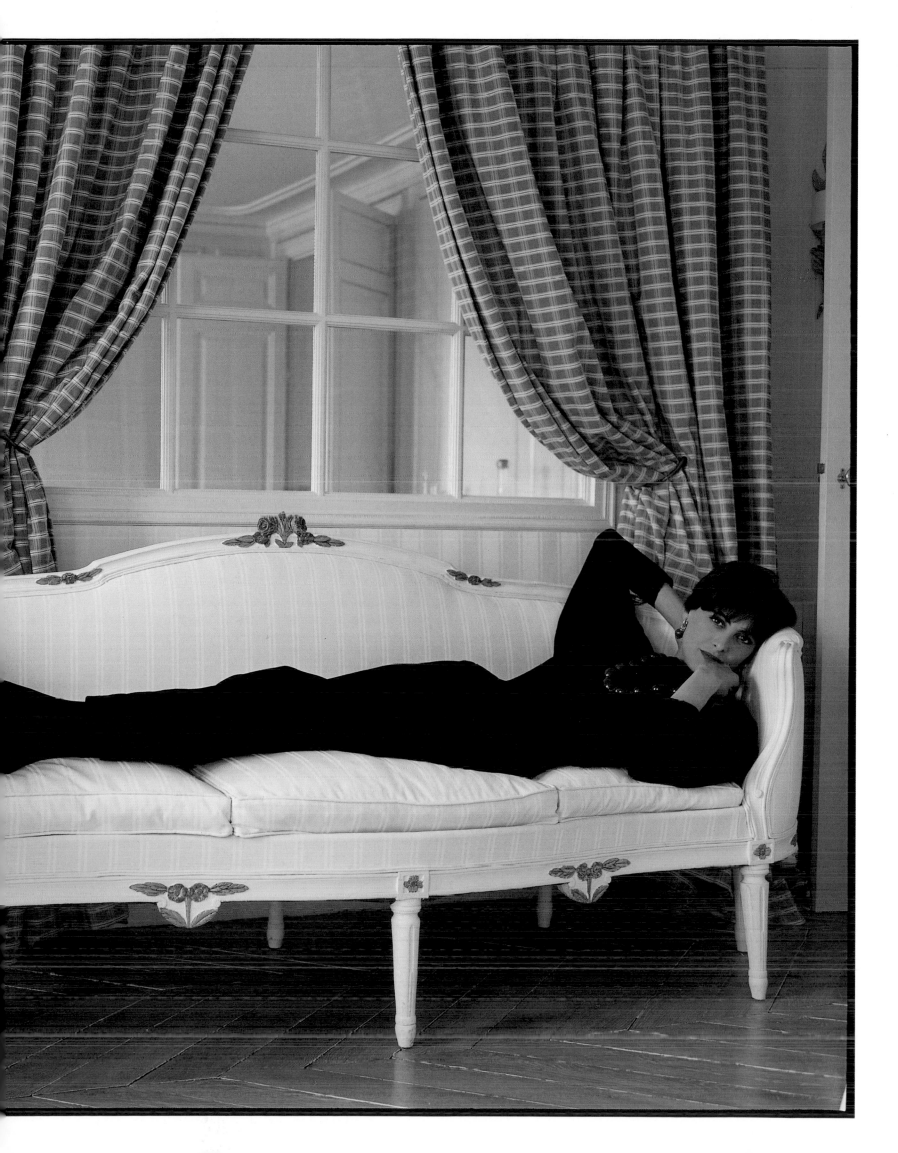

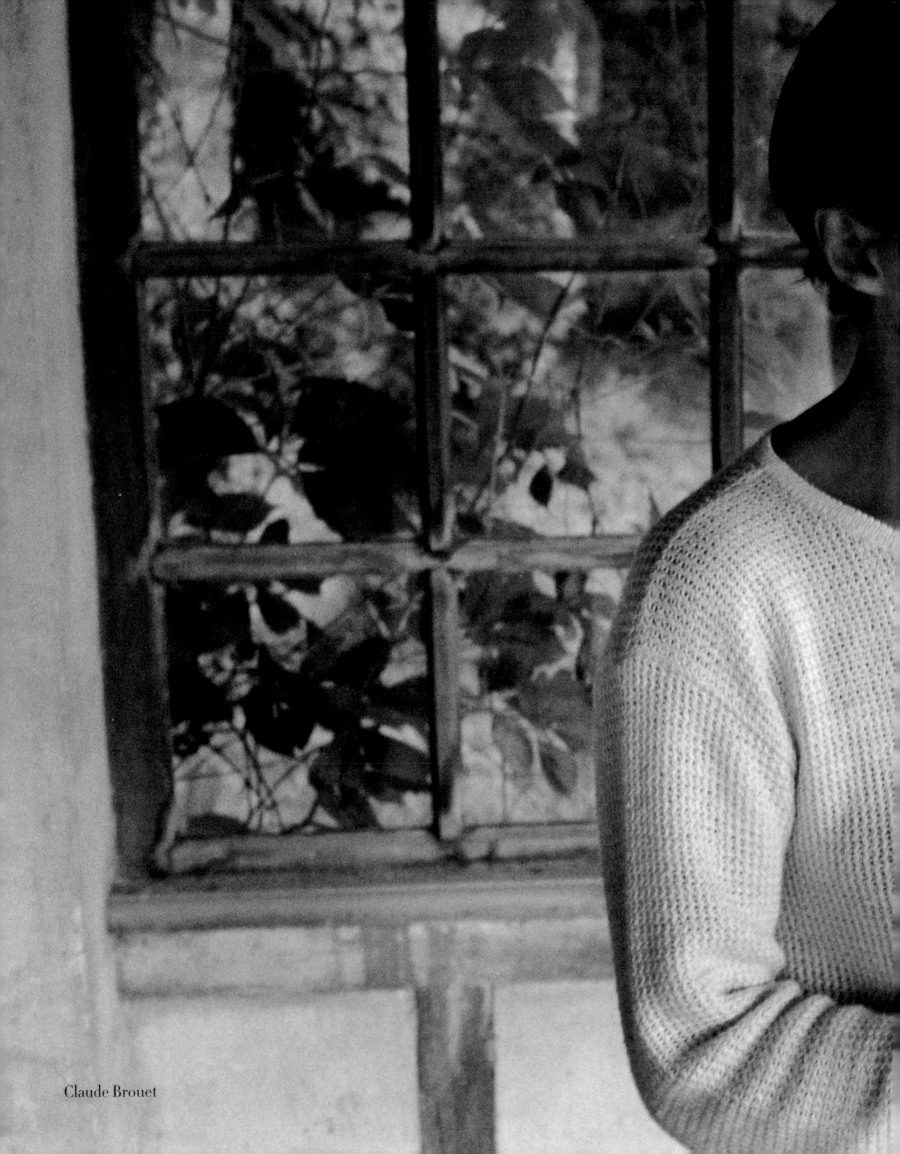

Claude Brouet

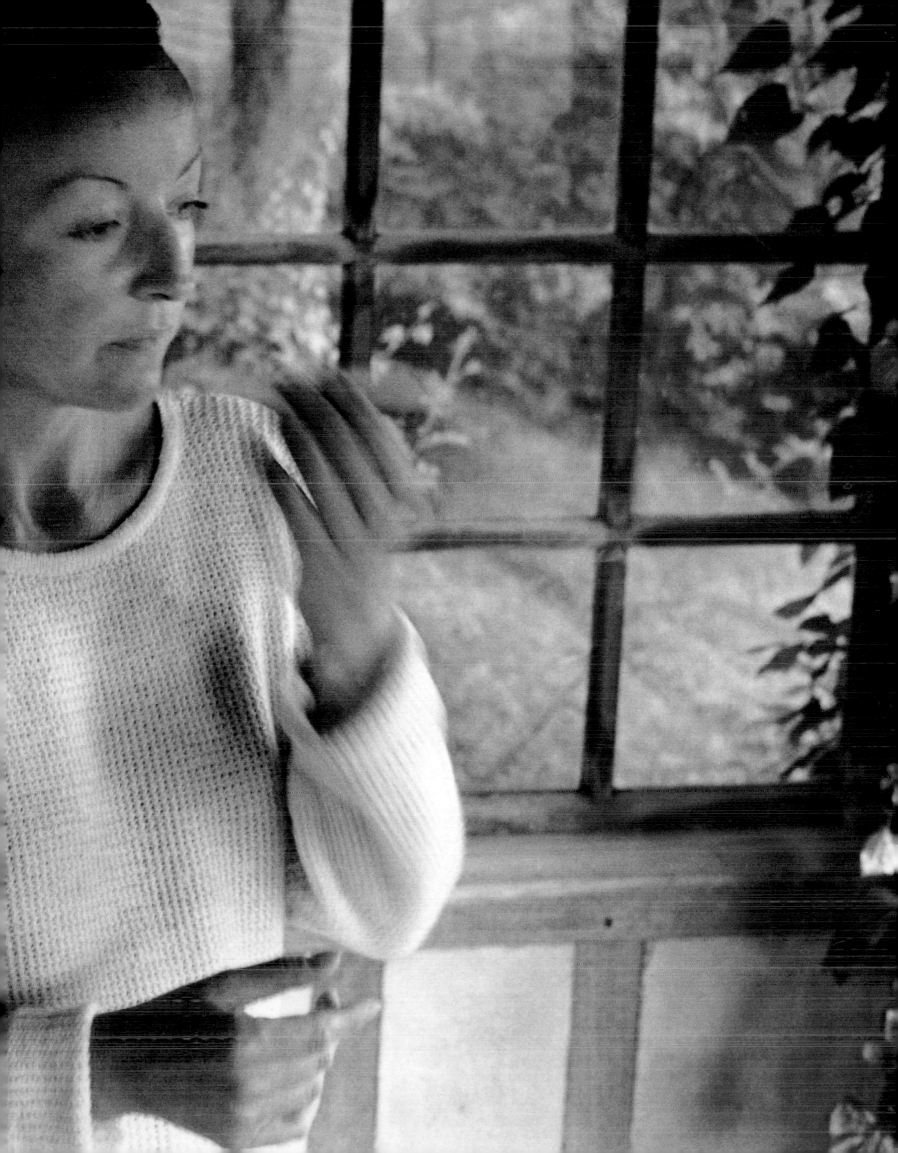

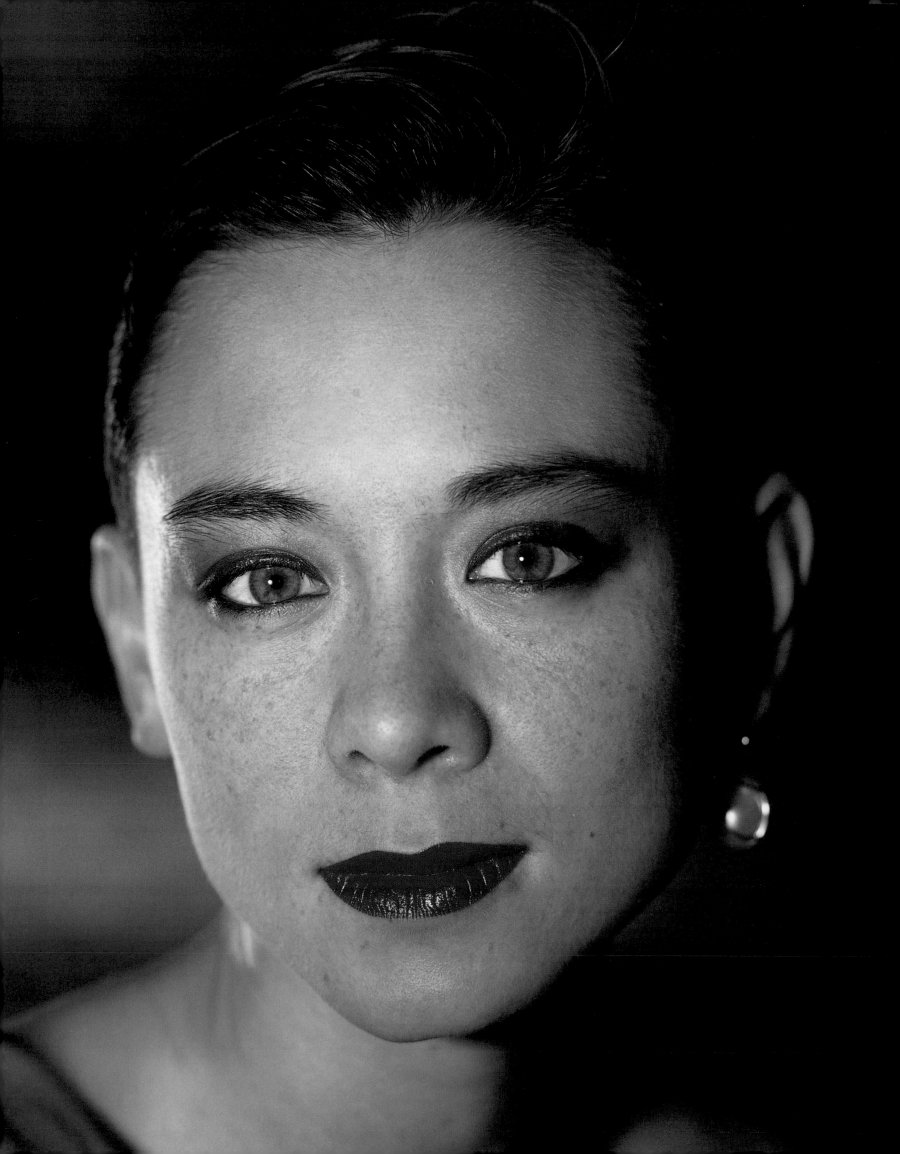

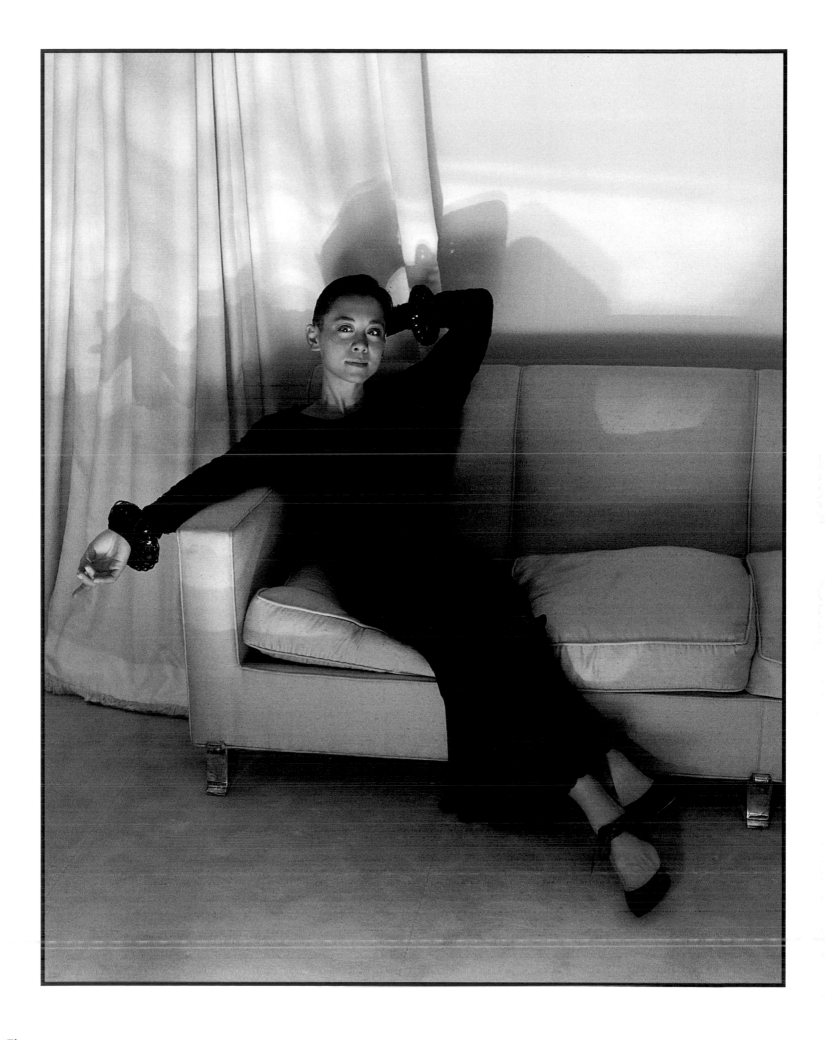

Tina Chow

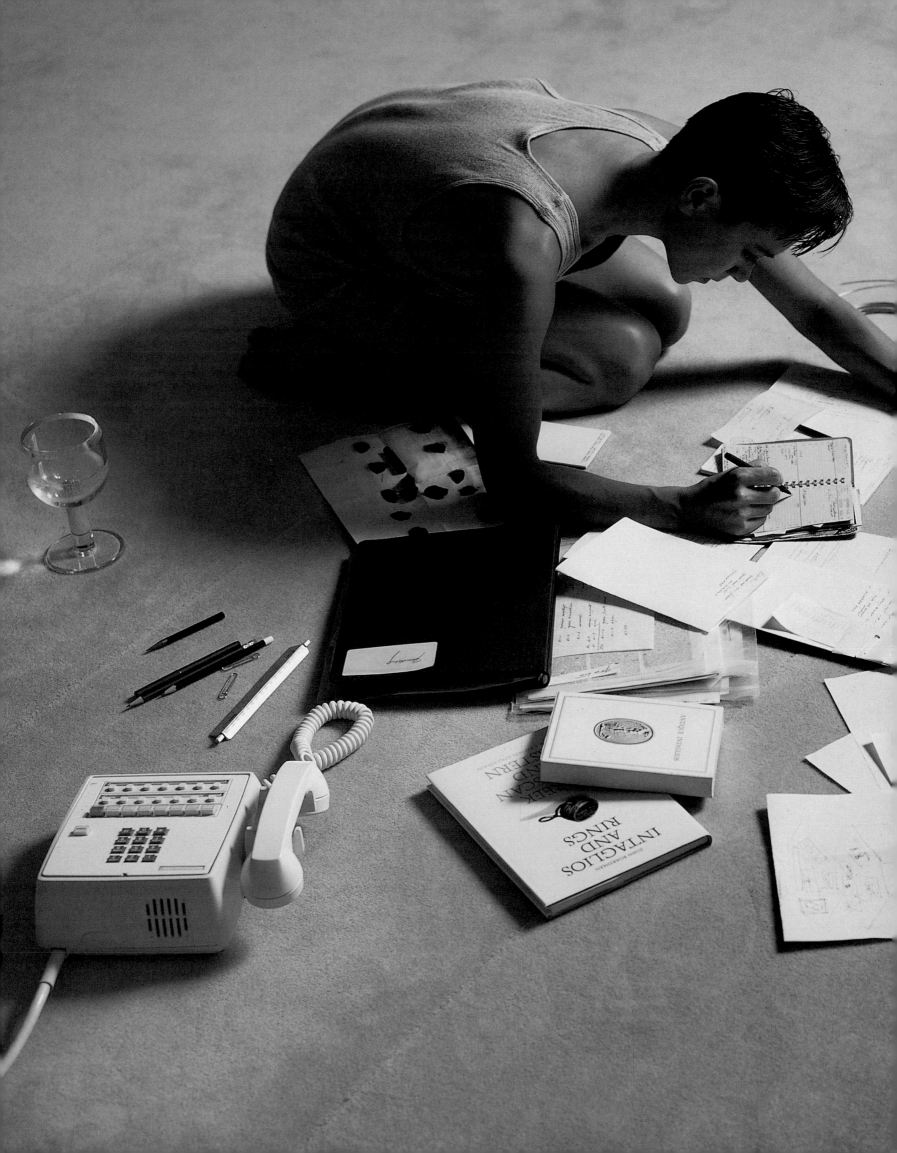

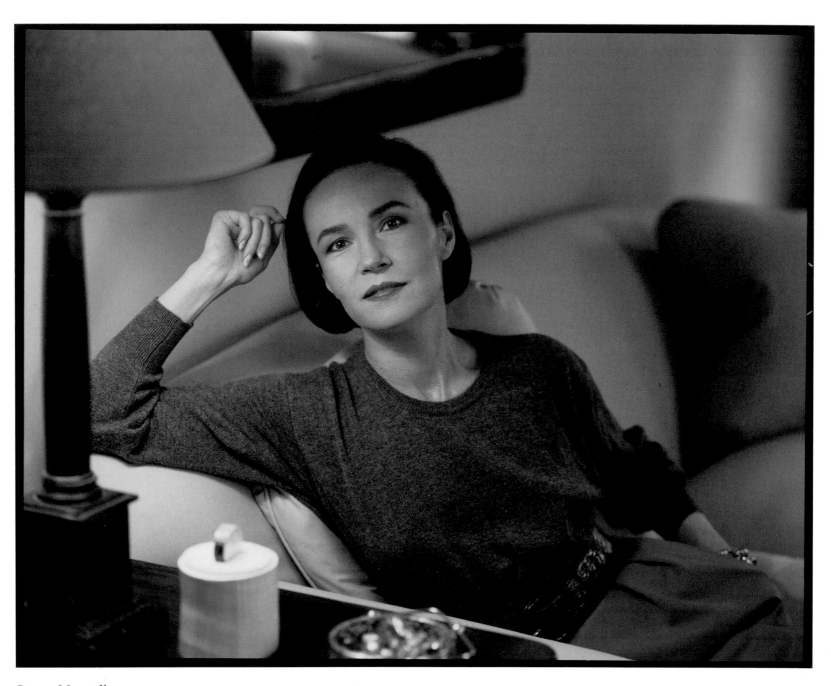

Laura Montalban

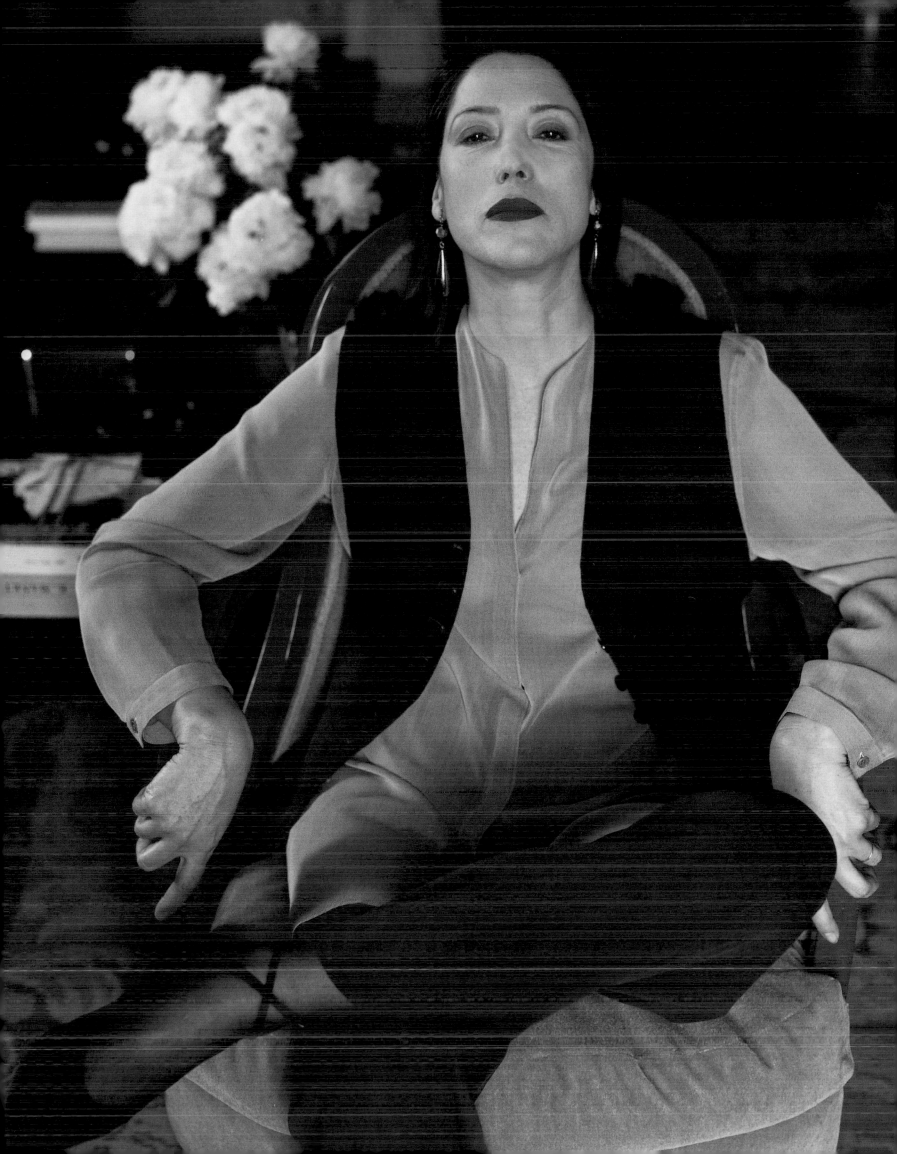

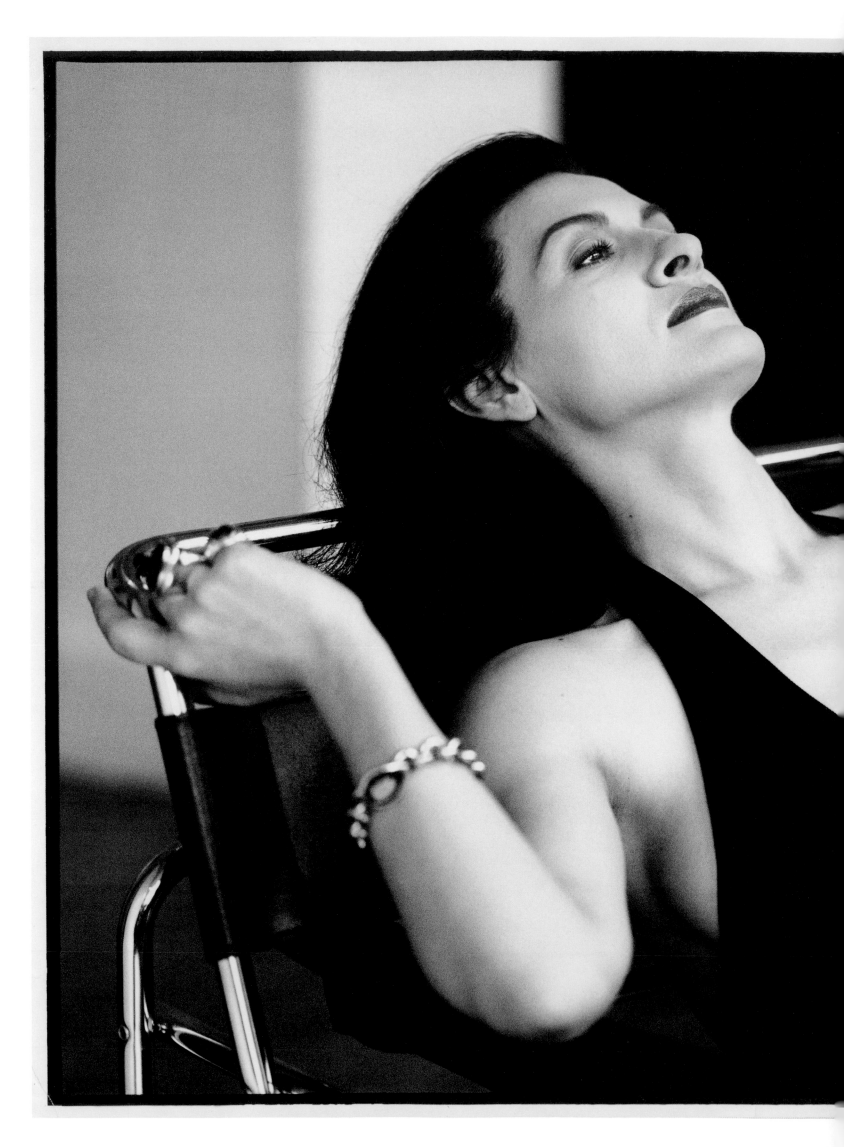

Paloma Picasso

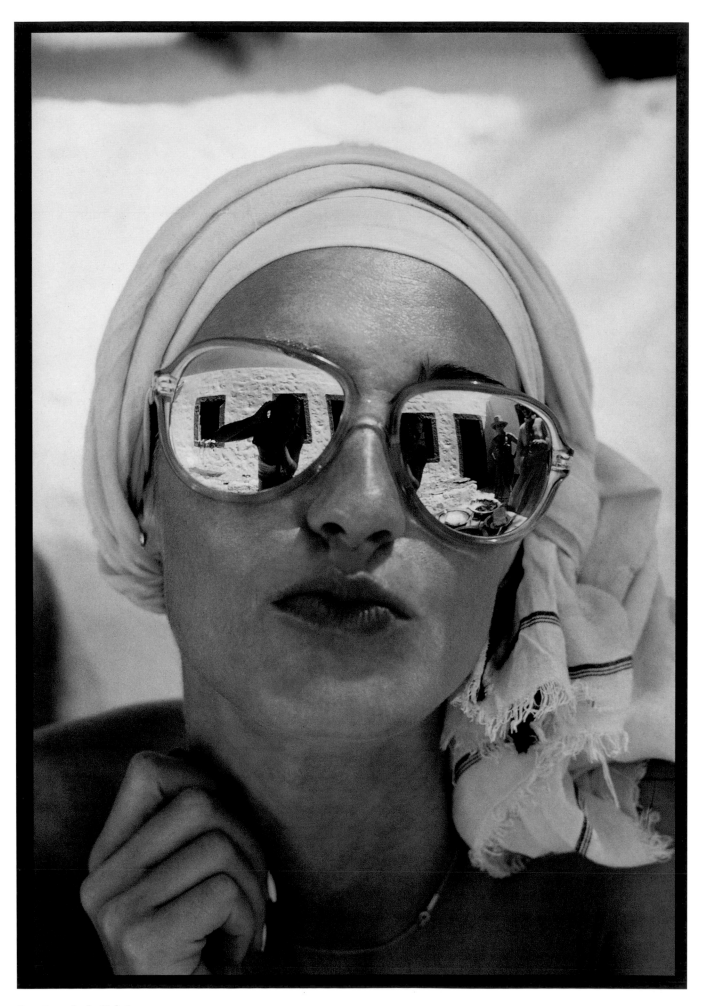

Loulou de la Falaise

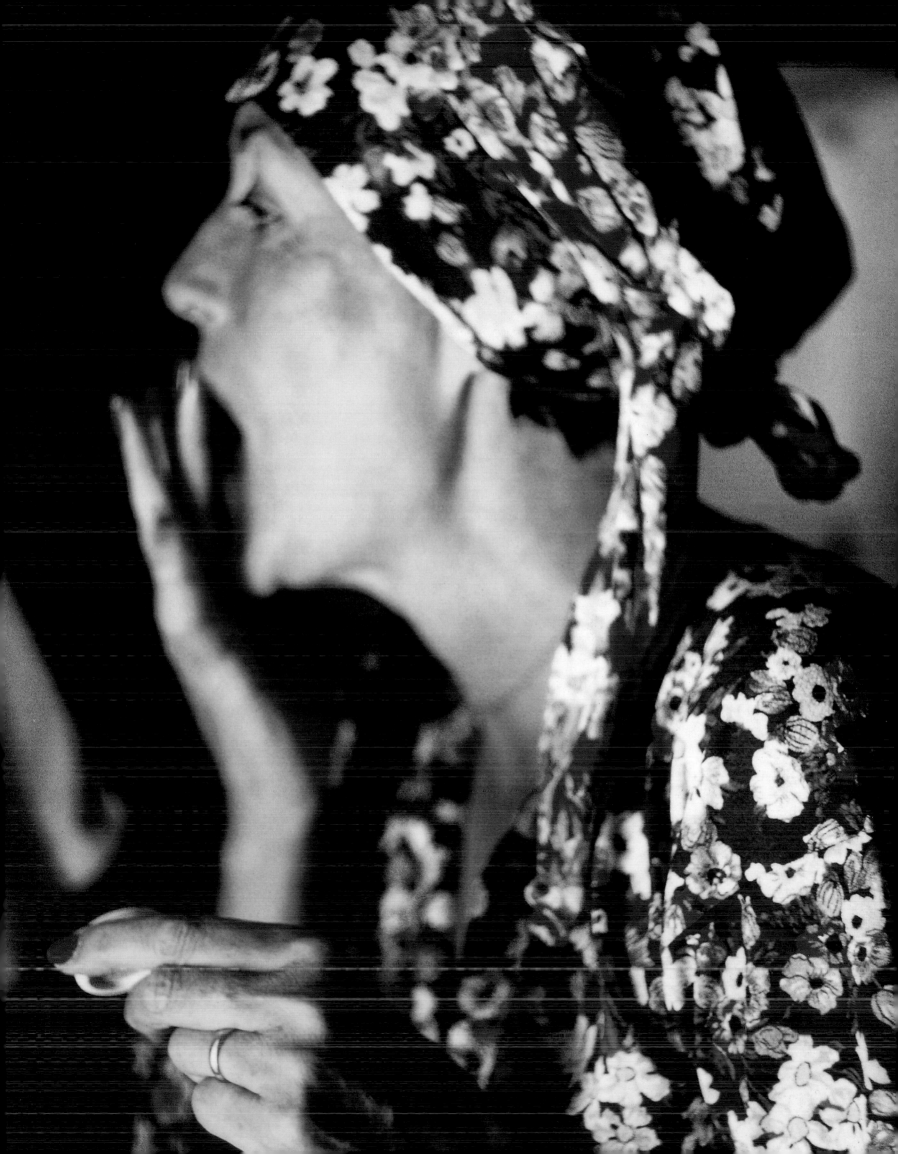

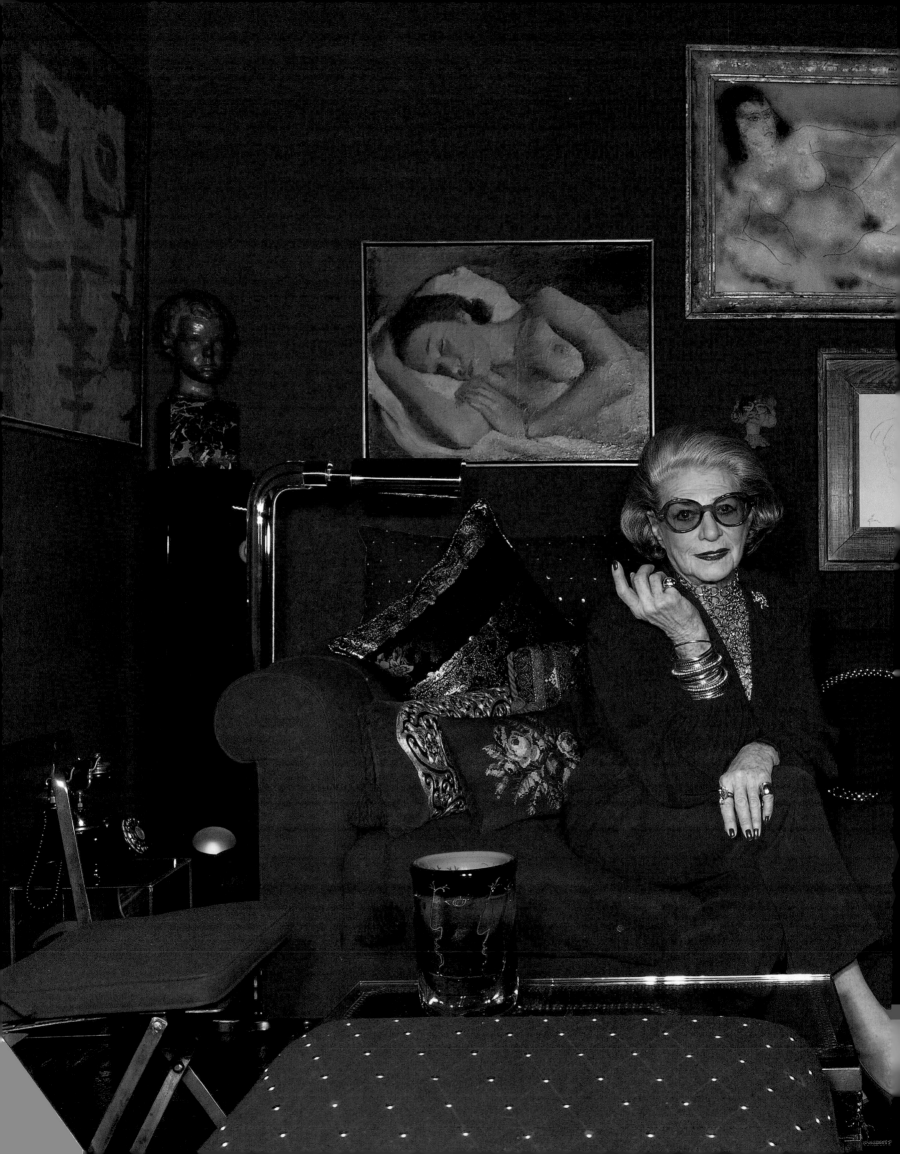

Pauline Trigère

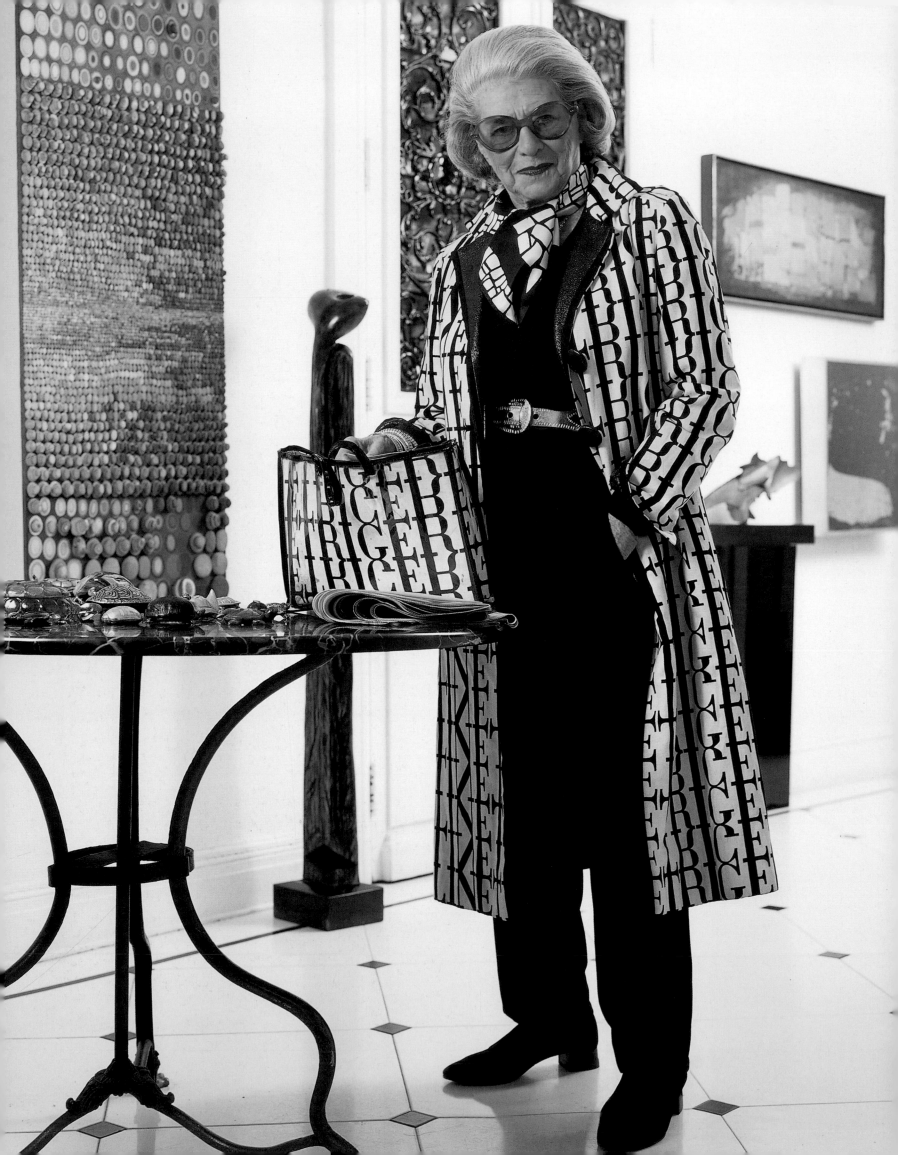

Pauline Trigère

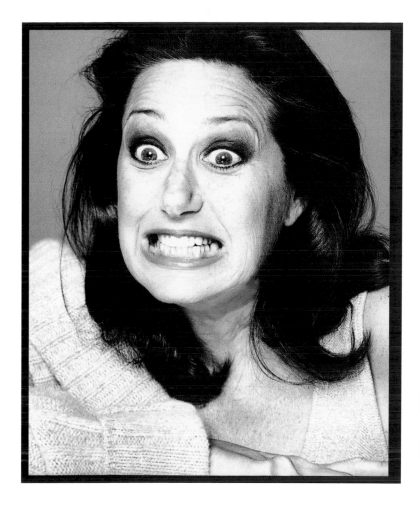

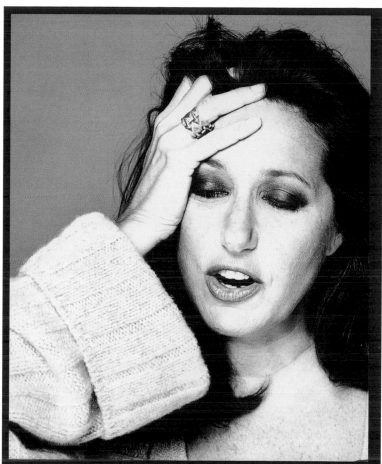

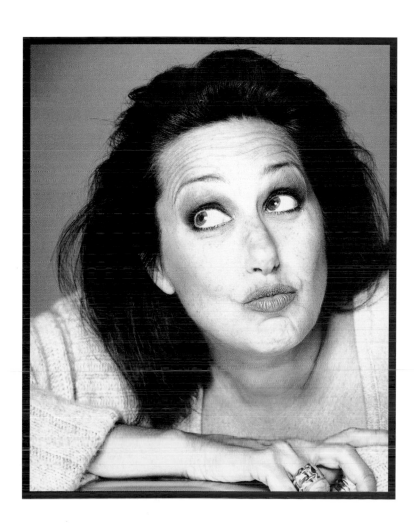

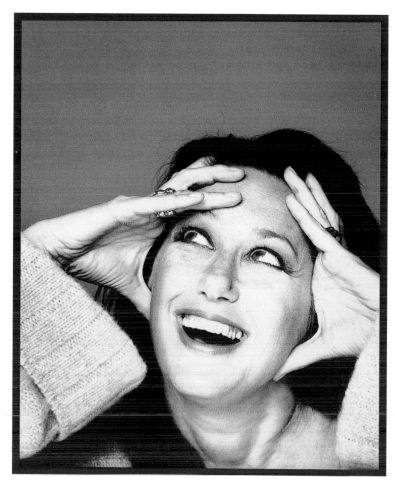

Donna Karan

Power Dames

Irritating and overused, the word "powerful" nevertheless describes a person whose actions have an effect on others, whether by design or not, positively or negatively. There's a moral that says that those who strive for power for its own sake may attain it but will never keep it. We also see that some of those who find themselves in possession of it, often end up resenting it. Power is a curious phenomenon, a tightrope balancing act that brings with it great responsibility.

There is a gallery in Barbara Walters' apartment that is wallpapered with framed photographs, chronicling her long and distinctive career. You see her with a broad spectrum of interview subjects, all of them people who made a mark on their times. Yet, uncannily, as you go from picture to picture, the constant presence of Barbara reads as the real story—you're fascinated by how her appearance evolves with the different situations and the tastes of the times. This I over-ambitiously wanted to convey in a photograph by recreating the picture wall for her portrait. Barbara was not amused, but consented to have all the photographs shipped to the studio while she was having her hair and make-up done. In the back of my head I started to worry that the collage of images would not read as intended, so to save my back I also took another, simpler picture. Barbara sank into the bright red chair with such relief she regaled us with a string of naughty jokes, showing yet another facet of her personality, and a great pair of gams, which rarely get to be seen on television.

A shy, young Anna Wintour was the editor on the project when I decided to morph from illustrator to photographer in mid-assignment. That was in London and the year was 1972. Six years later, as I moved to New York, my first job was a trip with Anna for *Viva*. During her tenure at *Vogue*, Anna has redefined the position of editor, by recognizing fashion as the big business it has become, and placing her magazine as one

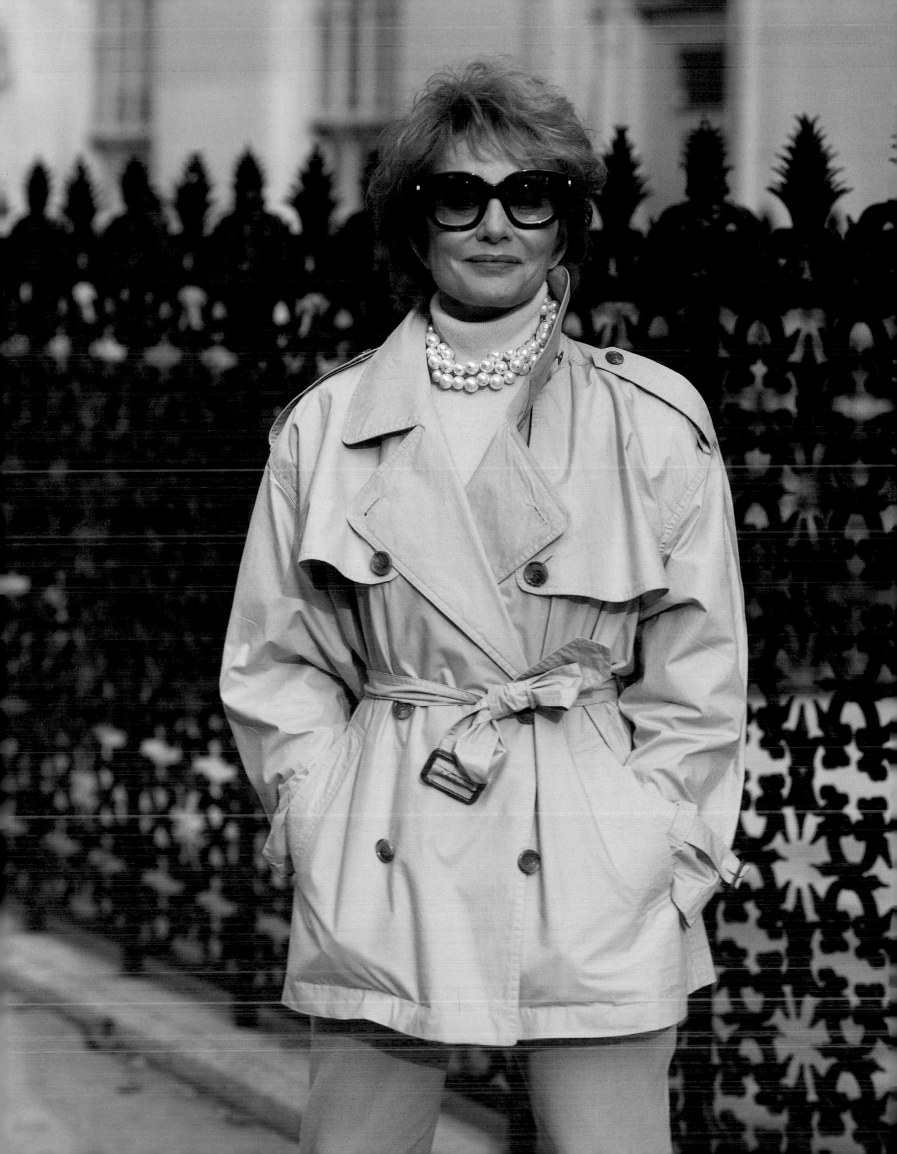

of its strongest players. Anna is fast and decisive. Here is one of several "official" portraits I've taken of her. I had found the green chair in an office fire sale the day before, and asked Anna to wear something red. She came, sat down, smiled, and left. The whole exercise took twelve minutes—I timed it—and that included hair and make-up!

Not what they call a "woman's woman," Pamela Harriman was, however, loved by many men. She knew how to engage: when she talked to you, she made you feel you were the only person that mattered. Once you've been under that beam, however briefly, you realize how rare it is. We did two pictures—one upbeat, and one of a quieter moment, collecting her thoughts for the evening's fund-raising dinner, which was being set up on the porch of her Georgetown house. As I took my leave, she stood on the stairs and, in her rather booming British voice, said, "Mr. Boman, if you ever find yourself in Barbados, don't hesitate to look me up."

While at *Vanity Fair*, Tina Brown commissioned many of the portraits you see in this book. I think her greatness as an editor is rooted in a passionate curiosity about people—not just their private lives, but what makes them tick. Whenever I came back from an assignment, she loved hearing about it in minutest detail. The picture here was taken at William Shawn's old desk after Tina moved over to *The New Yorker*. Of all the pictures I have taken of her, this is the one I think most shows the kind of vulnerable intelligence that lies under the bold surface.

Having produced a string of successful Broadway shows, Terry Allen Kramer produced the largest house in modern times on the oceanfront in Palm Beach—and started a frenzied new building boom. Barely completed, rumors were flying that her record was already about to be broken: a house on a neighboring site was measured by the number of cars its garage would hold. Sixteen.

Bianca Jagger was the subject of my first cover story for London *Vogue*. It was before I knew you could have an assistant, and much else for that matter. Bianca was greatly concerned about the amateur flash attachment I was using, and craftily unplugged its overnight recharger. My theory of how her beauty could handle a paparazzo effect didn't cut it with her. Here she is playing bored on Mistinguett's bed at "l'Hôtel" on the Rue des Beaux-Arts in Paris, one of the images from that series. The roses had been sent by an old admirer. I emerged rather frazzled from the whole experience. Bianca later put her glamorous former identity to good use, working for a number of worthy causes.

Since every move Jacqueline Kennedy Onassis made seemed to get recorded on film, I guess it was wishful thinking on my part that she would sit for a portrait. This vain prospect was further shattered when it turned out that *Vogue*'s story, "The Kennedy Women," would, in true Wintour style, be about the younger generation. Kathleen Kennedy Townsend and Kerry Kennedy Cuomo have keenly followed in their father Bobby's footsteps, while the unpredictability of fate has made Caroline Kennedy Schlossberg the lone survivor of an iconic American family that captivated the world.

Not every editor-in-chief picks up the phone to assign photography, but John F. Kennedy Jr. did, when he asked me to photograph Georgette Mosbacher for *George*. The poppy-haired cosmetics tycoon turned out to be a perfect match for her sumptuous surroundings, and the image a testament to its time.

Risking the wrath of her advisors, Marilyn Quayle donned her riding outfit for *Vogue*, and looked perfect. In a country where you are what you wear, I wonder if perhaps it is a longing to dress as they please that makes politicians eventually quit their game and the scrutiny that comes with it?

Picture me mowing the lawn in shorts and Wellington boots, when I was called to the telephone: "It's Elizabeth Dole." This sort of thing is not common in our house. Mrs. Dole was calling from Kennebunkport, while waiting to be jetted away from a weekend with the senior Bushes, and she just wanted to tell me how much she loved her picture in *Vogue*. A cynic could argue that this charming gesture might owe something to the fact that her husband was the Republican candidate for president, but I didn't have the heart to tell her that, as a mere U.S. resident, I was not registered to vote.

During her long tenure as restaurant critic for the *New York Times*, Mimi Sheraton was both respected and feared: her pen closed a number of establishments, while helping others to prosper. As she was still on the job, *Vanity Fair* had to maintain her cover. Mimi has an unusual knowledge of Scandinavian food, and invited me to her traditional New Year's *smörgåsbord*: all the foods of my childhood, served up in Greenwich Village.

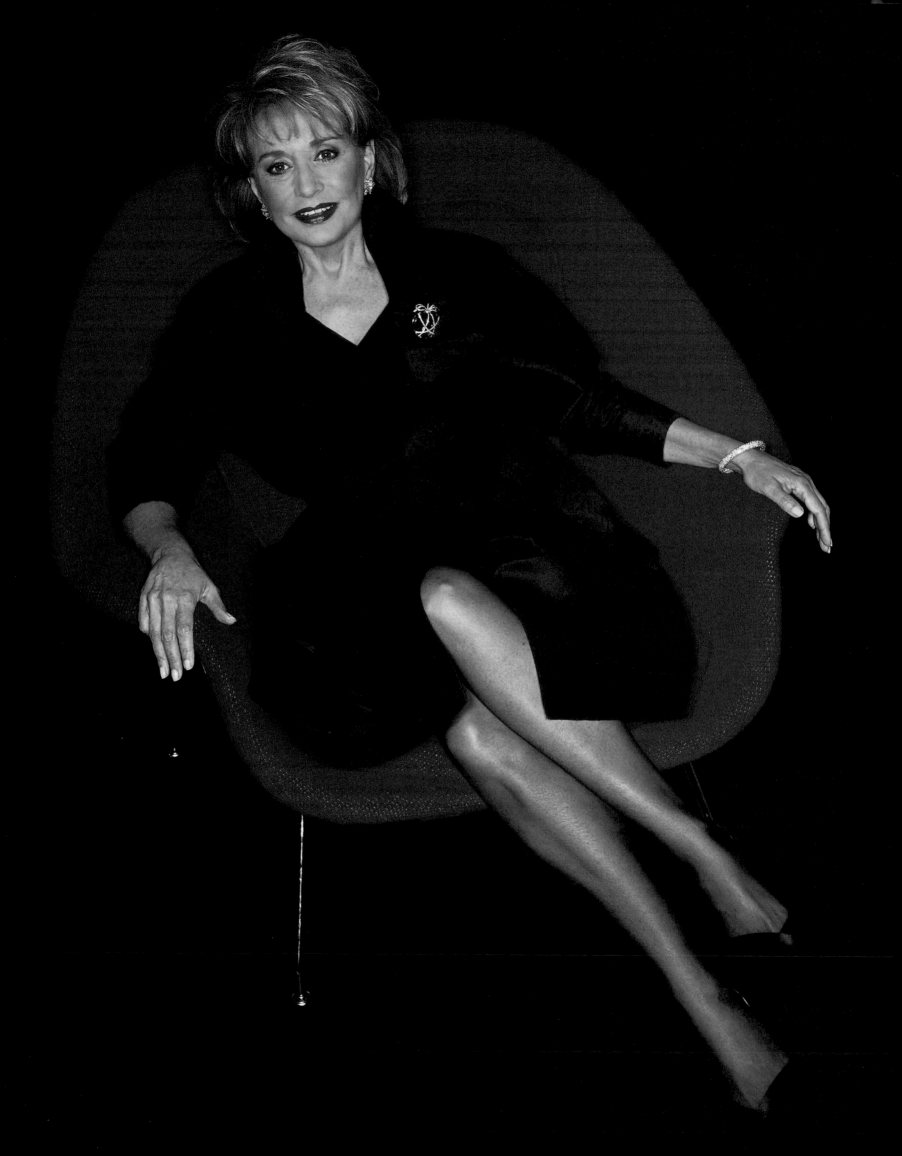

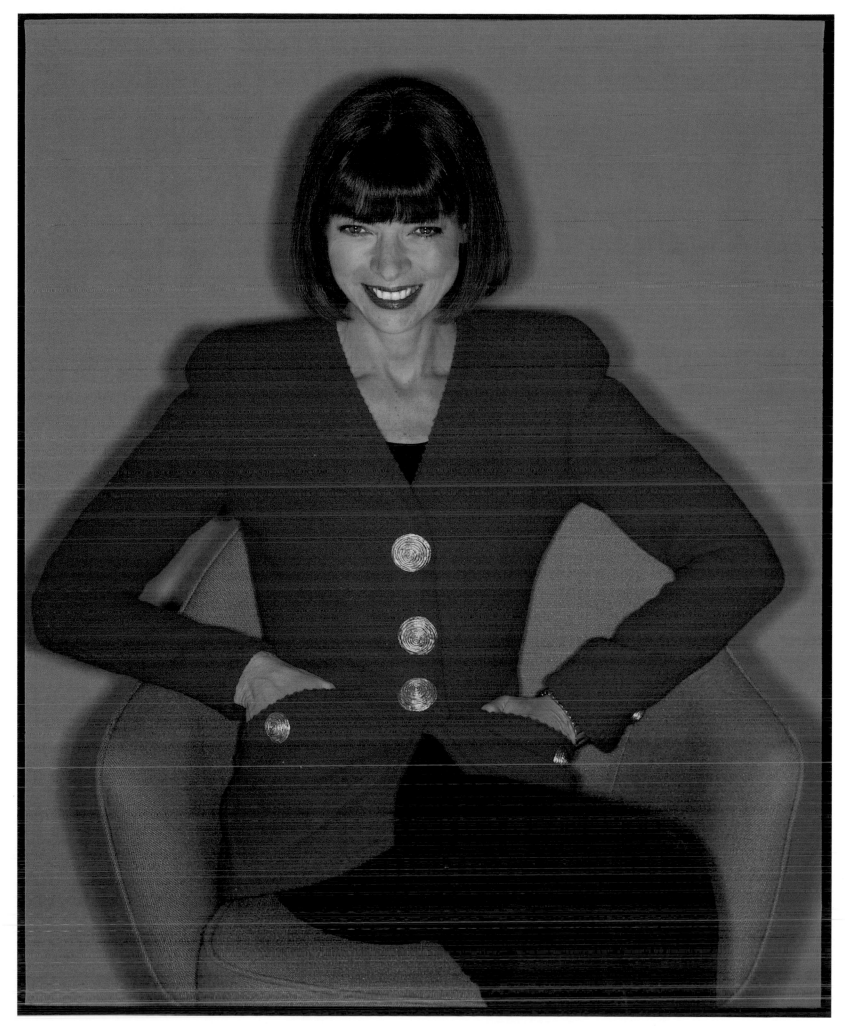

Anna Wintour

Barbara Walters

Pamela Harriman

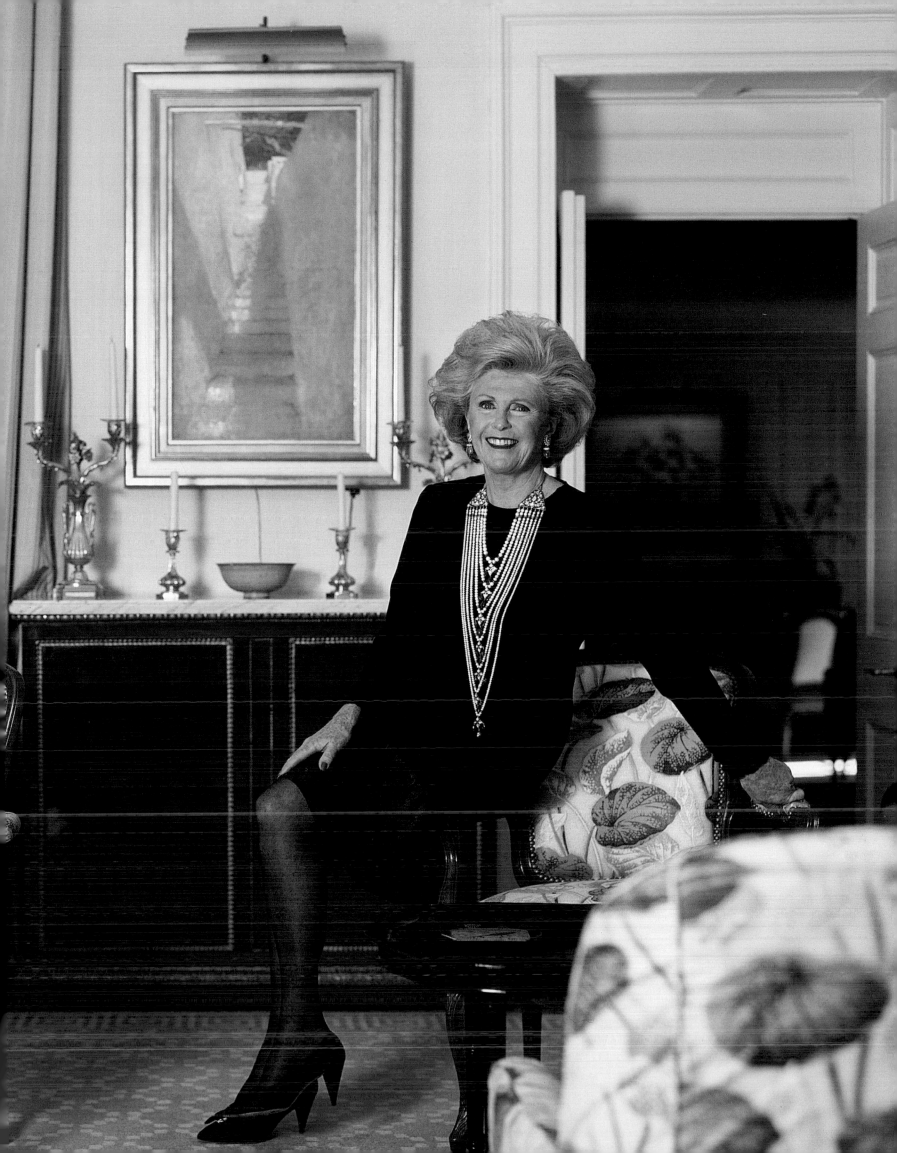

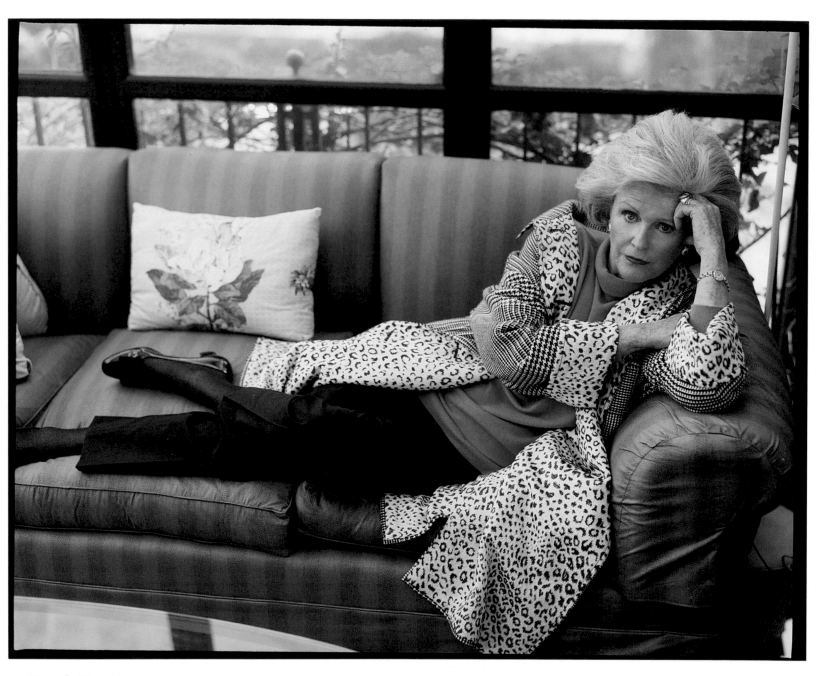

Pamela Harriman

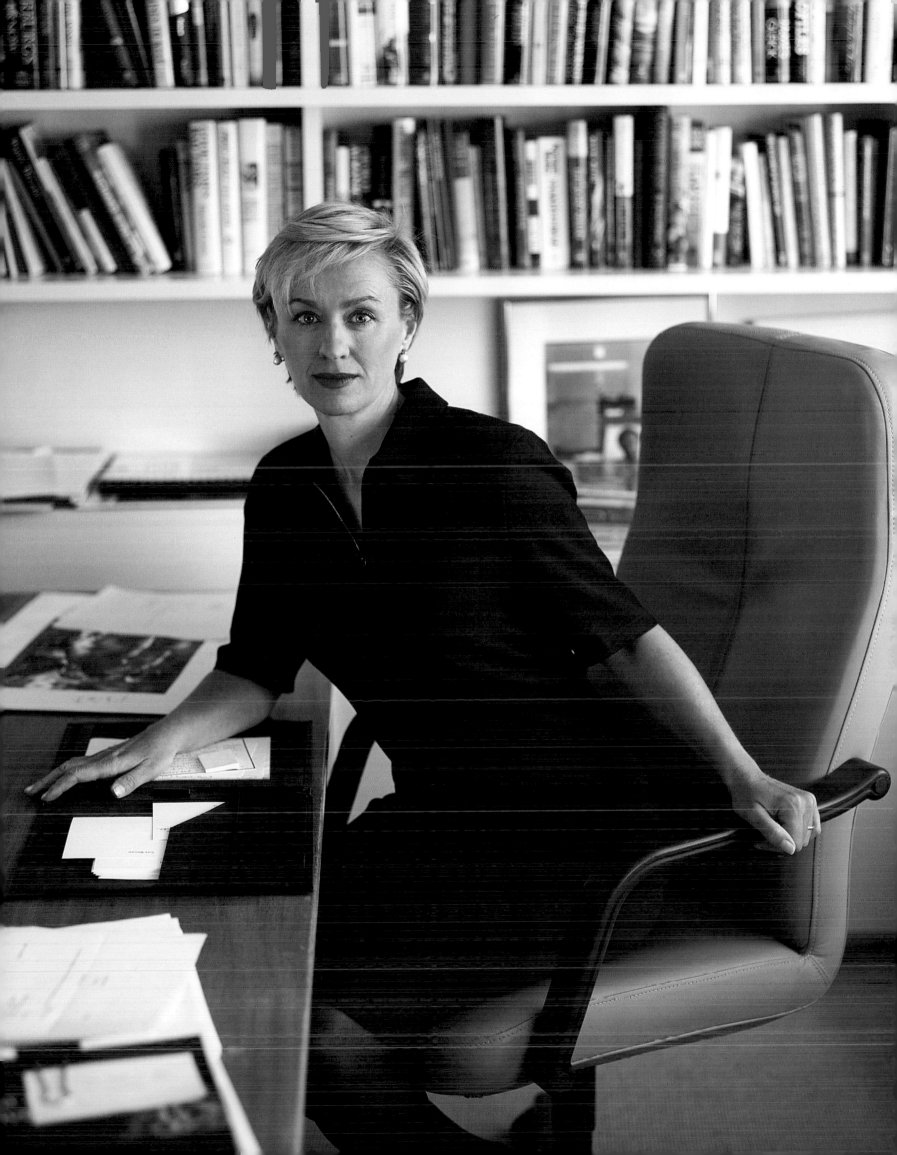

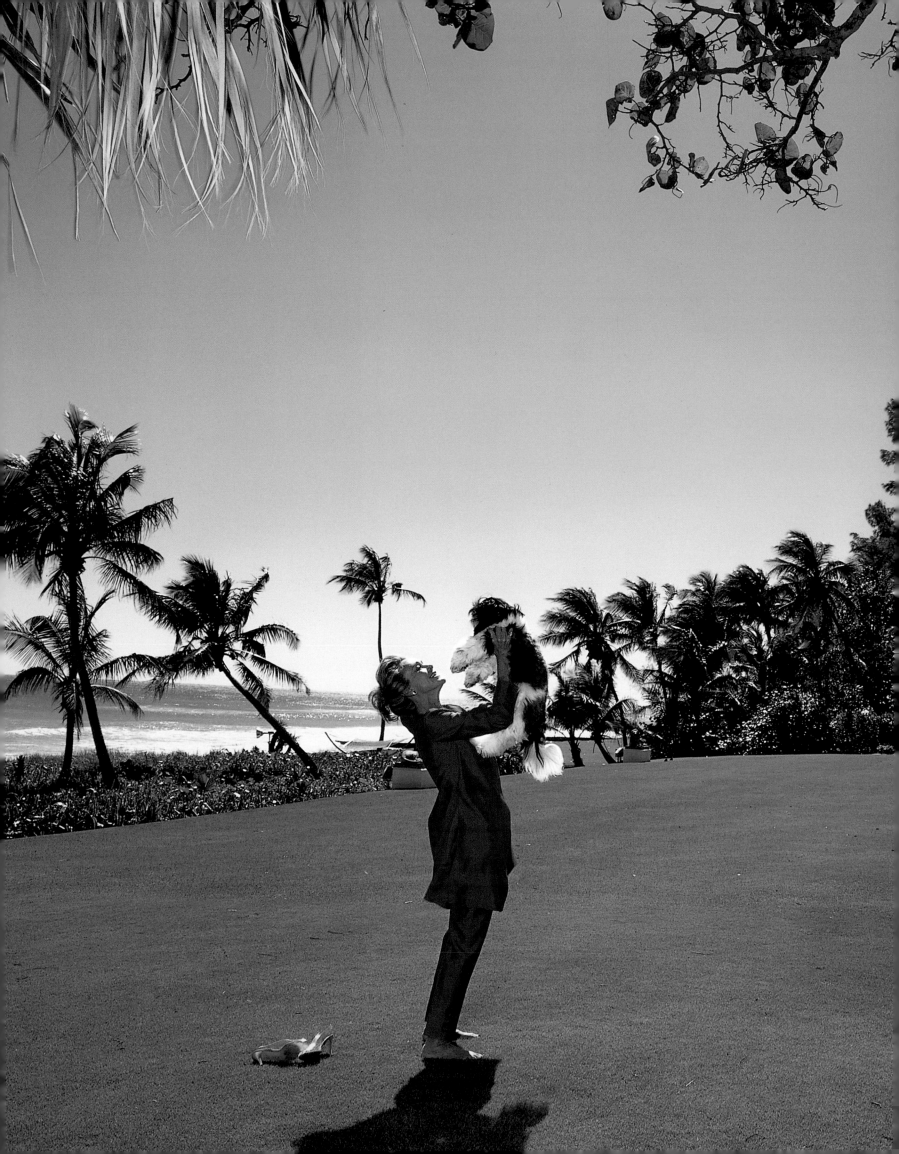

Terry Allen Kramer

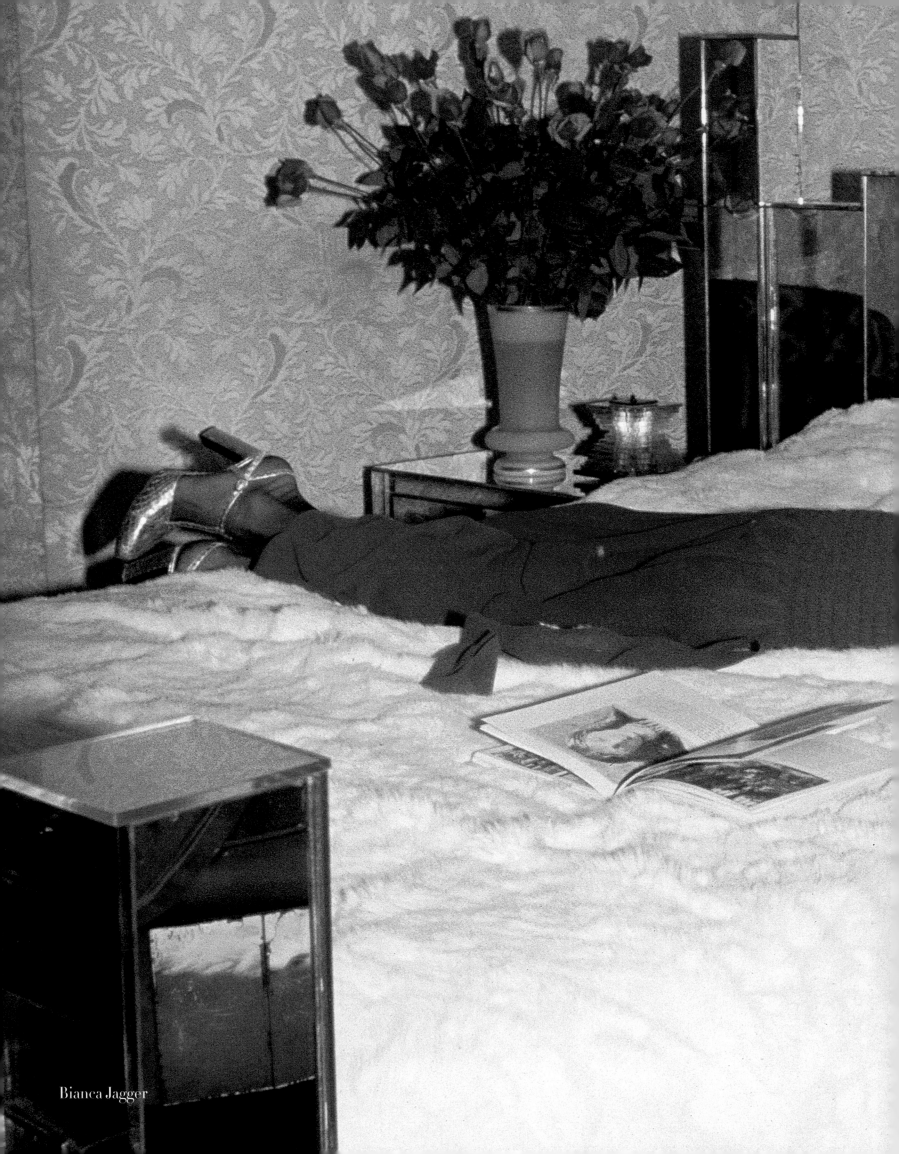

Bianca Jagger

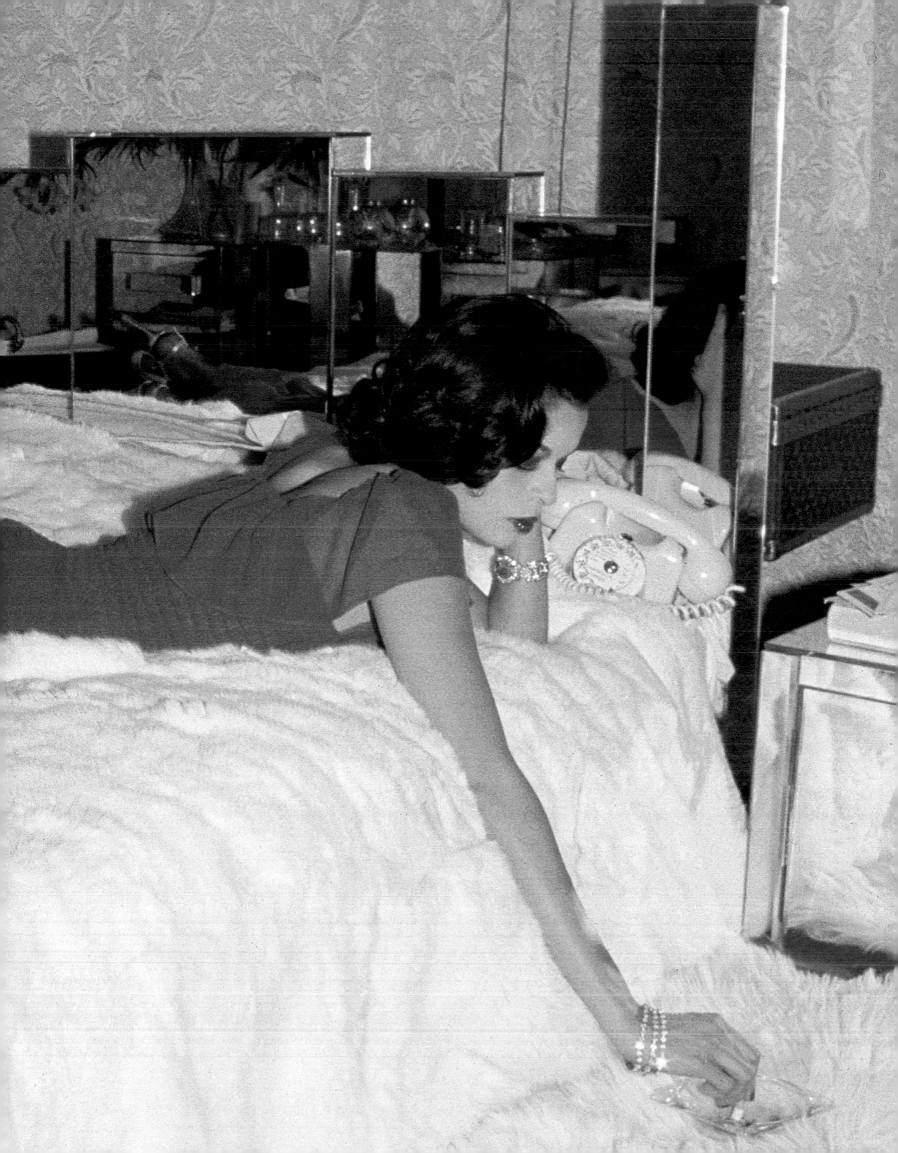

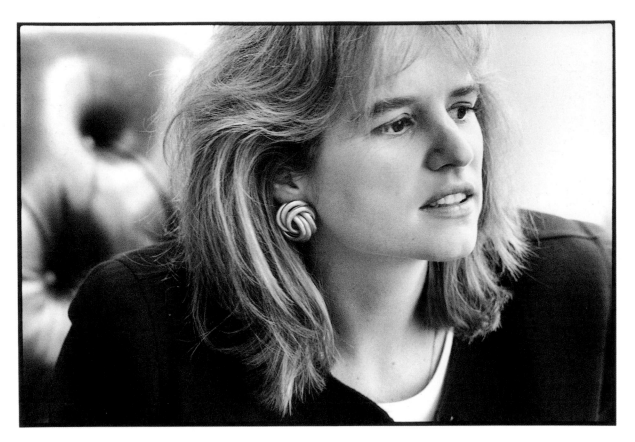

Kerry Kennedy Cuomo

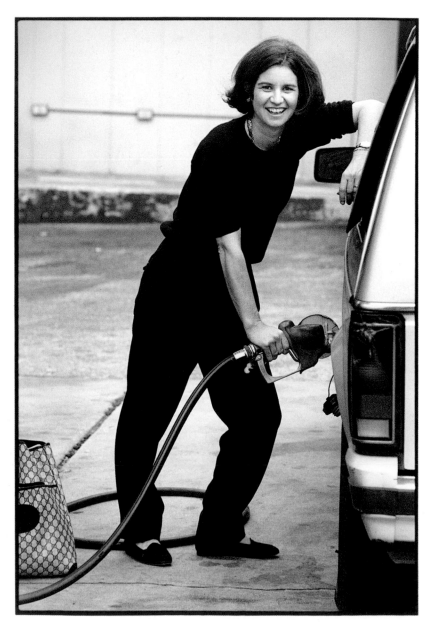

Kathleen Kennedy Townsend

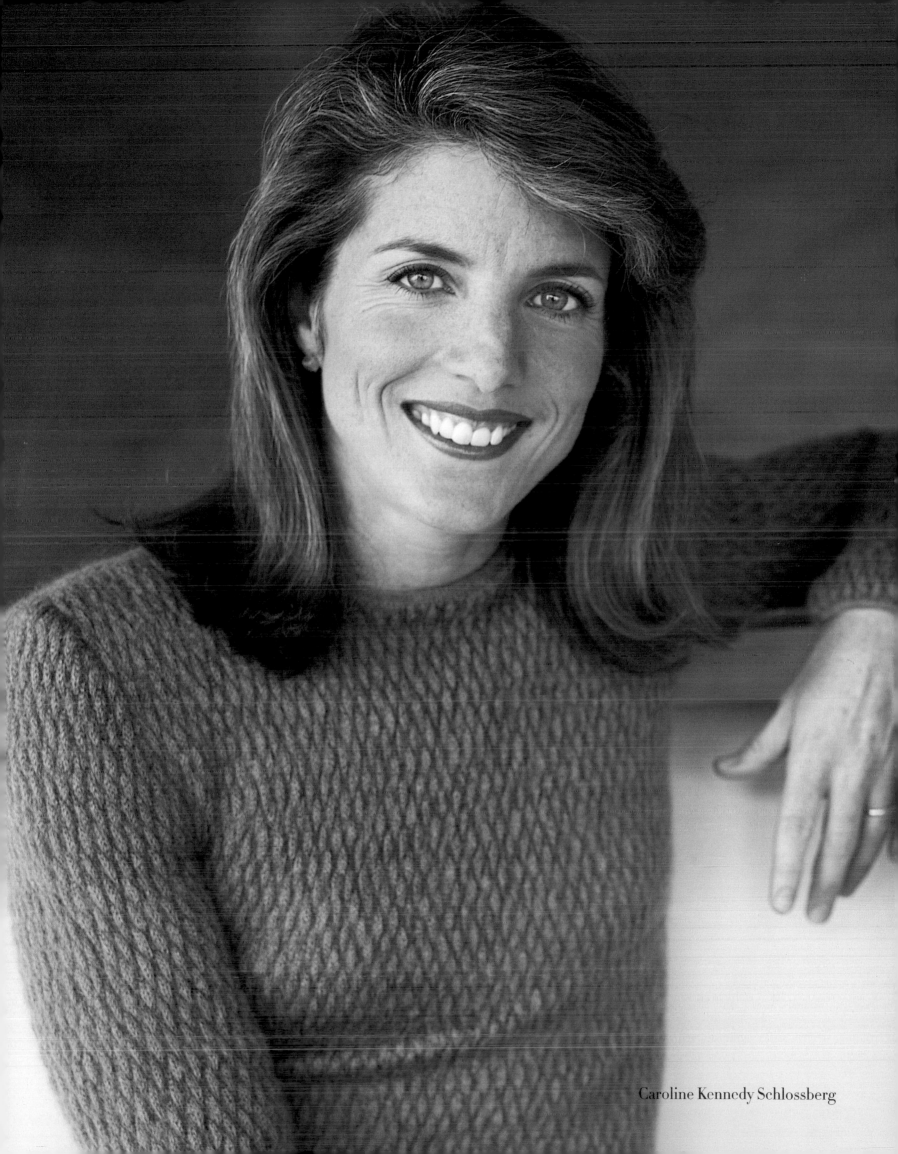

Caroline Kennedy Schlossberg

Georgette Mosbacher

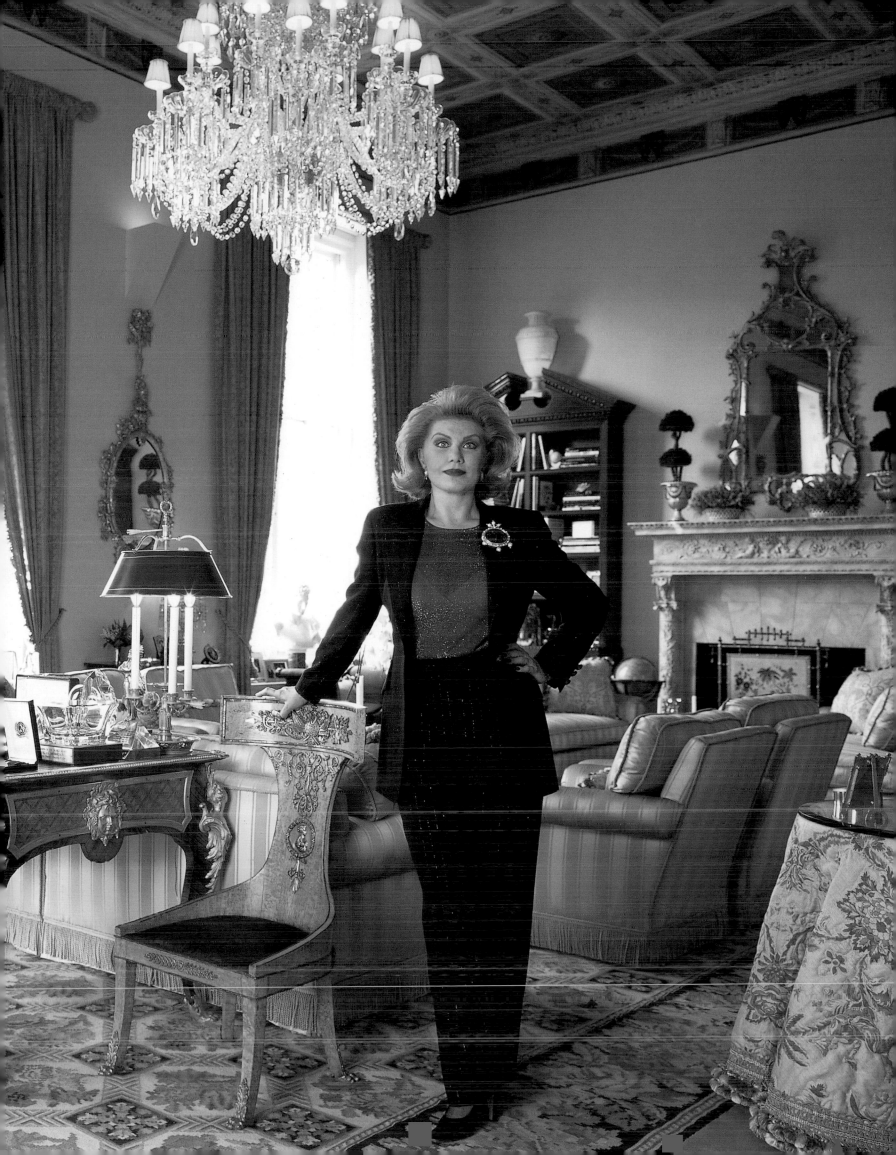

Marilyn Quayle

Elizabeth Dole

Mimi Sheraton

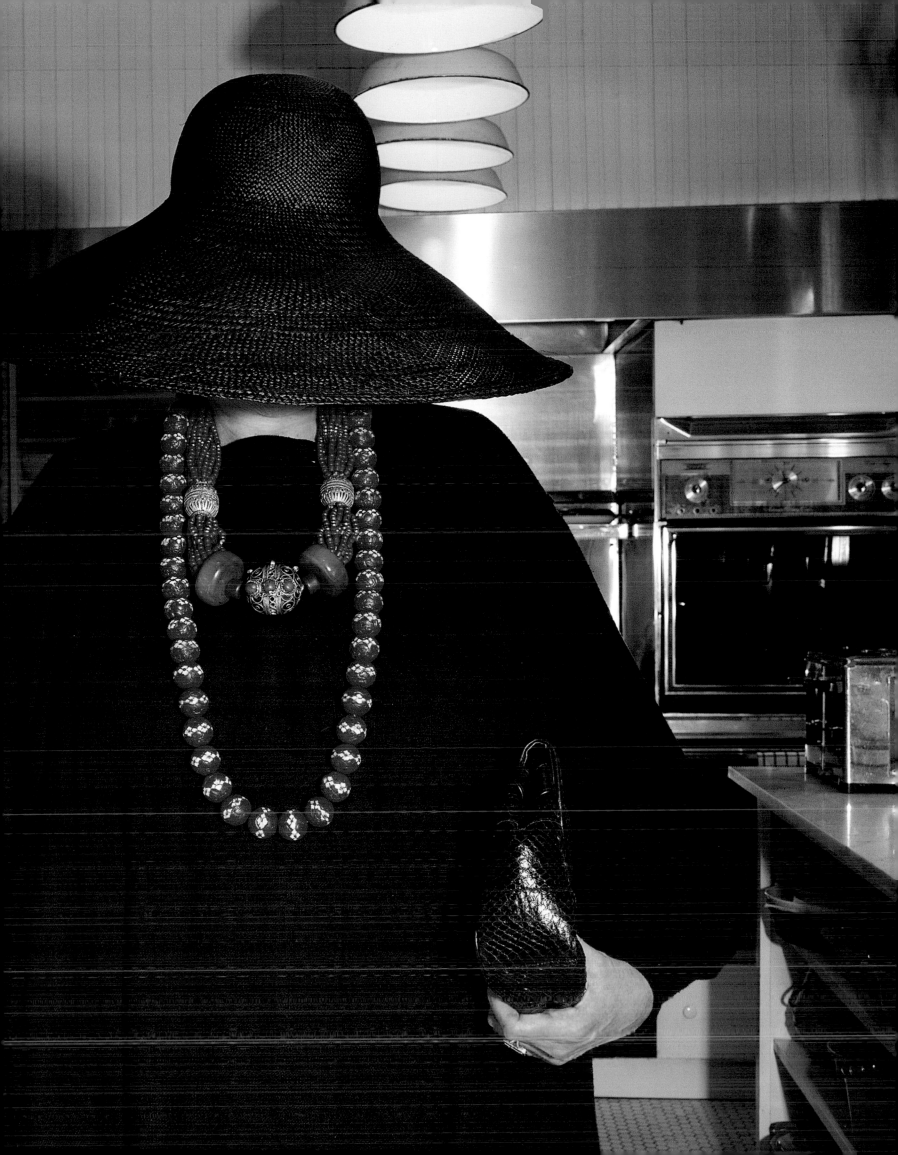

Society Dames

The notion of labeling people is of course obnoxious, but the dames here so rudely treated must especially forgive me—yet, perhaps also understand that theirs is a rank so aspired to by the many who will never reach it that this fact alone should give them some sense of satisfaction. Although prominence may remain a matter of circumstance, it should never be assumed that a society dame has not earned her stripes like the rest.

Anyone living in Paris who's not a Parisian will sooner or later feel an urge to scratch the irritability of the locals. Not many have done it as magnificently as São Schlumberger, when she placed her Louis Seize–style *rez-de-chaussée* in the hands of Gaban O'Keefe, the wild Irish decorator. His bold scheme of colors and mixture of styles had many jaws drop, and some permanently—much to São's amusement. She is truly what used to be known as a "lady," and deserves infinitely better than the illness she has suffered in recent years.

One day many years ago I spotted a Georgian tiara in the window of Phillips, the family jewelers in London's Bond Street. It was a wreath of oak twigs, with green leaves of pavé rose-cut emeralds set in gold, and acorns of baroque pearls, set with rose-cut diamonds in platinum. As was the habit of the penniless in London in those days, I went in to take a look. It was a wonder of ingenuity, its construction completely articulated— *tremblant*—so the leaves would flutter as the wearer moved. I say, when you can't have something, photograph it! So I related all this to Beatrix Miller, then editor of *Vogue*. We enlisted the young girl-about-town Nicky Weymouth, and I photographed her in John Richardson's flat in The Albany, all masculine Regency.

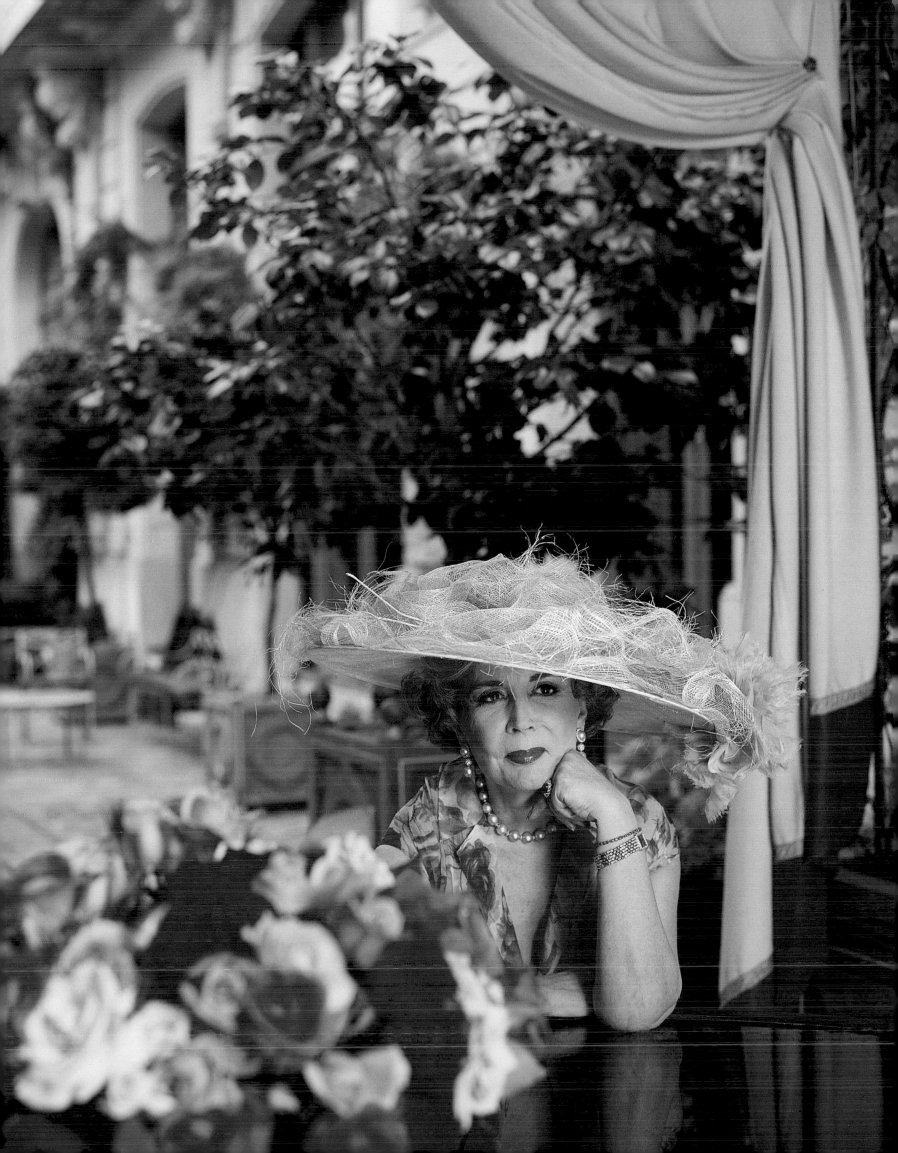

Carroll Petrie is philanthropy blueblood, and hasn't slowed down one bit since the loss of her husband, Milton. Their Fifth Avenue living room was a sea of pastel colors, designed around Carroll, a pretty pastel herself. I recognized that smile from photographing her daughter, Andrea de Portago, for British *Vogue* in the early seventies.

Five friends at the Metropolitan Museum of Art for the Alix Grès exhibition, in their personal Madame Grès couture. Mica Ertegün and Chessy Rayner designed tailored interiors in an otherwise chintzy world. The sculptress Betsy de Cuevas enviably found an enduring personal style. Isabel Eberstadt's daughter played fledgling fashion editor at eighteen to my photographer. And the luckiest guy in the room is he who gets to sit next to Nan Kempner.

Social prominence is measured by net worth, especially in the United States. But life with more is eerily similar to life with less: the emotions are the same. The secure possession of a big heart has helped Gayfryd Steinberg maintain stoic poise in the face of changing fortunes—and that is an admirable achievement.

Recognizing a woman's perfume has served me as an icebreaker more than once, and the more unusual the scent, the greater the effect. The editors of *W* stood back in incredulity when I announced "Après l'Ondée" to Susan Gutfreund, but it got us all a cup of some of the best coffee of our lives, impeccably served up in her Henri Samuel–designed apartment.

My first photographs of Oscar and Françoise de la Renta were for a *New York Times Magazine* cover story titled "Living Well Is the Best Revenge" which caused an uproar as it appeared in the face of a recession. Living well is of course a worthwhile ambition under any circumstance, and Françoise would be the first to agree. A former editor of Paris *Vogue*, she came to New York and put Oscar on the map. She could be quite formidable—feared by those she scorned, and loved by those she liked. Luckily for me, she knew the golden rule: be nice to the one who's about to take your picture. The one here, taken in her Vuillard-like study, has her pondering whom to put next to "Hank" Kissinger at that night's dinner party. She asked if I'd had lunch. Soon a tray arrived, with finger sandwiches and little carafes of red and white wine, each holding a glassful. The pleasure was in the measured simplicity as much as the refreshment. On a much sadder note, Françoise gave me the ultimate compliment when she requested my photograph for her *New York Times* obituary.

The person who thought Carolyne Roehm would make a fine cheerleader had the right idea. Her good humor is infectious, and that's a very healthy bug to have around. How many people do we know who have set out to study literature, music, languages, floristry, cooking, horseback riding, and interior decorating just so she can be better at being herself? She is tall and thin, full of energy, thoughtful to a fault, runs a mean house, offers a very fine table, indeed—and consequently just plain irritates some people.

The first time I saw Barbara de Kwiatkowski, she was Barbara Allen, arriving with Peter Beard at Andy Warhol's Factory in Union Square—a couple so good-looking they could have started a lucrative adoption business with their offspring. That was not to be. Barbara married Henryk de Kwiatkowski, who bought Calumet Farm, and she called on Sister Parrish to fix it up in that unpretentiously cheerful waspy way of hers. Babs sent me her photographs of natives from Africa way back then, and is still a pal today.

John and Patricia Kluge gave their enormous estate in the rolling Virginia hills to the local university when they divorced. But Patricia kept the vineyards and has turned them into a thriving business, where you can find a bottle of red for $495 in a David Linley wood-inlay box—the sort of thing that would make you a welcome guest at any dinner party.

Everyone has heard the tale of how Denise Hale escaped her native Yugoslavia by swimming the Adriatic with the family emeralds in her mouth. This feat of breathing technique under adverse conditions sounds very much like the plot of *Idiot's Delight*, where Norma Shearer finally was funny, but I'd be loath to speculate which inspired which. Both were mercifully rescued—Norma by a cruiser, Denise by a yacht—each encountering someone who at least at first glance vaguely resembled Mr. Right. Denise would only be photographed in profile and barefoot, and liked the resulting spread in *Vogue* well enough to have it reproduced on postage stamps, which she affixed to her letters for years.

Betsy Kaiser was, as Betsy Theodorakopoulos, a big time model, and sure can strike a pose. Now, she throws glamorous parties in Palm Beach, where she grows exotic orchids in all her trees and has covered everything in Balinese batiks.

C. Z. Guest was living proof that personal style stays with you forever. The last time I saw her, she was sitting on the steps of a Long Island porch, wearing a short cotton dress in the style of a man's shirt, her trademark cardigan over her shoulders, flat sandals, and a snappy short haircut. Her brilliant impersonation of Truman Capote was so spot on she could easily have taken it on the road.

Kathy Johnson Rayner did her East Hampton guest cottage in the Swedish country style, and after recording it for *Vogue*, I was asked to her midsummer night's party—a very Nordic celebration. Guests were greeted by flaxen-haired youths with wildflower wreaths around their heads. On the pond, rowboats had young birches strapped to their sides, and more wildflowers were frozen into blocks of ice surrounding the aquavit bottles—every detail straight from the watercolors of Carl Larsson. Kathy enjoys nothing more than giving elaborate, themed parties, and she certainly does her homework.

If I had thought of doing a book named "Jocks," I would have had to save Sandy Pittman for it. But it's been done, so we get the mountain-climbing archer here, at feeding time in the chicken coop instead. Sandy turned her farm's silo into a mountaineering exercise wall.

Ivana Trump was mapping her course, with *Vanity Fair* hot on her heels, to make sure nobody forgot her just because she was no longer Mrs. Donald. I arrived at Badrutt's Palace Hotel, in St. Moritz, some hours before Marina Schiano, and was viewed with such suspicion by the concierge that he did his utmost to try to shake my reservation from the ledger. I looked around me, and saw why: without a fur coat, branded luggage, and a mahogany tan, I simply did not fit in. Marina finally arrived, screaming so hard that Mr. Badrutt himself appeared, offering me a Tiffany bookmark (!). I was put in a tiny room in the former servants' quarters with a narrow single bed, yet the bedclothes were of typical Swiss downy plumpness. In revenge for my reception, I put my shoes outside the door every night, and every morning they looked brand-new. Marina brought extraordinary things for Ivana to wear, but had some trouble pulling up the zipper when it hit Ivana's opulent chest. At this, Ivana winked at me and said, "Nobody's complaining!" Once squeezed into place, she looked in the mirror, and said, "Can you believe it? I was thirty-seven on Thursday!"

Half Swedish by marriage, sometime decorator Merrill Stenbeck has such an eye, she does Swedish better than the Swedes. I found her on her sailboat, much as you'd have found Garbo in the South of France in the 1930s, timelessly casual.

Most people never tell you what they think of the picture you took of them. As we've seen, a few go out of their way to say they love it. Only Isabel Goldsmith, who was building an exclusive millionaires' resort on the Pacific coast of Mexico, went to the effort of sending a vitriolic letter, accusing me of refusing to photograph her in "the rays of the golden hour," meaning the late afternoon, when the light turns orange. The letter is now framed in my office.

As we walked into El Morocco on East Fifty-fourth Street, Dewi Sukarno asked me, "Why you want to photograph in night-club? I never go to night-club!" When she was made-up, coiffed, and dressed, I asked her to take a seat on one of the banquettes, and she said, "This one used to be Frank Sinatra table." That was very cute, I thought. Then we went over to Rumpelmayer's for more cheesecake, this time Mme. Sukarno's choice.

Marylou Whitney's idea of spending a few days with our crew was to make it a house party. We arrived in Saratoga Springs, were given lunch on the porch, took the "Eternal Bride" picture in her gazebo, and boarded her tiny tinny toy of an airplane, bound for her Adirondack camp. Marylou had warned us, "We dress for dinner." While I was putting on the red plaid jacket I thought might fit the surroundings, I heard people singing downstairs. As I approached the bar, I saw the butler in full livery, singing at the top of his lungs while marking the beat with the cocktail shaker. I was handed a sheet of lyrics and ordered to pipe in, as I beheld my assistant and stylist, both dapper and bewildered, and Marylou beaming in all her jewelry. An unexpected shot of the fun old days! The next morning, a knock on my door was followed by Marylou's hand, its index finger crooked through the loop of a terry-cloth bathrobe, and the remark, "Here! I so enjoy a man in a robe at breakfast." Not normally so obliging on a first date, but not wanting to rock the boat by insulting its captain, I ate my blueberry pancakes thus attired. The morning's plan was to photograph Marylou in the adorable little electric sloop that had been a gift from her lake-sharing neighbor, Marjorie Merriweather Post. When we started to speculate what she would wear, Marylou offered, "Let me surprise you!" Ten minutes later, she appeared in a Bavarian jacket, dirndl skirt, straw hat jauntily cocked, and a basket of artificial violets! *Vanity Fair* has since tried to avail itself of Marylou's styling talents, but scheduling conflicts have prevented this from materializing.

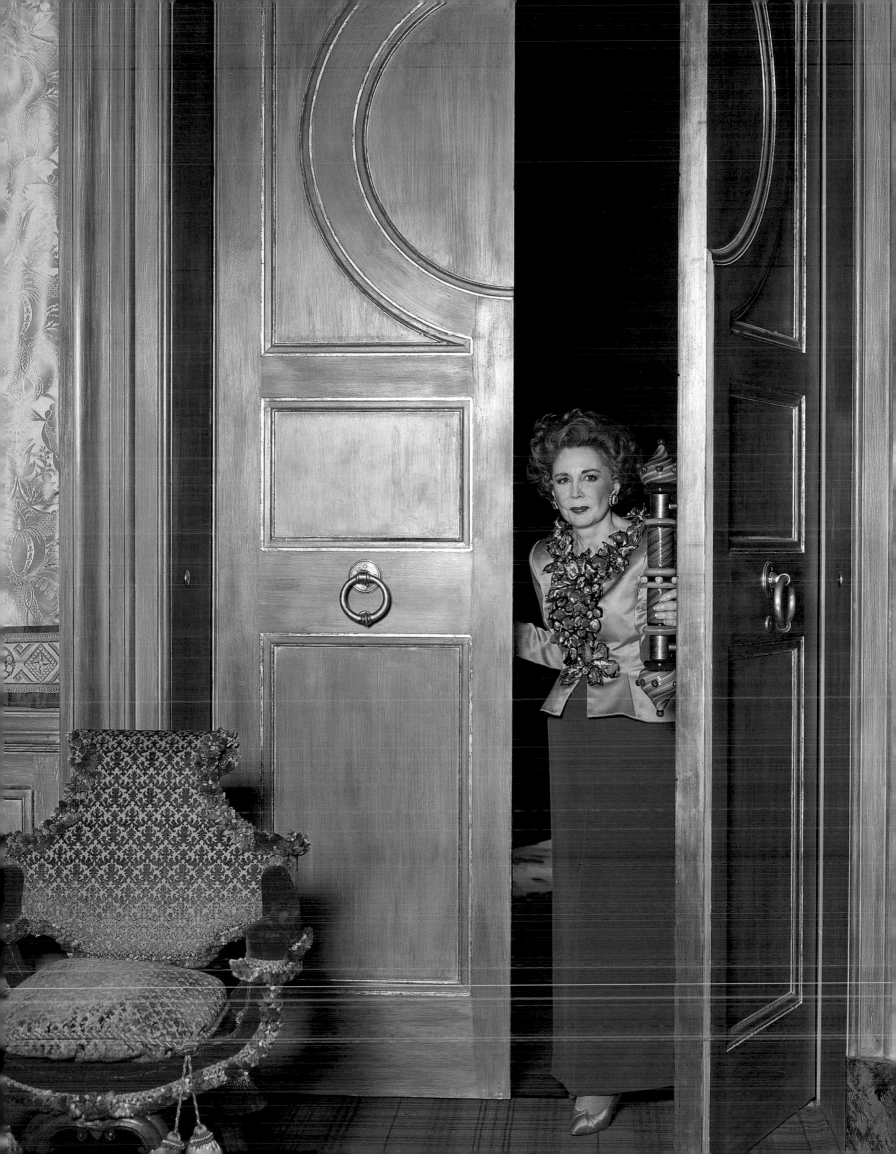

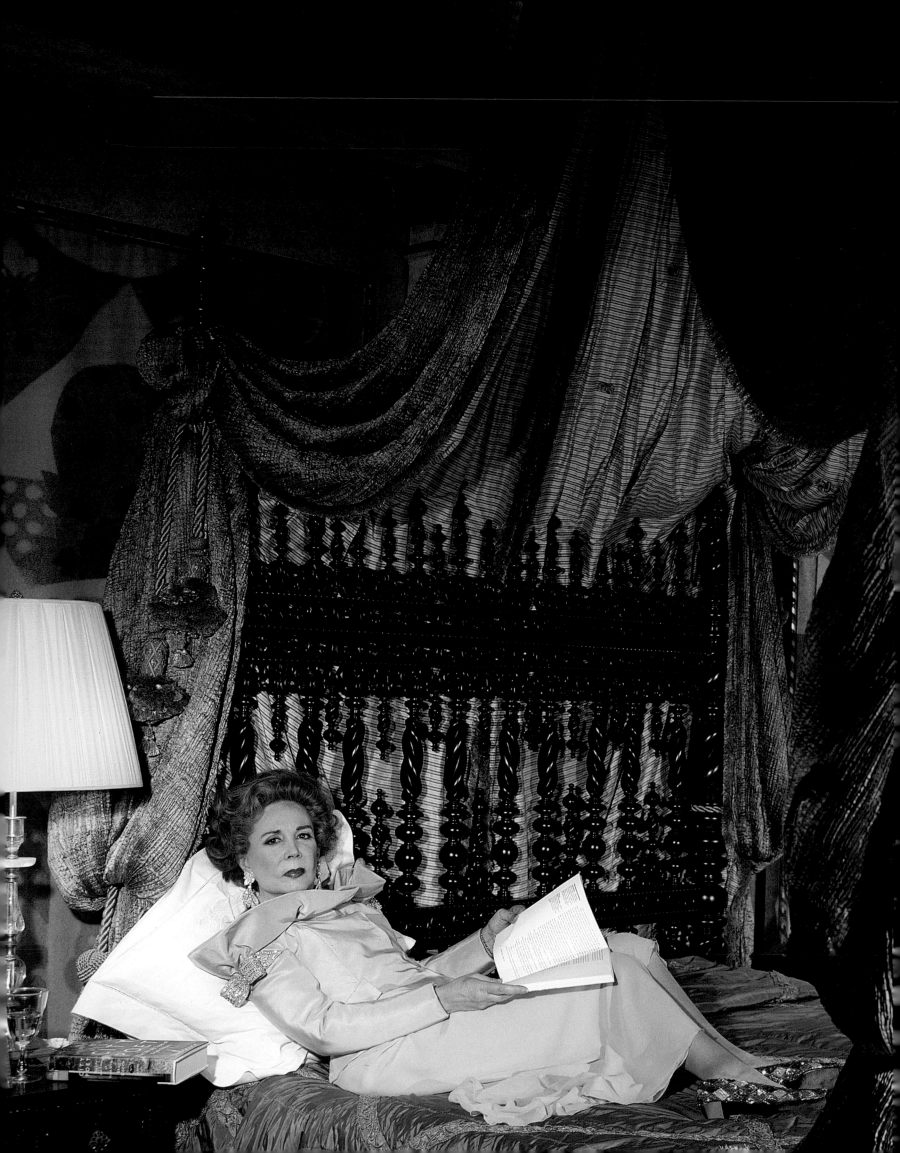

São Schlumberger

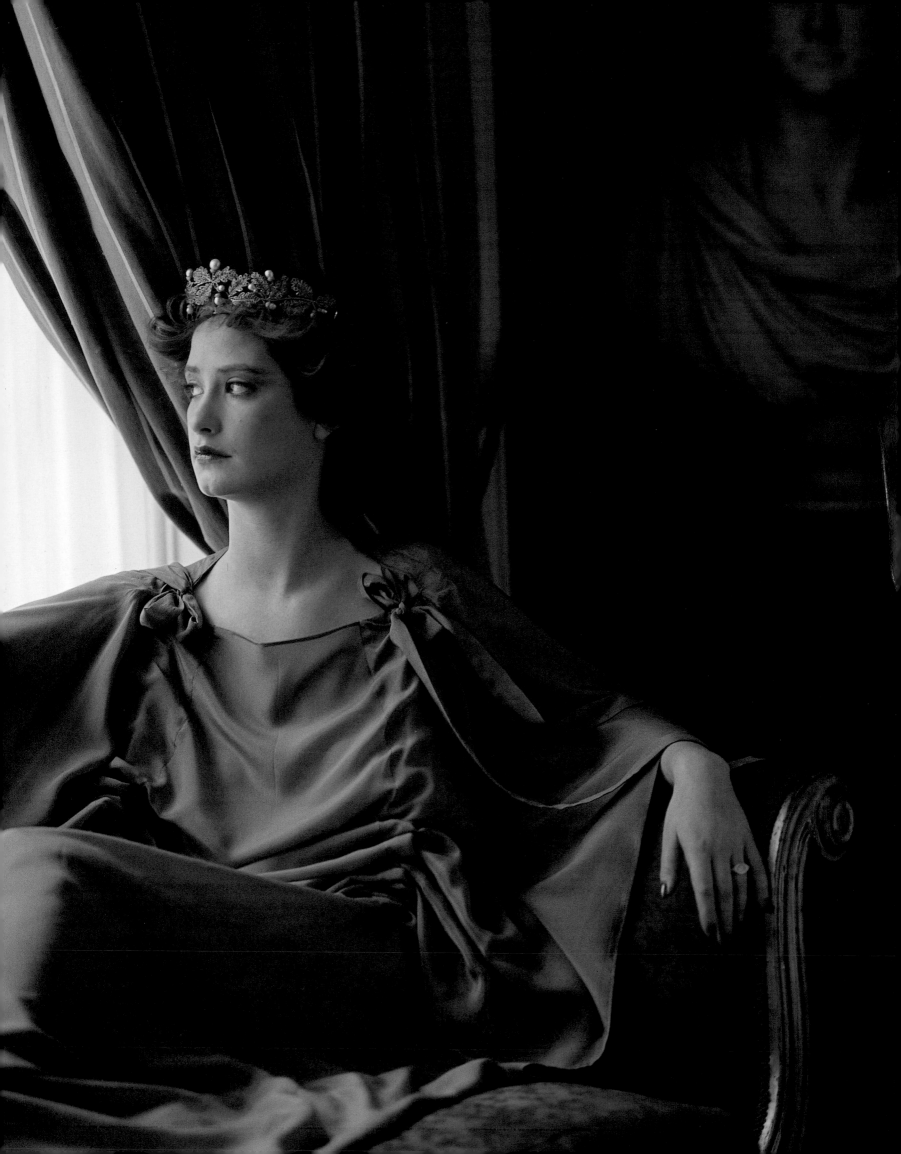

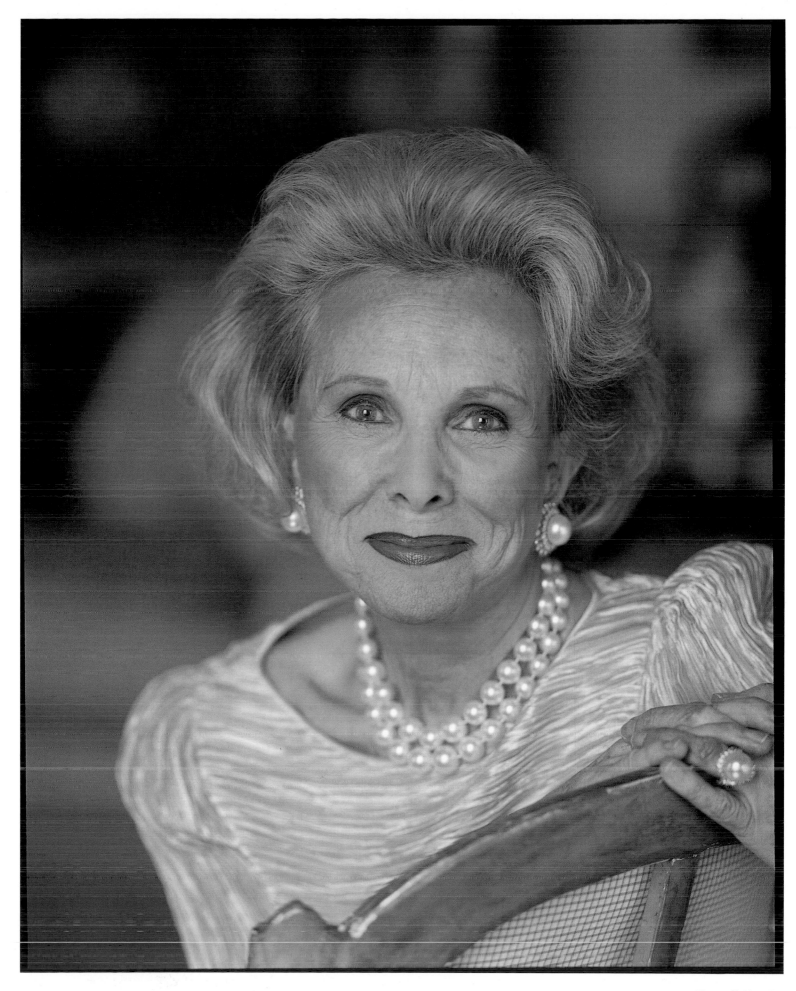

Carroll Petrie

Nicky Weymouth

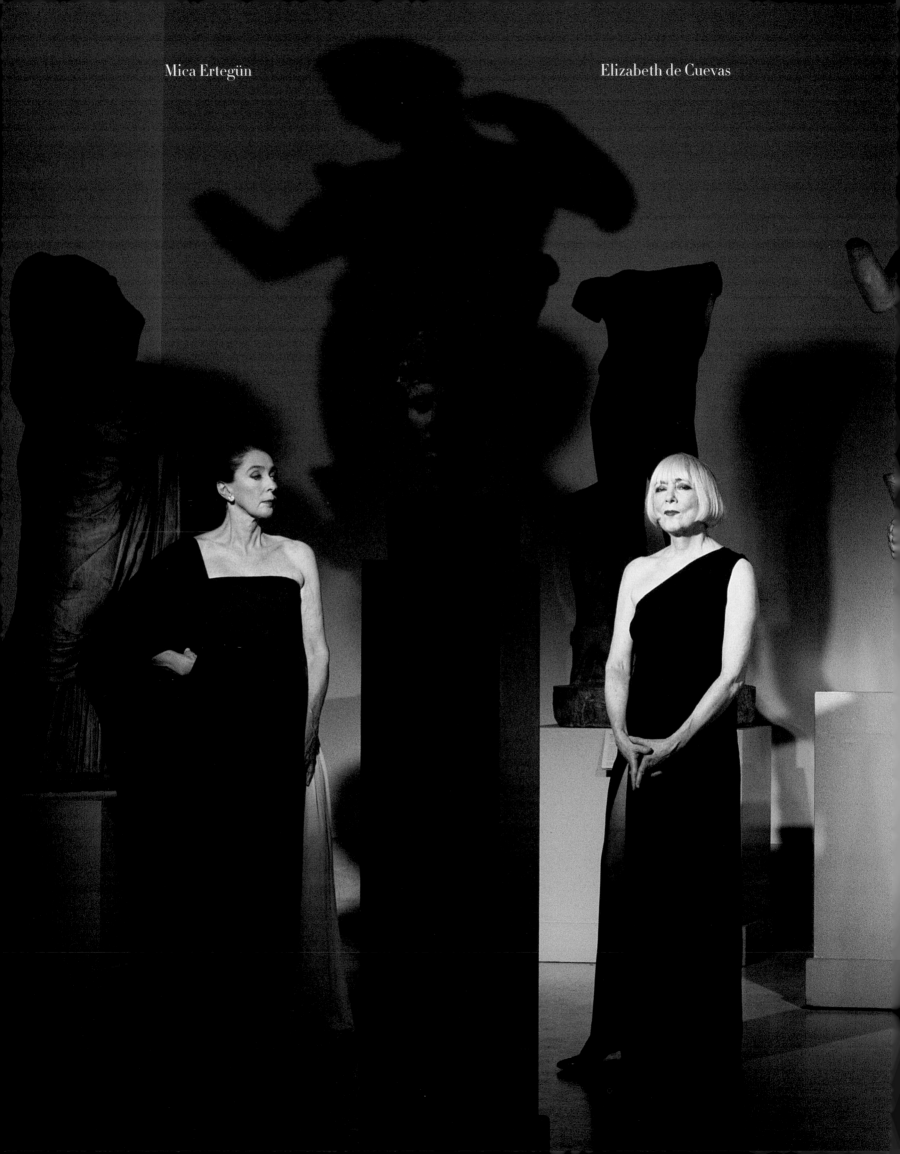

Mica Ertegün

Elizabeth de Cuevas

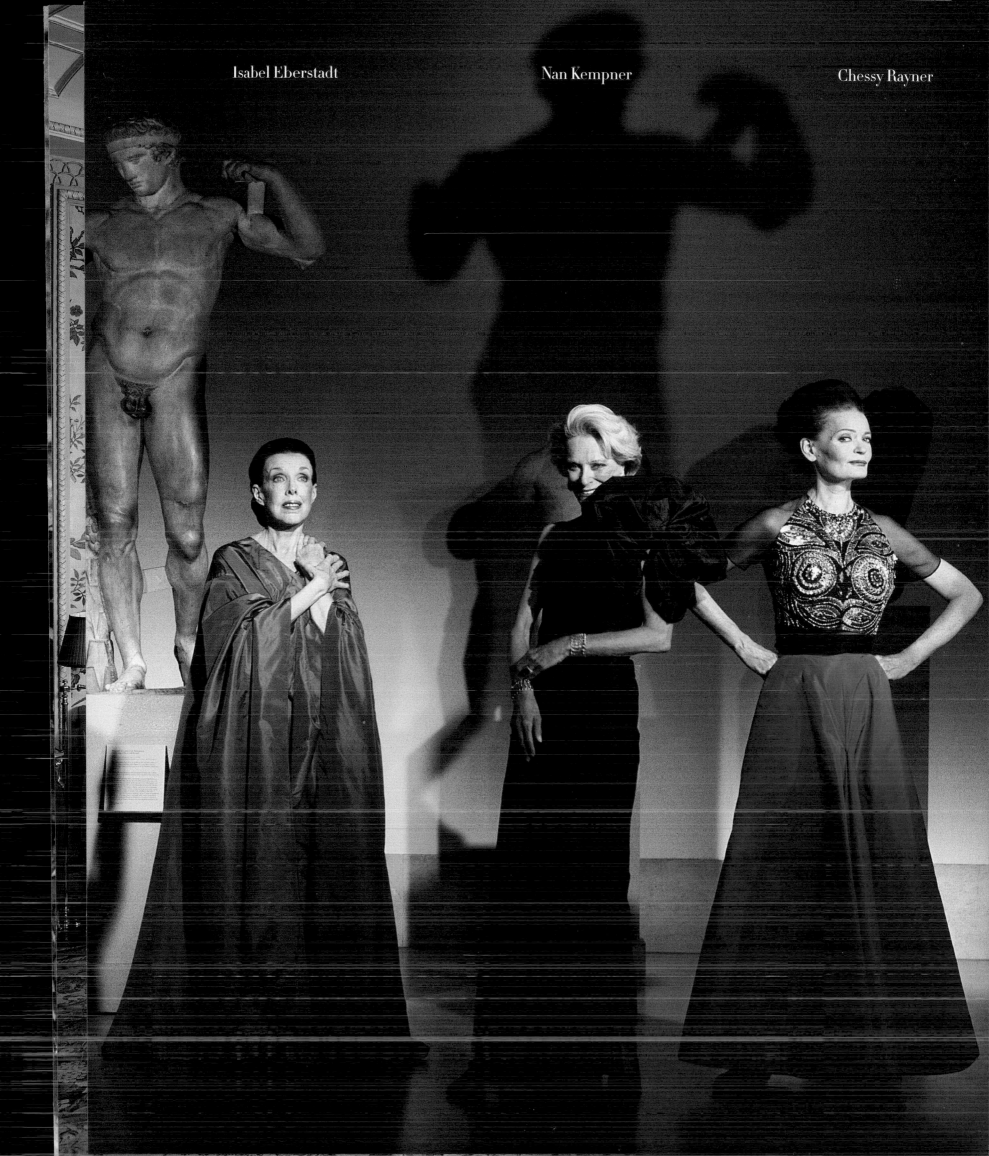

Isabel Eberstadt Nan Kempner Chessy Rayner

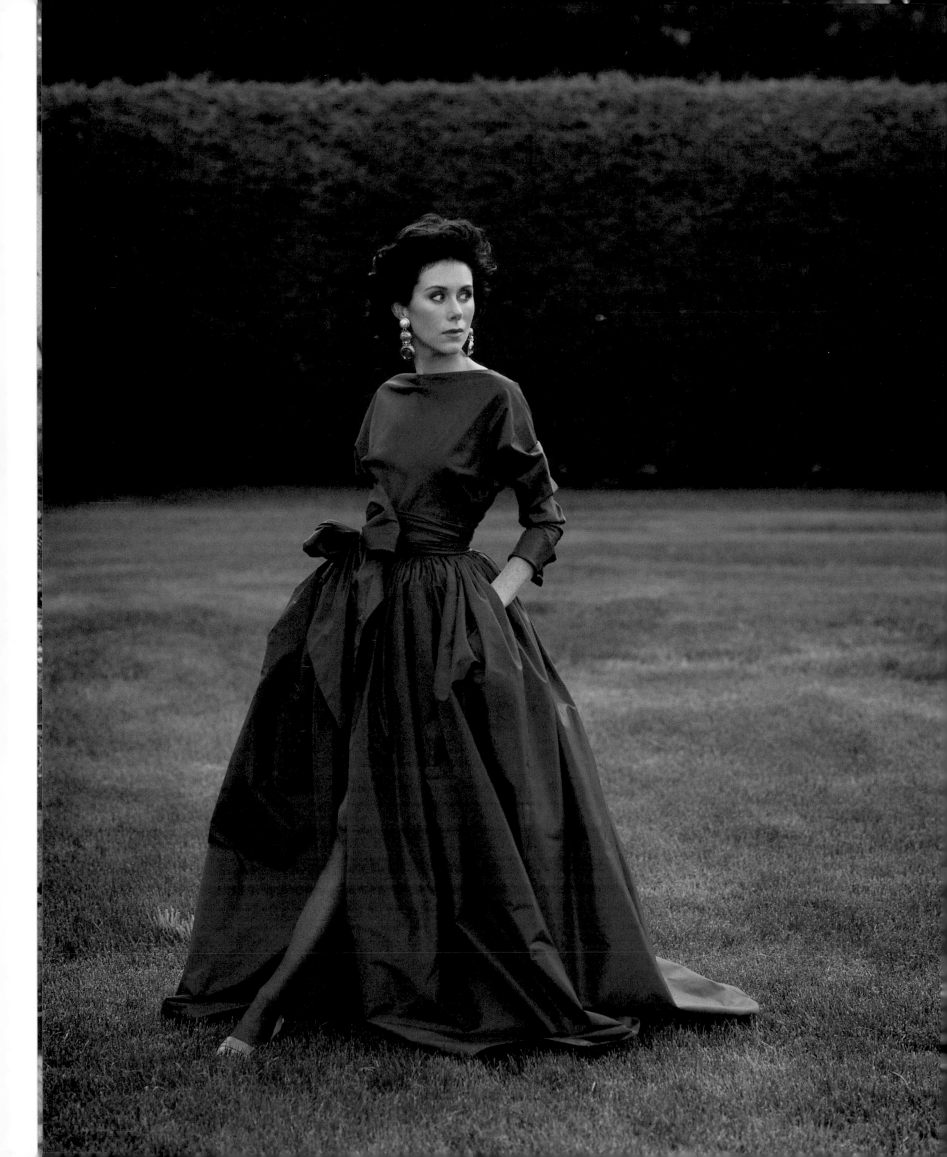

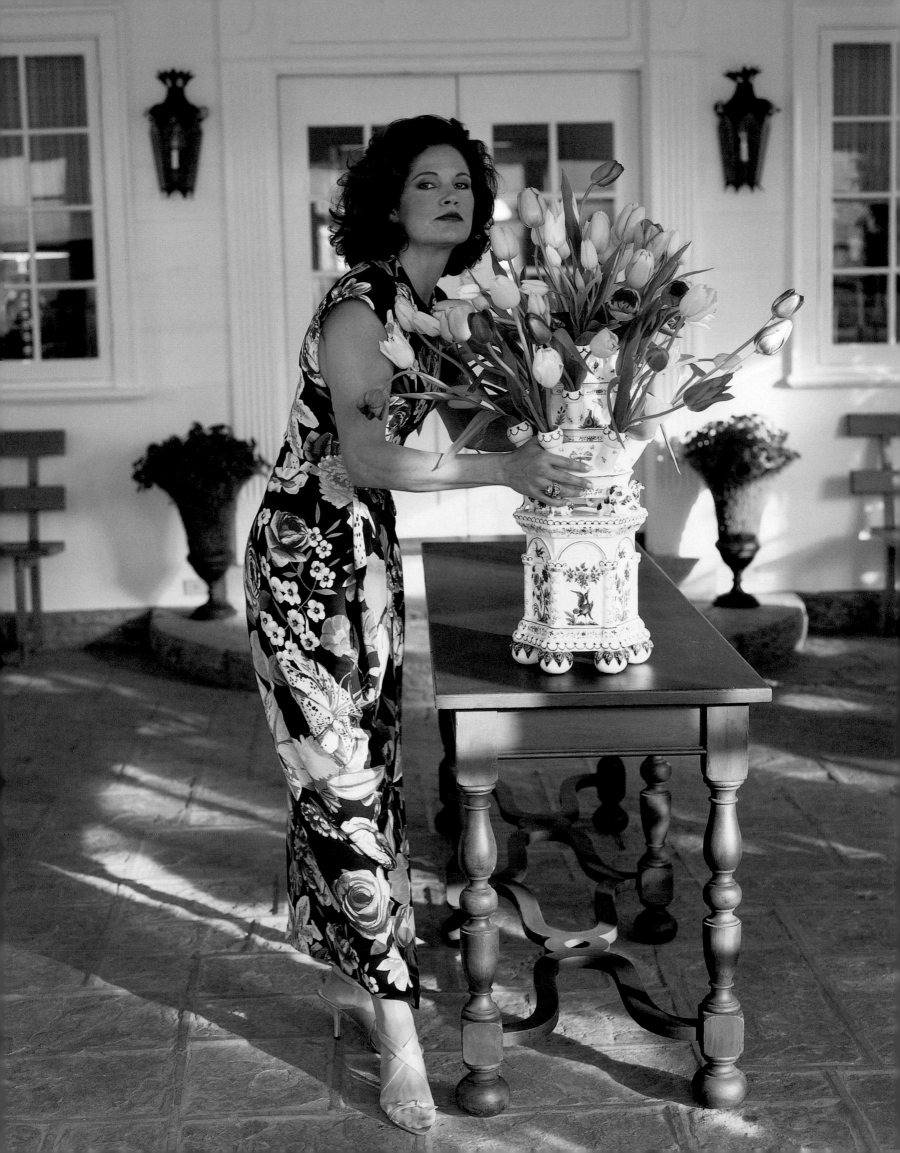

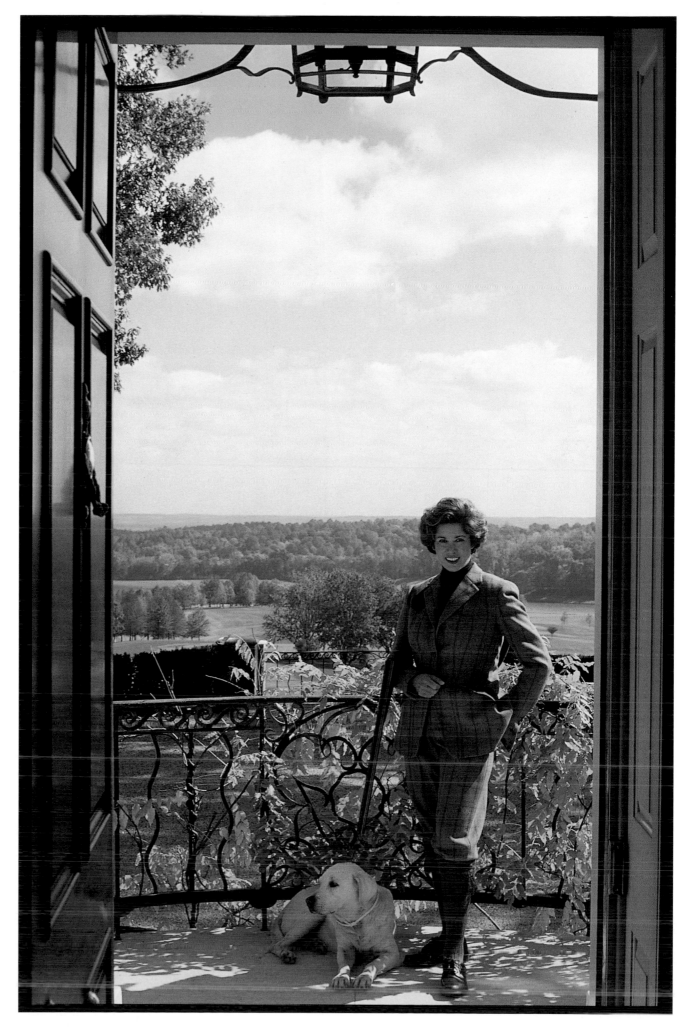

Patricia Kluge

Barbara de Kwiatkowski

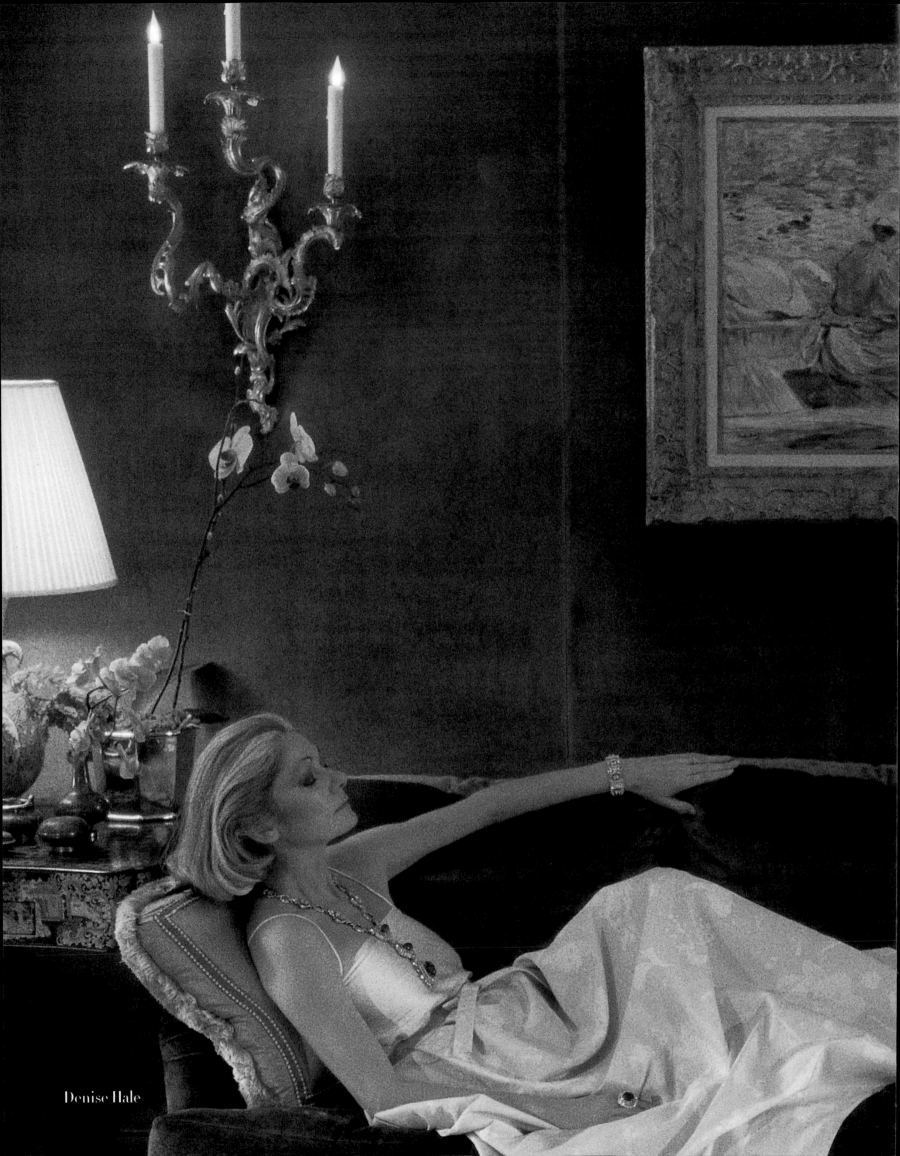

Denise Hale

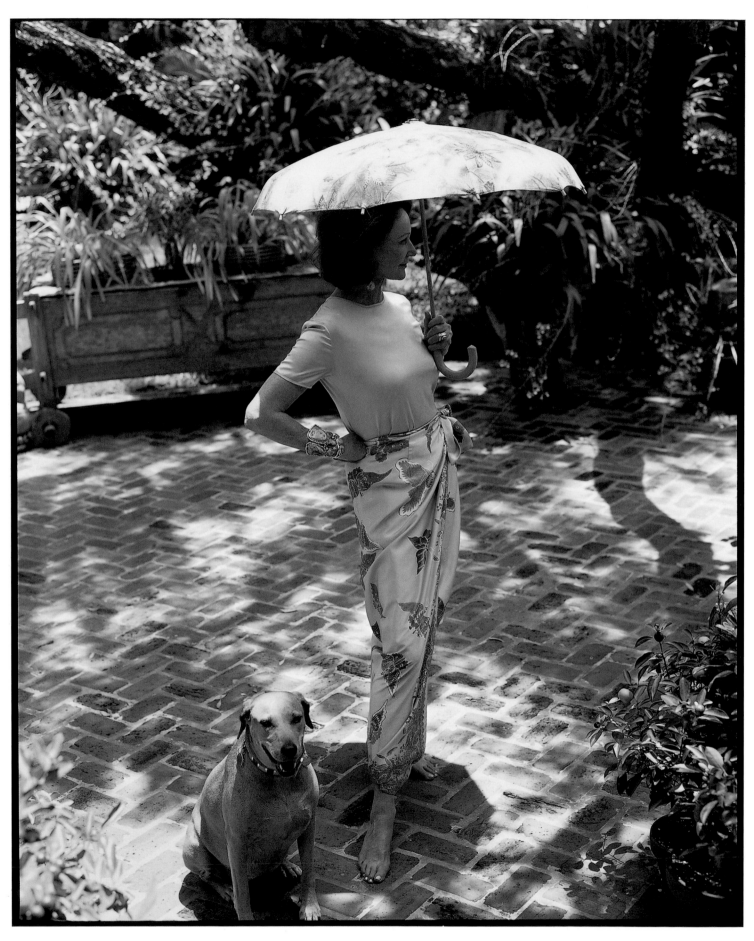

Betsy Kaiser

C. Z. Guest

Sandy Pittman

Kathy Johnson Rayner

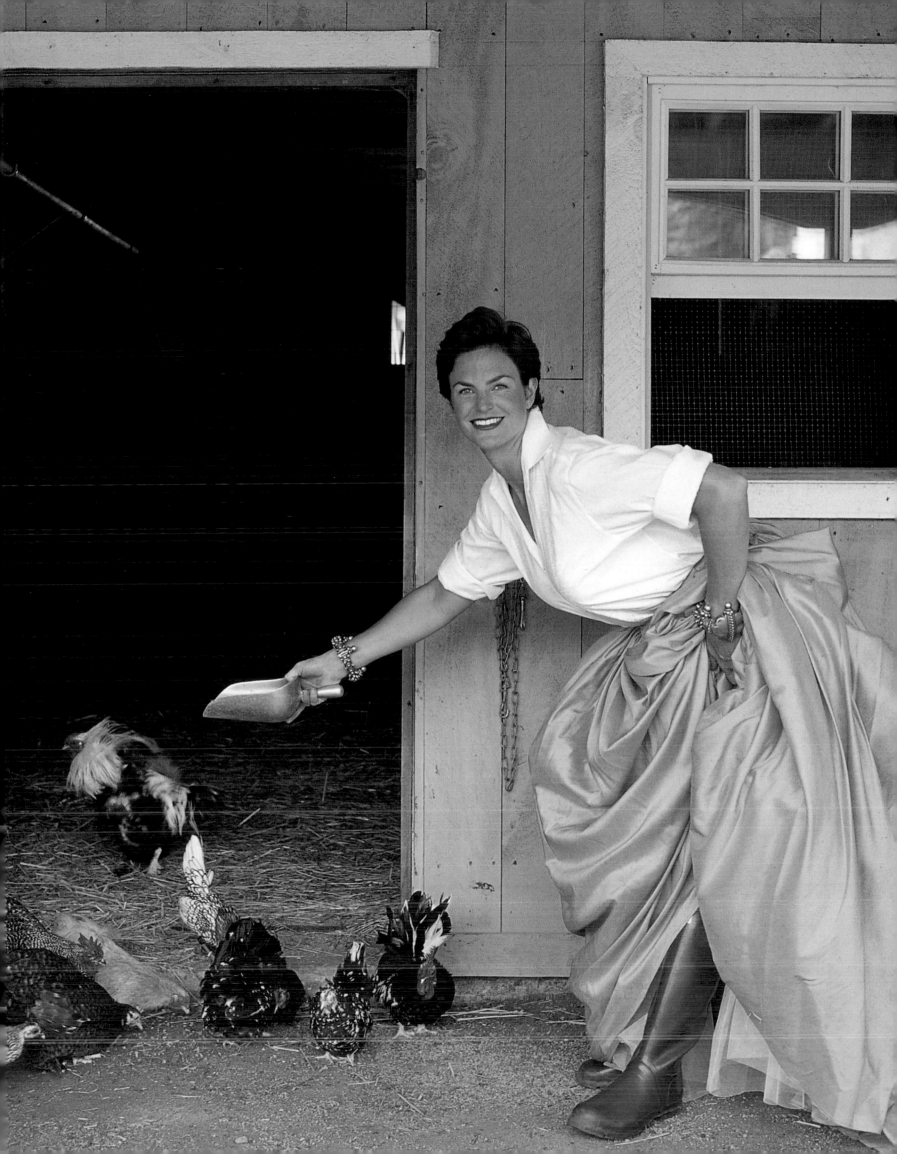

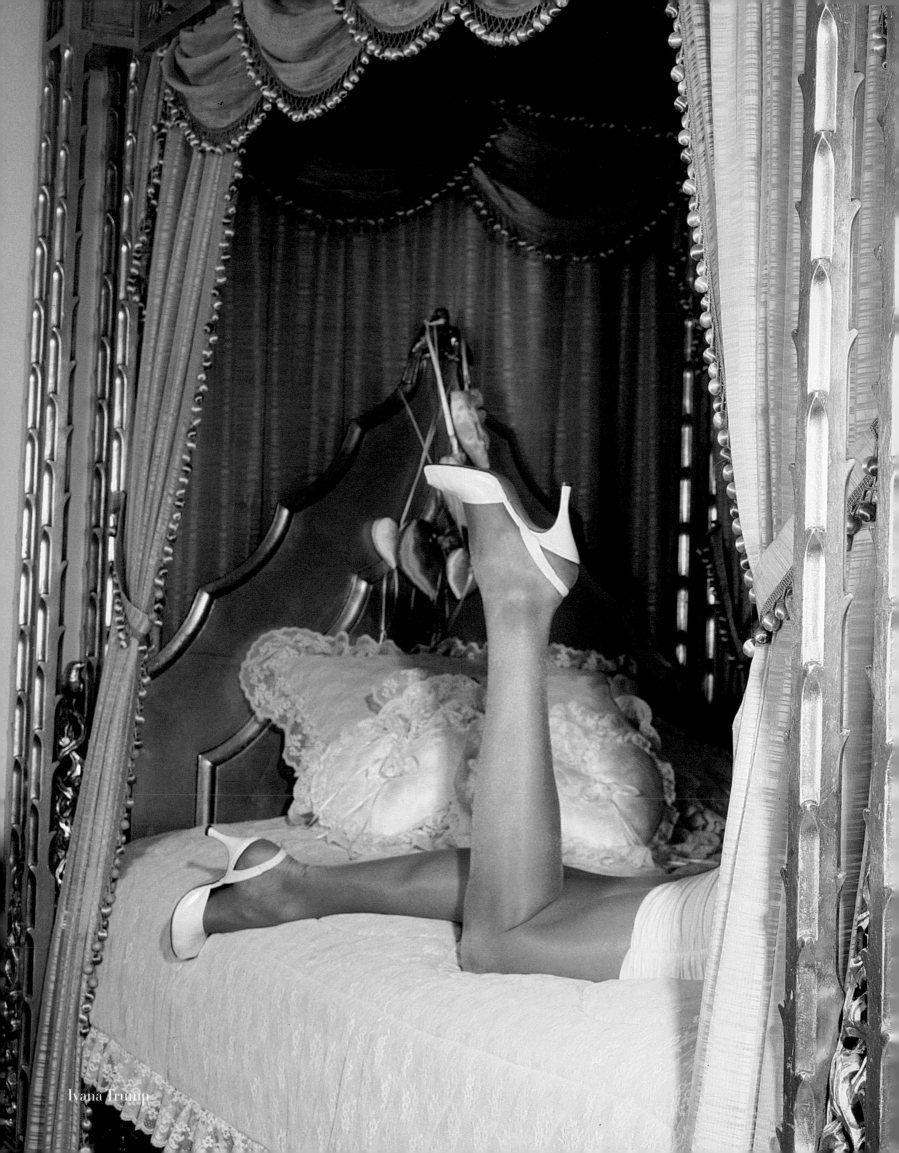

Ivana Trump

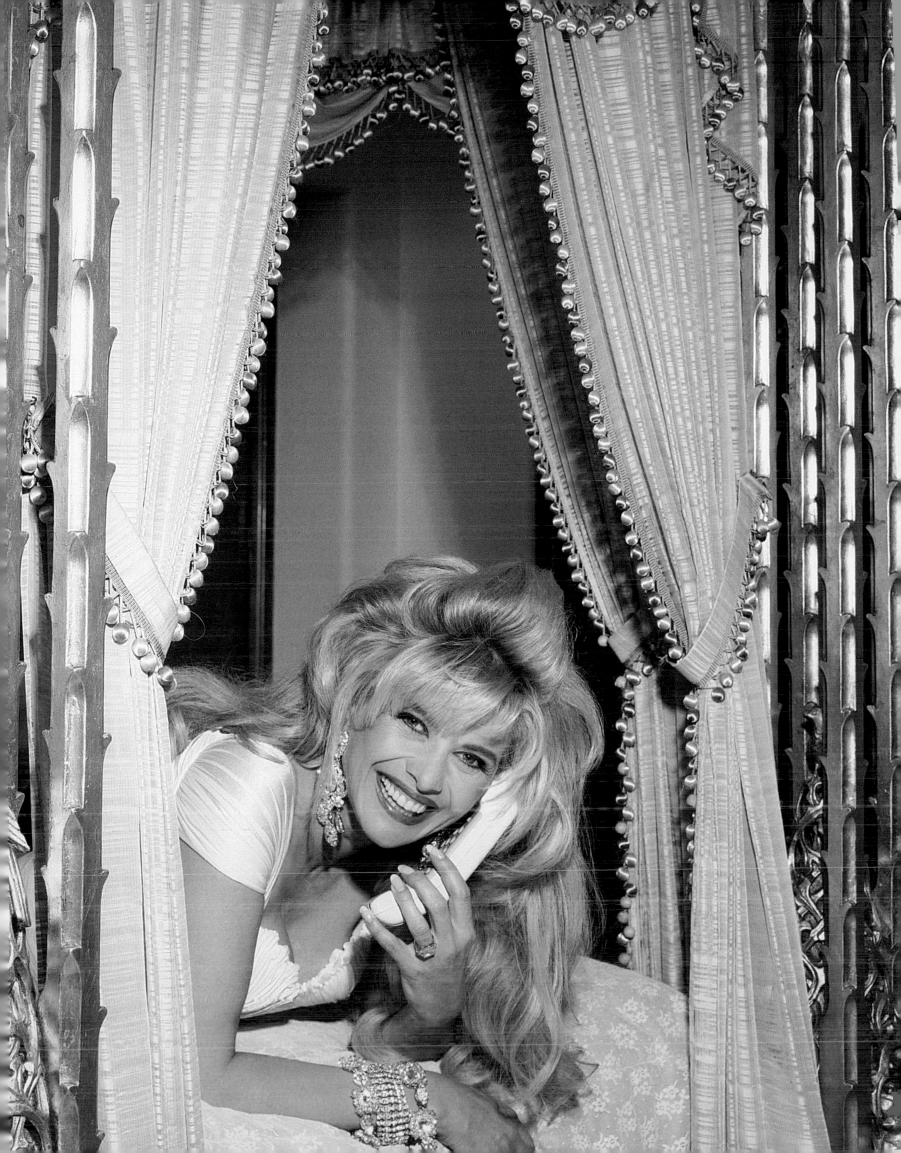

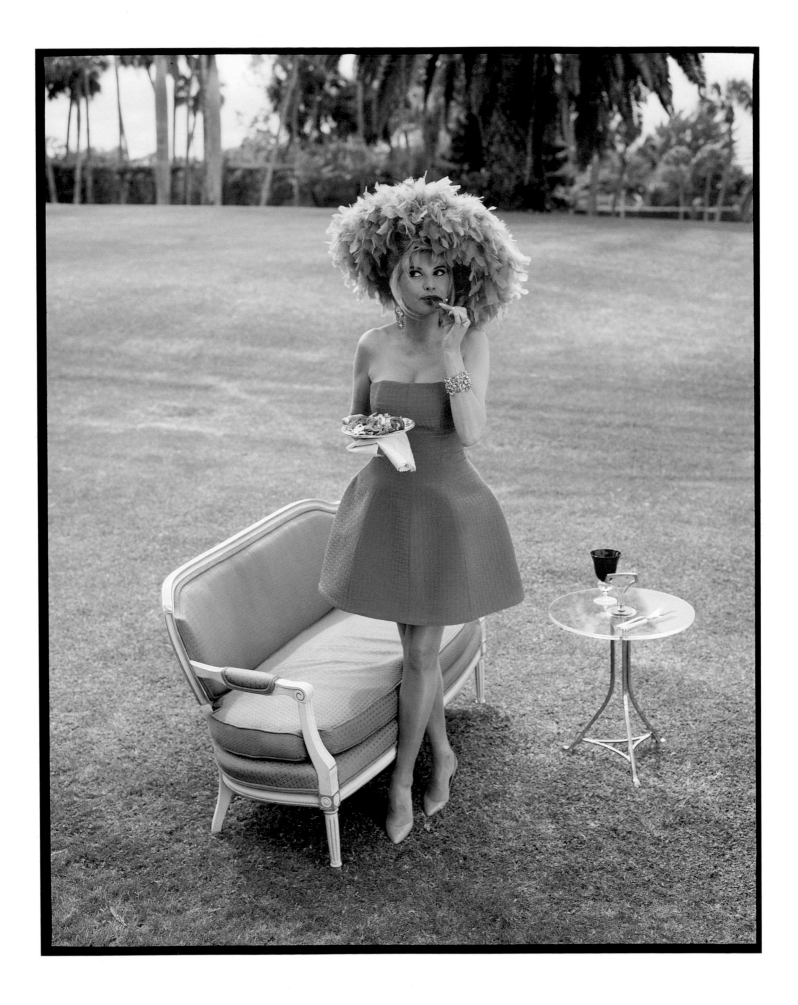

Ivana Trump

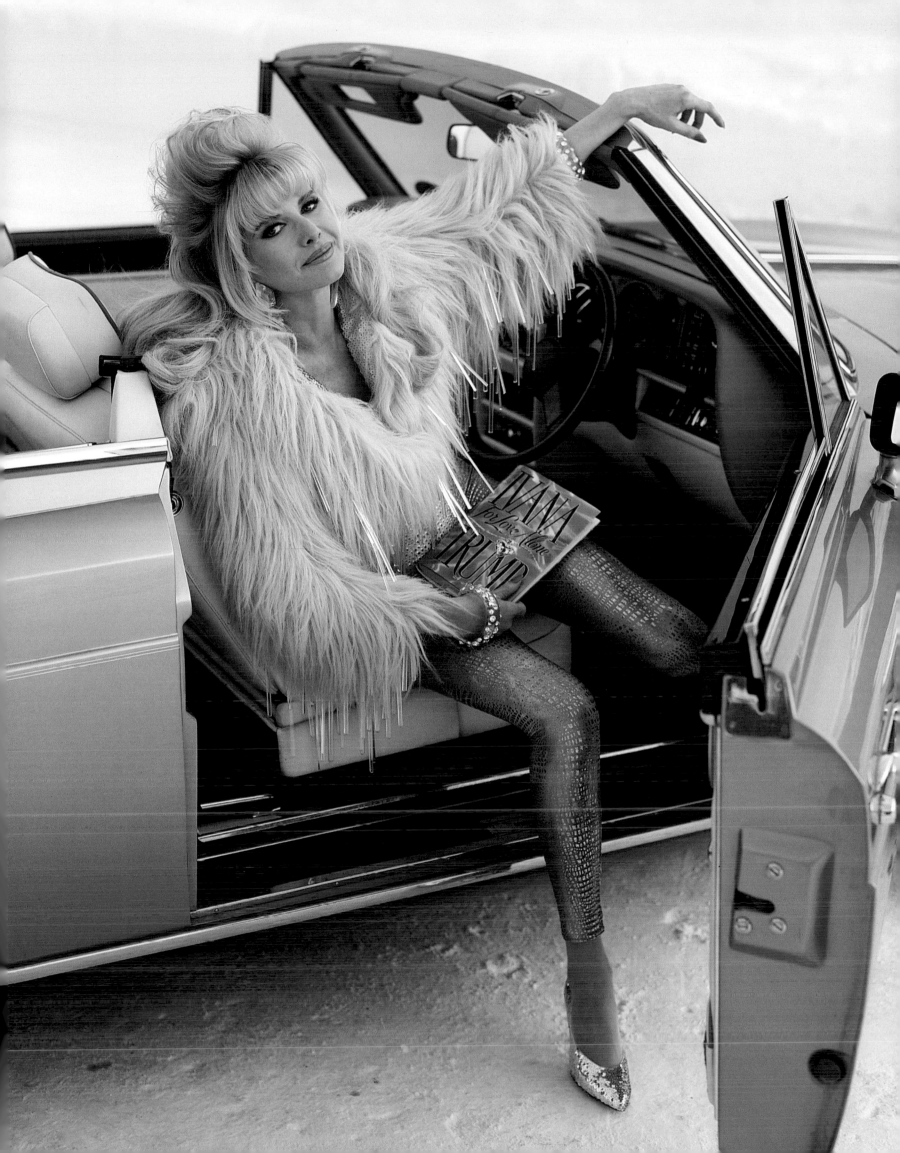

Merrill Stenbeck

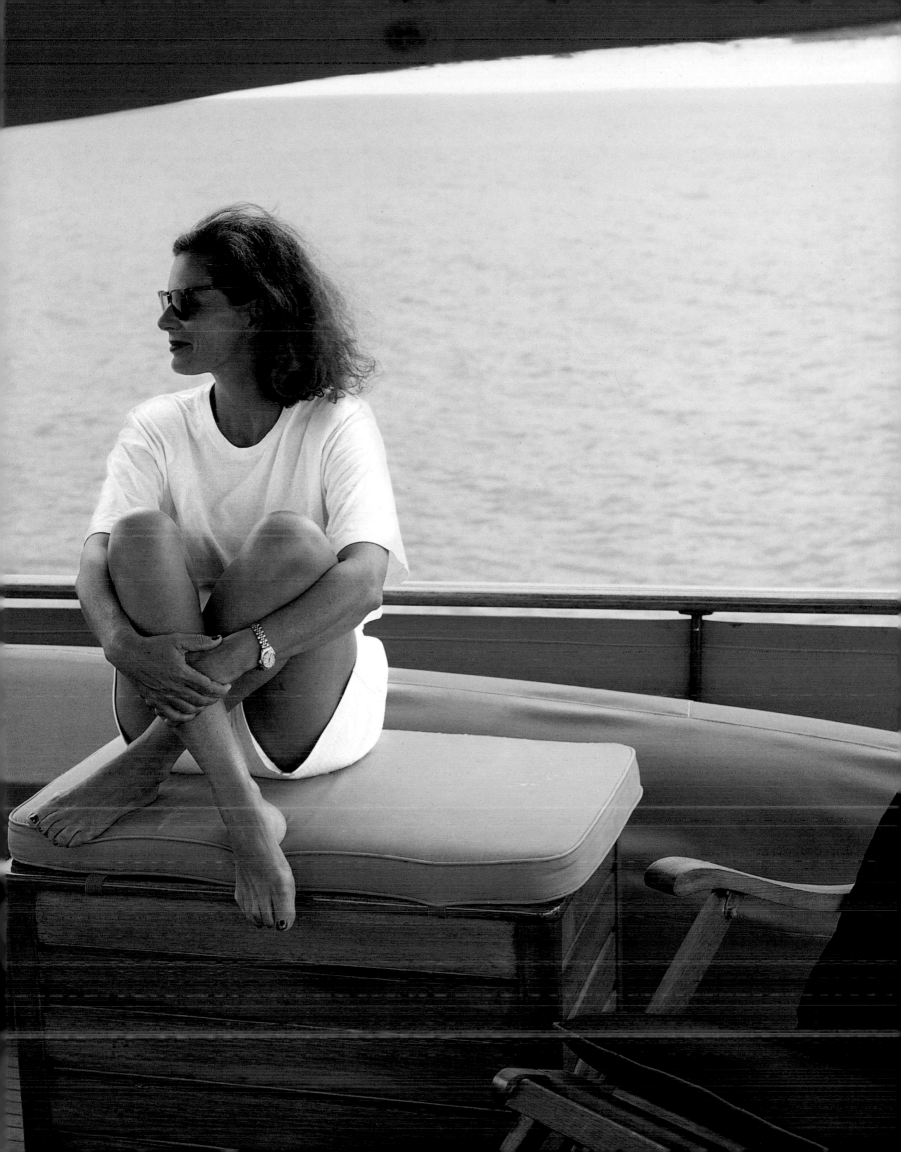

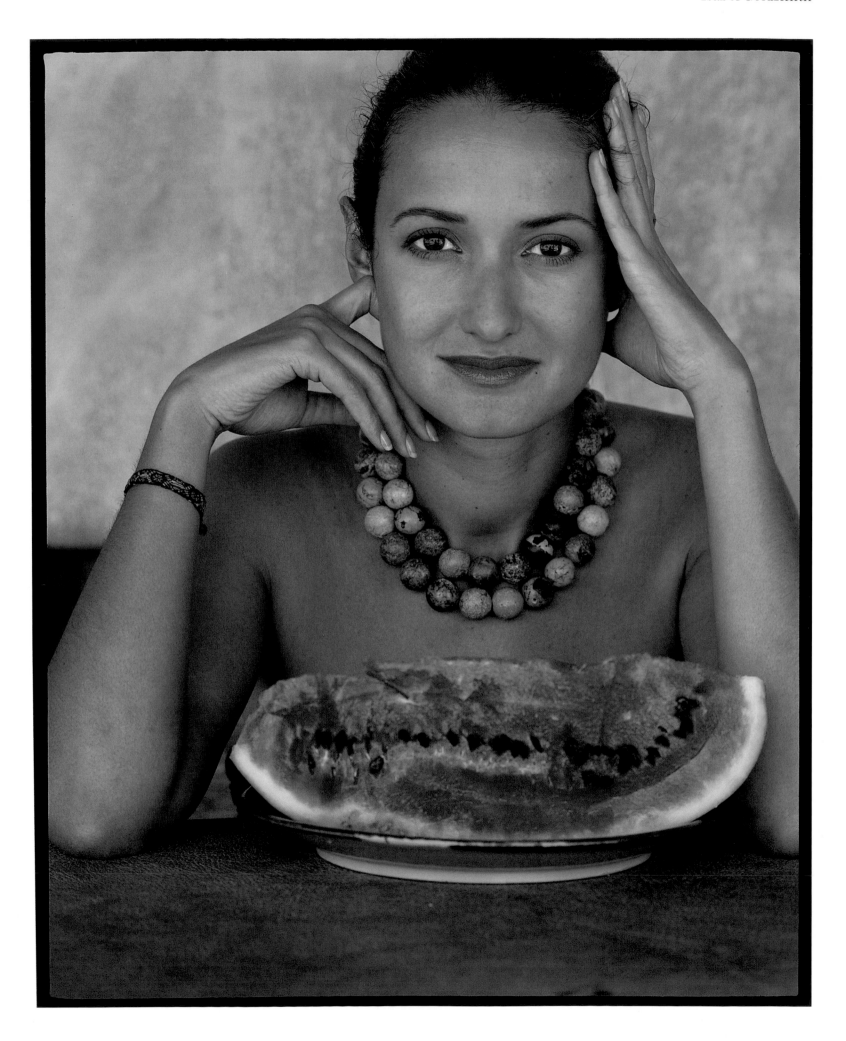

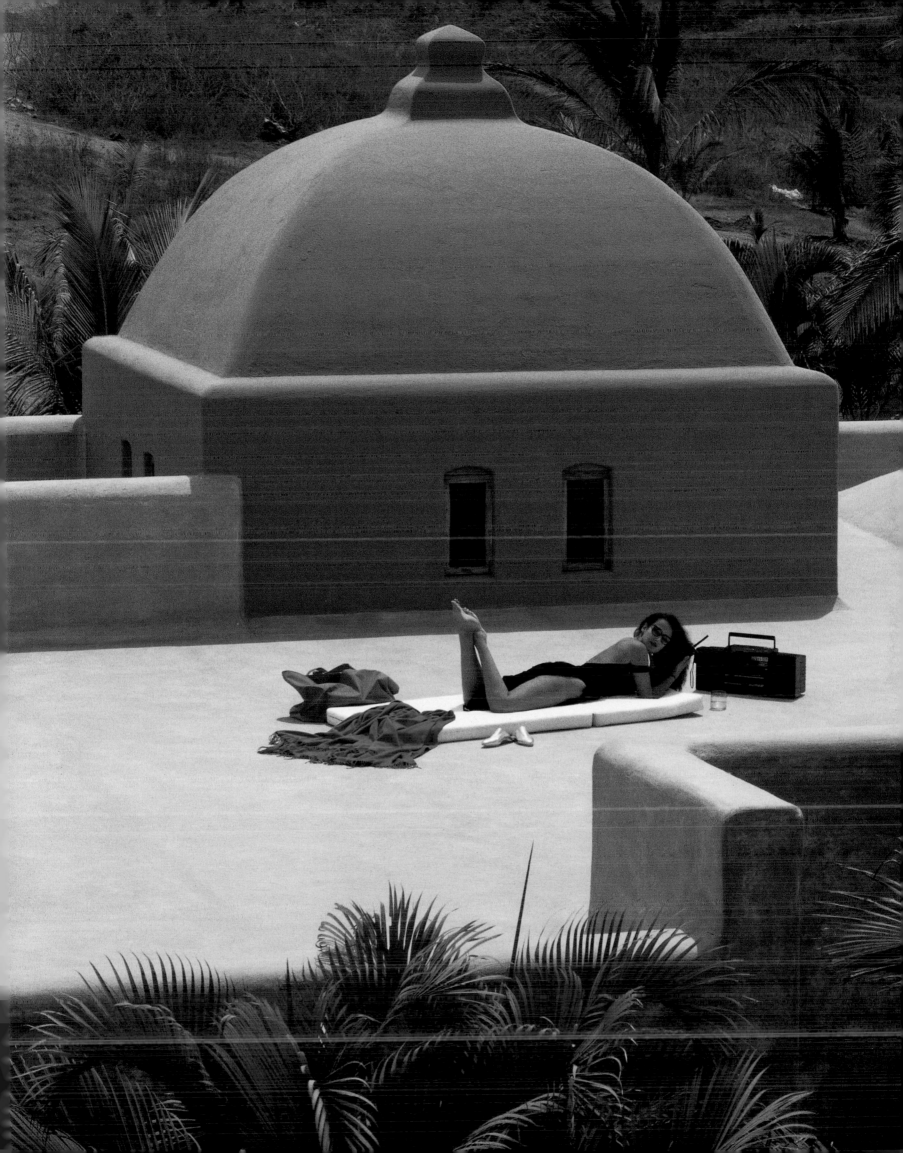

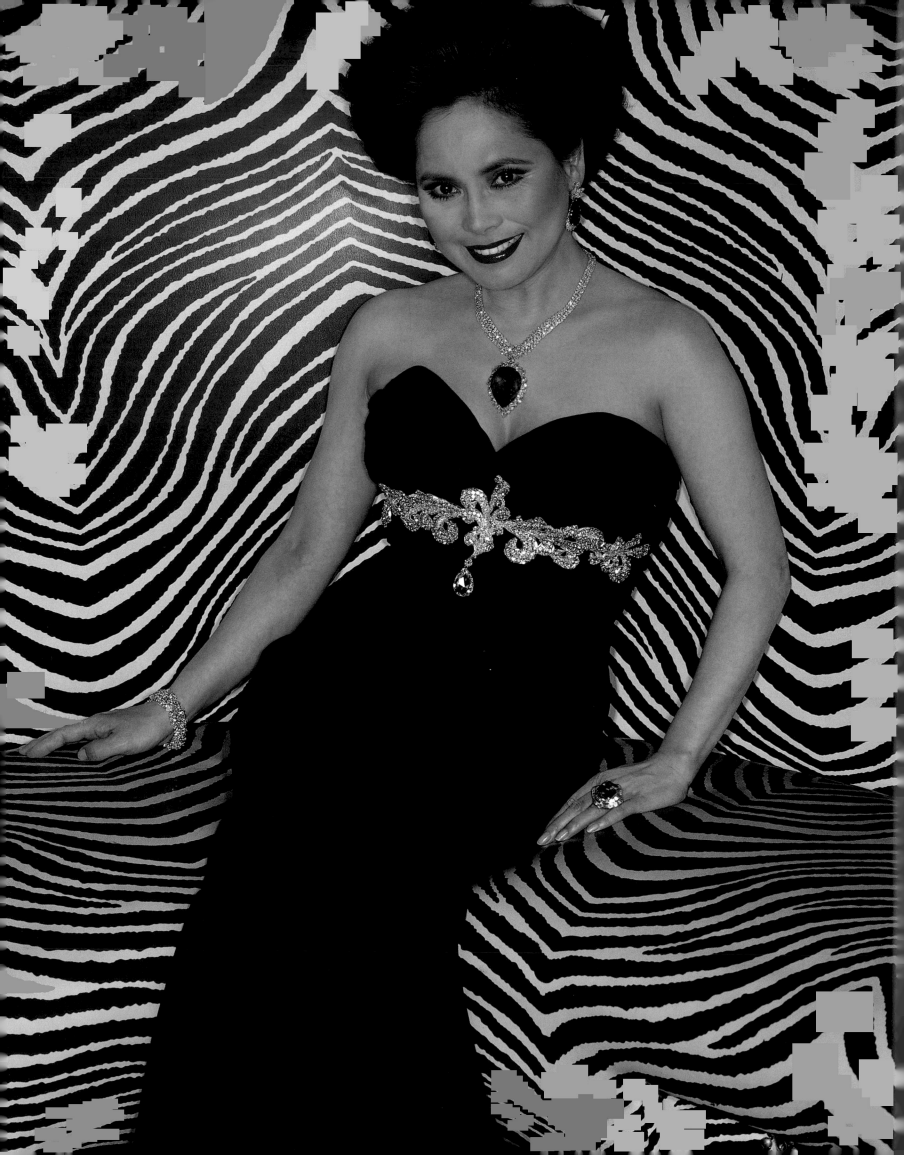

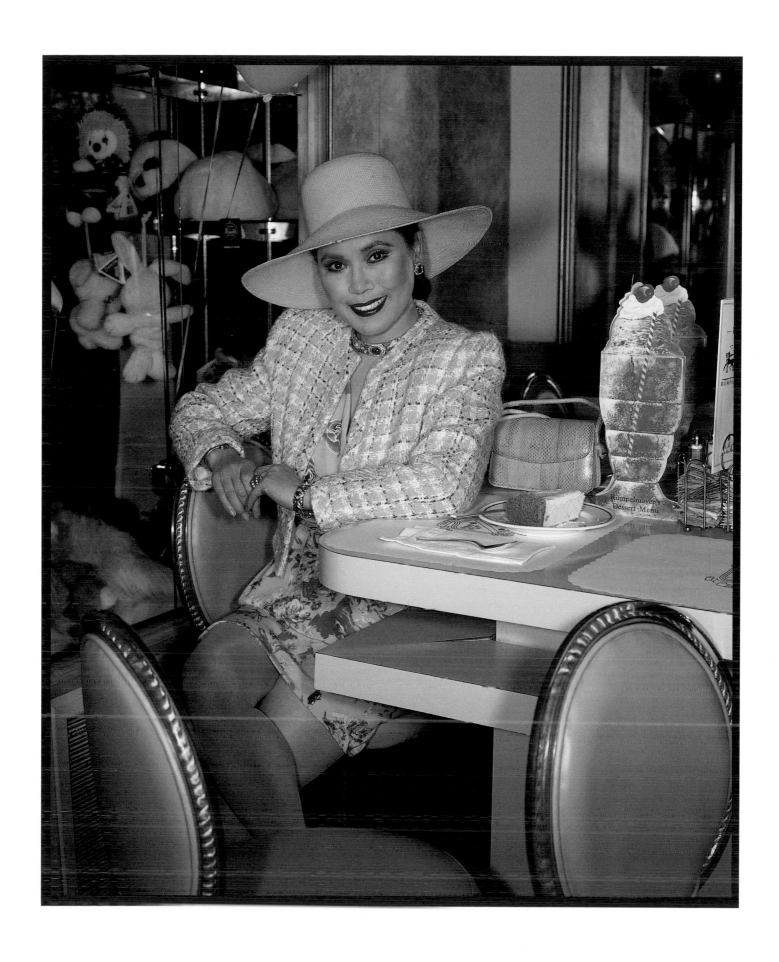

Dewi Sukarno

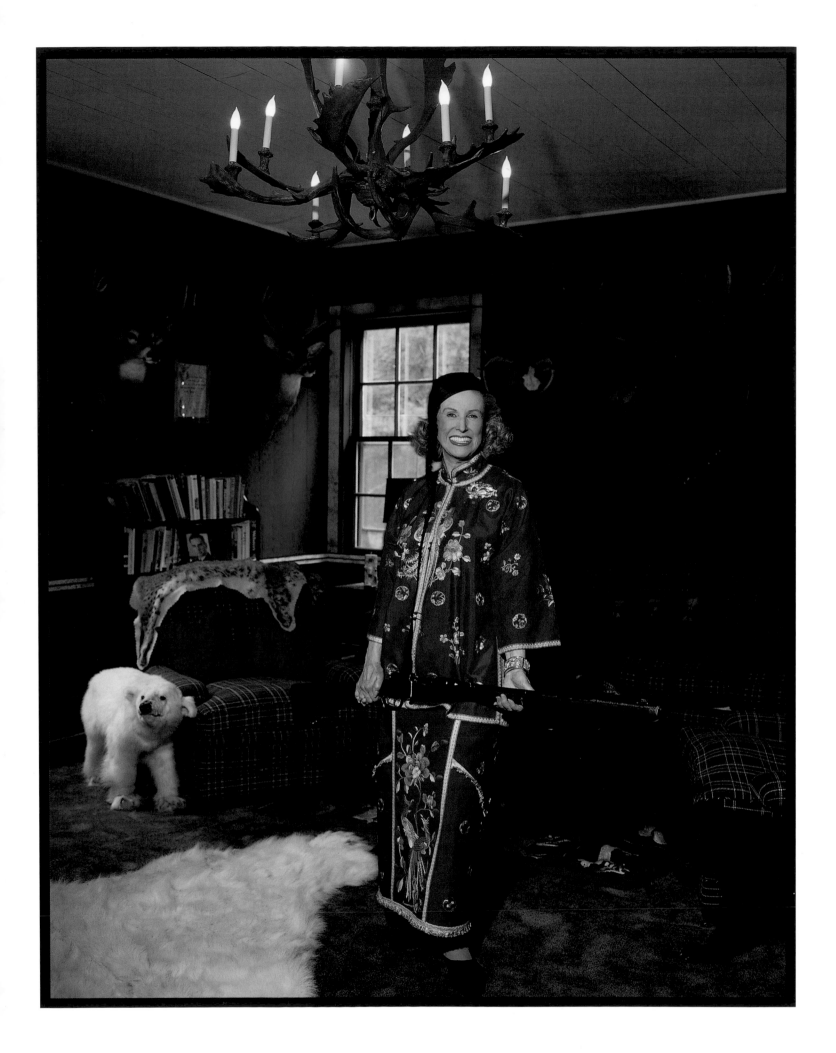

Marylou Whitney

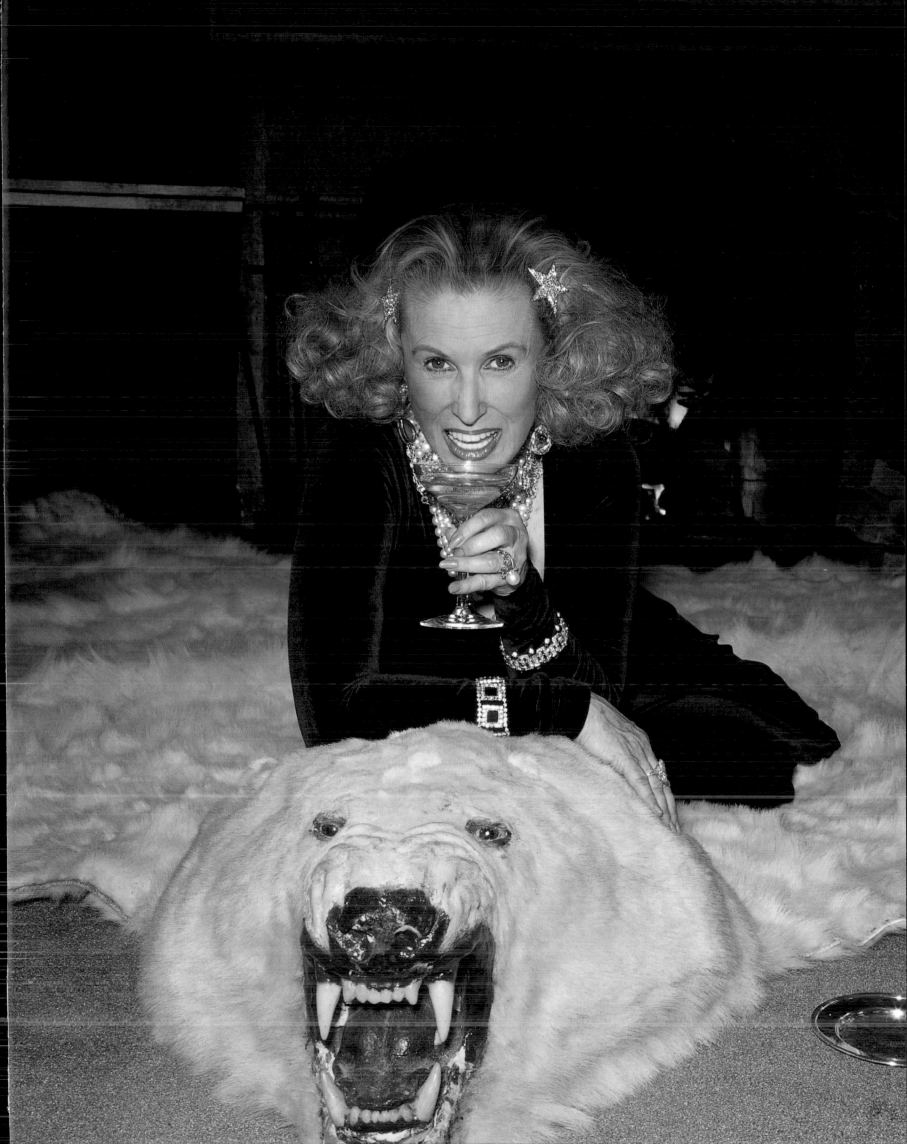

Credits

Cover, Ivana Trump, Palm Beach, 1992, *Vanity Fair*.

p. 2, Isabella Rossellini, New York, 1988, German *Vogue*, variant published.

pp. 4–5, Ivana Trump, St. Moritz, 1992, *Vanity Fair*, unpublished.

p. 7, Marylou Whitney, Saratoga Springs, 1995, *Vanity Fair*, unpublished.

p. 8, Dewi Sukarno, New York, 1992, *Vanity Fair*, unpublished.

p. 12, Ivana Trump, St. Moritz, 1992, *Vanity Fair*, unpublished.

p. 14, Sandy Pittman, Connecticut, 1995, *Vogue*, unpublished.

p. 17, Annette Bening, New York, 1990, *Vanity Fair*.

pp. 20–21, Joan Rivers, New York, 1990, *Vanity Fair*.

p. 22, Joan Rivers, New York, 1990, *Vanity Fair*, variant published.

p. 23, Debbie Reynolds, Las Vegas, 1994, *Vanity Fair*, variant published.

pp. 24, 25, Jean Howard, Beverly Hills, 1990, *Vanity Fair*.

pp. 26–27, Susan Forristal et al., New York, 1993, *Vanity Fair*.

pp. 28, 29, Cybill Shepherd, Bel Air, 1995, *Vanity Fair*, unpublished.

p. 30, Fanny Ardant, Paris, 1987, German *Vogue*.

p. 31, Carole Bouquet, 1987, German *Vogue*.

pp. 32–33, Amanda Lear, St.-Tropez, 1977, unpublished.

p. 34, Ione Skye, Beverly Hills, 1993, *Vogue*, variant published.

p. 35, Penélope Cruz, New York, 1993, *Vanity Fair*, unpublished.

p. 36, Stephanie Grimaldi, Paris, 1987, German *Vogue*, unpublished.

p. 37, Anouk Aimée, Paris, 1987, German *Vogue*, variant published.

p. 38, Isabella Rossellini, Bellport, Long Island, 1989, *House & Garden*, variant published.

p. 39, Isabella Rossellini, New York, 1985, Lancôme.

pp. 40–41, Grace Jones, New York, 1980, record cover art, variant published.

p. 42, Brooke Shields, New York, 1986, *Mademoiselle*, unpublished.

p. 43, Catherine Deneuve, Paris, 1987, German *Vogue*.

p. 45, Jennifer Bartlett, New York, 1992, *Vogue*.

pp. 48–49, Jennifer Bartlett, New York, 1986, unpublished.

pp. 50–51, Lenore Tawney, New York, 1990, *House & Garden*, unpublished.

p. 52, Louise Bourgeois, Brooklyn, 1993, British *Vogue*, variant published.

p. 53, Pat Steir, New York, 1990, *Vogue*, variant published.

pp. 54–55, Susan Rothenberg, Lamy, New Mexico, 1990, *Vogue*.

p. 56, Annalee Newman, New York, 1991, *Vogue*, unpublished.

p. 57, Deborah Berke, Seaside, Florida, 1992, *Vogue*, unpublished.

pp. 58–59, Francesca von Habsburg, Lugano, 1993, *Vanity Fair*, variant published.

p. 60, Francesca von Habsburg, Lugano, 1993, *Vanity Fair*, unpublished.

p. 61, Jayne Wrightsman, New York, 1996, unpublished.

p. 62, Doris Saatchi, New York, 1989, unpublished.

p. 63, Françoise Gilot, La Jolla, California, 1991, French *Vogue*.

pp. 64–65, Alba Clemente, New York, 1991, *Vanity Fair*, unpublished.

p. 66, Tatiana Tolstoya, New York, 1990, *Vogue*, variant published.

p. 67, Tama Janowitz, New York, 1991, *Allure*, variant published.

pp. 68–69, Jackie Collins, Beverly Hills, 1995, *Vanity Fair*.

p. 71, Jil Sander, Hamburg, 1994, *Vanity Fair*.

pp. 74–75, Diane von Furstenberg, Connecticut, 1993, *Vanity Fair*, variant published.

p. 76, Carolina Herrera, New York, 1988, *Vogue*, variant published.

p. 77, Carolina Herrera, Southhampton, 1993, *Vogue*, unpublished.

pp. 78–81, Inès de la Fressange, Paris, 1991, *Vogue*.

pp. 82–83, Claude Brouet, Juziers, France, 1975, unpublished.

p. 84, Tina Chow, New York, 1988, *Marie-Claire Beautés*.

p. 85, Tina Chow, New York, 1988, *Marie-Claire Beautés*, variant published.

pp. 86–87, Tina Chow, New York, 1988, *Marie-Claire Beautés*.

p. 88, Laura Montalban, New York, New York, 1989, *Mirabella*.

p. 89, Marina Schiano, New York, 1990, *House & Garden*.

pp. 90–91, Paloma Picasso, New York, 1989, Australian *Vogue*.

p. 92, Loulou de la Falaise, Patmos, Greece, 1975, unpublished.

p. 93, Maxime de la Falaise, Patmos, Greece, 1975, unpublished.

pp. 94–95, Pauline Trigère, New York, 1999, *Vanity Fair*, variant published.

p. 96, Pauline Trigère, New York, 1999, *Vanity Fair*.

p. 97, Donna Karan, New York, 1994, French *Vogue*, variant published.

p. 99, Barbara Walters, New York, 1991, *Vogue*, unpublished.

p. 102, Barbara Walters, New York, 1995, *Vanity Fair*, variant published.

p. 103, Anna Wintour, New York, 1992.

pp. 104–105, Pamela Harriman, Washington, 1992, *Vogue*, variant published.

p. 106, Pamela Harriman, Washington, 1992, *Vogue*, unpublished.

p. 107, Tina Brown, New York, 1998.

pp. 108–109, Terry Allen Kramer, Palm Beach, 1998, *W*.

pp. 110–111, Bianca Jagger, Paris, 1973, British *Vogue*.

p. 112, Kerry Kennedy Cuomo, New York, 1993, *Vogue*, variant published.

p. 112, Kathleen Kennedy Townsend, Maryland, 1993, *Vogue*, variant published.

p. 113, Caroline Kennedy Schlossberg, New York, 1995, *Vogue*, variant published.

pp. 114–115, Georgette Mosbacher, New York, 1999, *George*.

p. 116, Marilyn Quayle, Washington, 1990, *Vogue*, variant published.

p. 117, Elizabeth Dole, Washington, 1996, *Vogue*.

pp. 118–119, Mimi Sheraton, New York, 1991, *Vanity Fair*, variant published.

p. 121, São Schlumberger, Paris, 1993, *Vanity Fair*.

p. 125, São Schlumberger, Paris, 1993, *Vanity Fair*, unpublished.

pp. 126–127, São Schlumberger, Paris, 1993, *Vanity Fair*, variant published.

p. 128, Nicky Weymouth, London, 1977, British *Vogue*, unpublished.

p. 129, Carroll Petrie, New York, 1989, *House & Garden*.

pp. 130–131, Mica Ertegun et al., New York, 1994, *Vanity Fair*.

p. 132, Gayfryd Steinberg, Quogue, Long Island, 2000, *House Beautiful*.

p. 133, Susan Gutfreund, New York, 1994, *W*, variant published.

pp. 134–135, Françoise de la Renta, New York, 1982, *House & Garden*, variant published.

pp. 136–137, Carolyne Roehm, Connecticut, 1990, *Vogue*.

p. 138, Barbara de Kwiatkowski, Lexington, Kentucky, 1993, *Vogue*, unpublished.

p. 139, Patricia Kluge, Charlottesville, Virginia, 1994, *W*.

pp. 140–141, Denise Hale, San Francisco, 1984, *Vogue*.

p. 142, Betsy Kaiser, Palm Beach, 1997, *House & Garden*, unpublished.

p. 143, C. Z. Guest, Old Westbury, Long Island, 1998, *House & Garden*, unpublished.

p. 144, Kathy Johnson Rayner, East Hampton, 1997, *Vogue*, unpublished.

p. 145, Sandy Pittman, Connecticut, 1995, *Vogue*, variant published.

pp. 146–147, Ivana Trump, Palm Beach, 1992, *Vanity Fair*, variant published.

p. 148, Ivana Trump, Palm Beach, 1992, *Vanity Fair*.

p. 149, Ivana Trump, St. Moritz, 1992, *Vanity Fair*, unpublished.

pp. 150–151, Merrill Stenbeck, Lyford Cay, 1991, *Vogue*, variant published.

p. 152, Isabel Goldsmith, Mexico, 1989, *Vanity Fair*, variant published.

p. 153, Isabel Goldsmith, Mexico, 1989, *Vanity Fair*, unpublished.

p. 154, Dewi Sukarno, New York, 1992, *Vanity Fair*.

p. 155, Dewi Sukarno, New York, 1992, *Vanity Fair*, unpublished.

p. 156, Marylou Whitney, Adirondacks, 1995, *Vanity Fair*, unpublished.

p. 157, Marylou Whitney, Adirondacks, 1995, *Vanity Fair*.

Acknowledgments

First of all, I wish to express my gratitude to the editors of the publications that originally commissioned the photographs which form the substance of this book, and to the subjects who submitted to the travails of a sitting with me as photographer. As mentioned in the introduction, fate sent me to my subjects, and their number has not been altered by whom I might think should or should not be included. The idea of adding Raquel and Miss Ross and Cher and all the others, tempting as it was, would have turned this into a nightmare of meritocracy, and such judgment is not for me to make. Those who I have photographed and are not to be found in this volume will have to blame the fact on the disarray of my archives, with my apologies.

Mark Magowan was a friend by the time I wondered aloud if this book idea might be of interest, and he brought it with him when he joined Alexis Gregory at Vendome Press. Alexis thought it "rather amusing," especially as he seems to know every dame in the book and many more, and has cheerfully moved the project along. My editor, Christopher Sweet, came directly from working on two successful books of somewhat similar interest, and fit the shoe perfectly. Miko McGinty can convert her great enthusiasm into cool graphic pages, and rode loftily above my interference, which knows no subtlety.

Every conversation I've had with Bob Colacello since he sweetly agreed to write the introduction to this book has sunk us deeper into a past which only confirmed the idea that Bob was the perfect, veteran dame-watching, writer.

To the stylists and embellishers of faces and coiffures, the individual mention of whom would tax my memory at the grave risk of unfair accreditation, my recognition of talent, skill, and team spirit.

As time gives us perspective of even the recent past, it is my hope that these images, some familiar, some seen for the first time, will give both pleasure and amusement, and convey some of the spirit of their subjects and their situations at a particular place in time.

First published in the United States of America in 2005 by
The Vendome Press
1334 York Avenue
New York, N.Y. 10021

Library of Congress Cataloging-in-Publication Data

Boman, Eric, 1946–
 Eric Boman's Dames / by Eric Boman ; introduction by Bob Colacello.
 p. cm.
 Includes bibliographical references.
 ISBN 0-86565-164-7 (hardcover : alk. paper)
 1. Photography of women. 2. Boman, Eric, 1946– I. Title.
 TR681.W6B63 2005
 779'.24—dc22
 2005014136

2005 2006 2007 2008 / 10 9 8 7 6 5 4 3 2 1

Designed by Miko McGinty
Printed in China